THE WIRED MUSEUM

The Wired Museum:
Emerging Technology and Changing Paradigms

Library of Congress Cataloging-in-Publication Data

The wired museum : emerging technology and changing
 paradigms / Katherine Jones-Garmil, editor ; introduction by
 Maxwell L. Anderson.
 p. cm.
 Includes bibliographic references.
 ISBN 0-931201-36-5 (pbk.)
 1. Museums—Data processing. 2. Museums—Techno-
logical innovations. 3. Information technology. 4. Museum
techniques.
I. Jones-Garmil, Katherine, 1949–
AM7.W58 1997 97-11054
069'.0285—dc21 CIP

THE WIRED MUSEUM

Emerging Technology and Changing Paradigms

KATHERINE JONES-GARMIL, EDITOR
INTRODUCTION BY MAXWELL L. ANDERSON

AMERICAN ASSOCIATION OF MUSEUMS

WASHINGTON DC
1997

TABLE OF CONTENTS

AUTHORS

STEPHEN ALSFORD is special projects officer in the directorate of the Canadian Museum of Civilization, Hull, Quebec. Since 1994, he has been responsible for planning and developing the museum's World Wide Web site. Alsford has written books, booklets and numerous articles on museological and medieval history subjects. He often writes with George MacDonald; together they are co-authors of the book *A Museum for the Global Village*.

MAXWELL L. ANDERSON is director of the Art Gallery of Ontario, Toronto, Canada. He oversees initiatives in new media for the Association of Art Museum Directors. Most recently director of Emory University's Michael C. Carlos Museum, he is the author of *Pompeian Frescoes in the Metropolitan Museum of Art* (1987), and co-author of *Radiance in Stone* (1988).

DAVID BEARMAN is president of Archives and Museum Informatics, a Pittsburgh-based consulting firm. He consults on issues relating to electronic records, integrating multi-format cultural information and museum information systems, and edits the quarterly journal *Archives and Museum Informatics*. Since 1991 he has organized and chaired the International Conferences on Hypermedia and Interactivity in Museums (ICHIM) and Museums and the Web: An International Conference.

HOWARD BESSER is visiting associate professor at the University of California's School of Information Management & Systems. As a specialist in social and cultural changes resulting from new information technology, he consults for libraries, museums, and arts organizations, and is a frequent speaker at professional con-

ferences. Besser has been on the Management Committee of the Museum Education Site Licensing Project (MESL) since its inception.

JAMES R. BLACKABY is senior systems developer in the Office of Technology Initiatives at the United States Holocaust Memorial Museum, Washington, D.C. He has worked for many years as a consultant, as a museum professional, and as an educator to enable museums to realize their potential as significant sources of cultural information.

GUY HERMANN is director of information services for Mystic Seaport in Mystic, Conn. He is also managing editor of the museum's World Wide Web site. He has written on computing for publications including *Spectra*, *The Lawyer's PC*, and *The Journal of Light Construction*. He is currently president of the Museum Computer Network.

LESLIE JOHNSTON is new media specialist for the Stanford University Museum of Art and the Department of Art in Stanford, Calif., where she manages networked information resources and multimedia projects. Previously, she was the systems project coordinator at the Historic New Orleans Collection and the database specialist at the Getty Research Institute for the History of Art and the Humanities. She is a past president of the Museum Computer Network, and has served on its board of directors since 1992.

KATHERINE JONES-GARMIL is assistant director for information services and technology at the Peabody Museum of Archaeology and Ethnology at Harvard University, Cambridge, Mass. She is responsible for the development of new media applications as well as the technological infrastructure of the museum. She is a former

president of the board of directors and is currently the program director of the Museum Computer Network.

GEORGE F. MACDONALD is president & CEO of the Canadian Museum of Civilization Corporation and executive director of the Canadian Museum of Civilization, Hull, Quebec. Previously, he was head of the New Accommodation Task Force charged with designing this institution. He has also held positions at the International Council of Museums, the National Historic Sites and Monuments Board of Canada, the National Archives of Canada Advisory Board, the Committee of the National Museum of the American Indian National Campaign, and the Board of the American Association for State and Local History.

LYN ELLIOT SHERWOOD is director general of the Canadian Heritage Information Network (CHIN), Hull, Quebec, the agency responsible for maintaining the national inventories of Canadian museum collections. She has held positions with the National Museums of Canada, the Canadian Radio-Television and Telecommunications Commission, the Privy Council Office, the Department of Communications, and the Department of Canadian Heritage. As a consultant, she specialized in communications policy and history.

DIANE M. ZORICH is a museum information management consultant specializing in museum documentation and issues related to museum information on electronic networks. Previously she was data manager at the Association of Systematics Collections in Washington, D.C., and documentation manager at the Peabody Museum of Archaeology and Ethnology at Harvard University. She is past president and current board member of the Museum Computer Network.

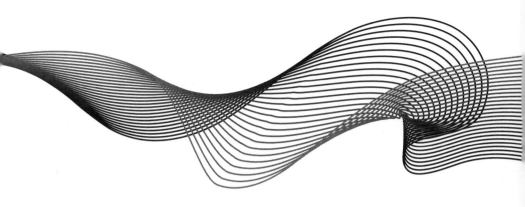

INTRODUCTION

MAXWELL L. ANDERSON

Director
Art Gallery of Ontario, Toronto, Canada
Liaison for Information Technology
Association of Art Museum Directors

The substance of this book lies in the various inter-
pretive paths the contributors take to the same
end. The divergent points of view expressed here-
in are typical of the spectrum of perspectives that char-
acterize the information technology field in museums.
Katherine Jones-Garmil captures the heady transitions
from one moment to the next over the 30 years of exper-
imentation with computers in museums. The picture
she paints is one of prescient innovations side-by-side with
failed attempts. Lyn Elliot Sherwood considers the ways
in which a top-down approach to managing informa-
tion technology resources will bear fruit, and speaks
with authority on behalf of the Canadian perspective.
Unlike her counterparts to the south, her views, which
are also consonant with a European rather than a U.S.
model, presume the necessity of government participa-
tion in building the best possible networked environ-
ment for museums. She takes the position that for the
foreseeable future, museum-based computer projects will
not be commercially viable and will require subsidies. Pre-
dicting the convergence of commercial and non-com-
mercial interests in this field, she gives us a blueprint

for collaborative thinking, and observes that we are moving, at last, from thinking about what is technically feasible to how we should serve audiences. It is premature, she argues, to undertake massive digitization projects, and she urges us to consider models like the Museum Educational Site Licensing Project (MESL).

Diane M. Zorich considers the current offerings of museums on the Internet, and points the way to success: integration of on-line resources. Unlike simple linking, she notes, full-scale integration will be necessary for the rich interchange that we all envision for a networked future. She spells out the many ways in which an integrated approach must be implemented, keeping in mind the structure and value of data, as well as the interests of end users. She singles out various efforts today that qualify as proofs of concept, and urges further exploration of the capabilities of a truly integrated digital cultural heritage system.

Howard Besser takes us closer to an understanding of how museums are likely to be transformed by the explosion of technological tools in the coming years. He takes the position that the personalized on-line experience may not in fact stimulate attendance, but may to some degree replace it. He makes the case for a reduced role for intermediaries in this new environment, and also proposes newly cooperative efforts among museums. He suggests that the distance between collections management and on-line exhibitions will shrink, and argues that there will be a fundamental shift in scholarship. That shift would entail working from homes and offices rather than from specialized environments like libraries. This should mean an interconnectedness in museum research, and new ways of thinking about collections. He also considers the likely impact of mass production of high-quality images on our reverence for the original artwork,

and wonders whether such widespread accessibility will ironically lead to diminished access to the original work. He asks whether museums will move from being the equivalent of archives to being the successors to today's libraries, and speculates that as a consequence, the institutional authority of museums will begin to wane. The potential for the erosion of high culture in general exists, he fears, and yet he wonders whether the result will instead be greater visual literacy among the broad population. His concern remains that market forces may result in greater mediocrity in what is offered, but tempers this admittedly bleak perspective with room to imagine a better outcome.

James R. Blackaby examines the fruitful contributions of integrated information systems, focusing on the U.S. Holocaust Memorial Museum in Washington, D.C. Integrated technology tools are for the most part already available, he notes, adding that curators are search engines, too, since they are highly sophisticated filing systems. He observes that file cabinets were devised first to contain and second to sort; whereas today's computers are meant first to sort and second to contain. Blackaby reminds us that computer innovations have until very recently been predicated on the assumption that a human interpreter would be present to cull and provide data to the end user. He considers the many obstacles facing us as we attempt to move towards a transparent experience of museums through computers; that multiple information sources complicate our ability to collaborate; that institutionally politicized and complex systems inhibit use because of the learning curve necessary to operate them; that warehousing data has enjoyed a higher premium than using it to arrive at new ideas.

David Bearman assesses the lessons of the Museum Educational Site Licensing project, and concludes that this is

a worthy direction for the museum community to pursue. In considering the options available to rights-holding institutions like art museums, he advocates the creation of a Rights and Reproductions Organization (RRO). Other routes available to museums include the agency resale model, which involves re-licensing through a third party, and the brokerage model, through which rights holders set individual prices and collect use-based income. The current model, the product licensing model, requires that negotiations cover each transaction separately, which acts to inhibit demand, since the market is so owner-controlled.

Guy Hermann enumerates a series of questions that confound many museum administrators and provides helpful answers. He considers the external factors that will drive museums to networked technology, including how digital information will grow geometrically and how networked computers will improve communication among museums and between museums and their publics. He helps chart a useful course for museum leaders seeking direction—requiring elasticity, demanding an emphasis on standards, connectivity, and interoperability, urging the collection of information in digital form, and exhorting museums to experiment. Hermann translates a number of pervasive acronyms and provides potent advice on appropriate hardware for museums of any size. He spells out how technology can help a museum fulfill its mission, urging the provision of desktops for those with desks and the establishment of links among computers on-site. He suggests defining software needs according to users' priorities rather than to novelty or blunt power, and advocates adequate training for staff.

CURRENT THINKING ABOUT THE WIRED MUSEUM

This book has several aims. It is intended not to predict the future but to provide ways of thinking about the use

of technology in museums. The authors all know how fast-changing the field is, and that today's prognostications will fuel tomorrow's ironic reminiscences, which is both a daunting challenge and an exhilarating fact of the electronic environment. The essays focus on the challenges facing North American museums, but the global implications of high technology are at the core of its potential. While not all are convinced that this will be possible, there is general agreement among the contributors that electronic connectivity should be used to increase and enhance the attendance of museums. The museums that have taken the trouble to analyze the effects of multimedia encounters in or near their galleries have found that such experiences only prolong and render more profound each museum visit.

Those who would draw battle lines between the technophiles and technophobes are creating a false dichotomy. The changes that art museums have sustained technologically are incremental and halting; the first telephone lines in art museums were doubtless decried, no less so than the introduction of desktop computers. It is easy to single out examples of the sweeping changes in telecommunications that have thus far proved a mixed blessing—voice mail foremost among them. That innovation is surely in its infancy, since it is as unsatisfactory an instrument as any. But as it becomes interactive and capable of hyperlinking, its potential may be realized in a variety of salutary ways.

The unremitting bombardment of our senses that bills itself as the "information age" has elicited a ragged answering volley of critical essays. These have included sensational tracts predicting the demise of polite society as its inevitable consequence (it's probably a bit late to be concerned). Several commentators have exhorted us to give up connectivity out of their sense that Orwellian

prophecies were some 50 years early but nonetheless on the mark. Films like *The Net* serve this vision in popular culture. It would be misguided to suggest that simply because a means to an end is technologically possible, that end is desirable, and yet this is the unexamined reflex of those of us applauding the trend towards "wired" and networked art museums. The latest phases of information technology are so fresh and powerful that their effect on our encounters with artworks has yet to be understood. This writer takes the position that the future is on-line, and that shrink-wrapped delivery systems like CD-ROMs will have a relatively brief shelf-life.

MUSEUMS AS RESEARCH INSTITUTES

Why do we look at art? Museums began in the late 18th century as monuments to wealth and civic patrimony. In the 19th century it was an educational imperative that raised a thousand marble columns, occasioned by a desire to elevate the working class. Today the impulse to go to a museum may be derived from pure curiosity, snobbism, a spiritual search, a yearning for a non-commercial public place of beauty, or a hundred other factors. A critical issue now confronting curators—the stewards of our cultural heritage—is how to provide curious but unfocused audiences with a lens permitting a clear and faithful understanding of the work of art. This mandate is at odds with the curator's traditional responsibility: not to provide the means of understanding, but to complete the original research enabling others within and outside their institutions to grind and polish the lens. Until a generation ago, providing information about our collections was a sufficiently daunting task, but now the interpretive skills of our scholars are being called upon for emerging delivery systems. These are not monographs reaching 400 specialists, but on-line home pages

on the World Wide Web accessible to millions. While scholarly presses turn to CD-ROMs to publish those unprofitable tracts that may be said to have a fighting chance of advancing human knowledge, all but the largest museums are finding it increasingly difficult to afford subsidizing research on art historical matters that would seem esoteric to a networked public.

The coming intellectual realignment of art museums points to a phase in which joint appointments with universities provide a partial solution. In this way, true scholarship on works of art in the public trust may be subsidized by like-minded institutions, while neither need shoulder the financial burden alone. Those specialists who continue to work *exclusively* at museums will have as their charge an increased emphasis on interpretation for the public—to the inevitable detriment of their contributions as researchers, an identity to be reclaimed during their free time or while on leave.

The price of this change, with its restriction of generous research freedoms, may at first seem high, but the fact is that the delivery systems now at our command will actually allow museums to reach a growing population *without* a risk of compromising intellectual standards. Since the provision of varying levels of interpretation is one of the benefits of digital technology—rather than the watered-down lowest common denominator known as the wall label—digital access will allow any user with any background to feel at ease with interpretive material. Thus the museum can actually furnish more information more easily to more users than before, both from its own scholarly ranks and from specialists at universities and museums worldwide. The decentralization of expertise, which has begun in "long-distance learning" at universities, is imminent at museums as well.

It would be beneficial, for example, to prepare for a visit to a permanent collection or a special exhibition by downloading a virtual preview of that display—replete with three-dimensional navigation in the galleries and instant access to comparable works in other collections globally. With such information already in the hands of the visitor, the jockeying for enlightenment that characterizes the orientation gallery of every show would no longer be as harrowing. The scholar could preview the varied perspectives of colleagues about works in the exhibition, and the scholar will be the first with such access, given the hegemony of universities on the Internet today. Scholars will soon be followed by members of the general public, who may pull down background about the social circumstances characterizing the period. In turn, the provision of information in several languages would make for a worldwide audience more closely engaged in the life of our museums, and would even contribute to language training among North American students.

The visit to a museum would be the culmination of a learning process and the point of departure for real enrichment, instead of the compressed learning/entertainment/socialization center that we are now asked to be. In examining the actual visit, rather than the imagined ideal one, it is clear that we ask the impossible of our viewers in going from a first acquaintance with a work or period to appreciating it in all its glory in the course of a few minutes. The Metropolitan Opera has acknowledged as much by mounting subscripts on the back of theater seats. The pursuit of a reverie is the much-vaunted goal of a visit to our galleries, but the obstacles to that pursuit are many, ranging from jostling crowds seeking enlightenment along with you to the abstract declarations of label copy that offer precious few pointers to the uninitiated. The day will come when

it will seem ludicrous to have furnished generations of visitors with but a few pithy words on the wall.

ENHANCED UNDERSTANDING IS NO SUBSTITUTE FOR LOOKING

The oft-repeated fear that providing multimedia encounters with artworks will diminish the potential viewer's appetite for the original is demonstrably false. Each summer and fall, thousands of college students flock to European museums in hot pursuit of those artworks they have come to know and love through unfocused, inaccurately colored slides pirated from color plates printed in textbooks derived from transparencies rented from museums or photographic archives. Their appetite to see and to be in the presence of the original work is not only whetted by these lamentable reproductions, but is in direct proportion to the extent to which they have lingered over those illustrations—in textbooks, on postcards, and on T-shirts.

In the emerging landscape of on-line images, the appetite for the original will only deepen, as people of all ages become better acquainted with the works of art that appear on their screens. The Pavlovian reflexes so skillfully honed by the world of advertising will be no less in play in the arena of art reproductions. Repeated images of desirable consumer goods—from cars to hamburgers—today exercise an appreciable influence on the desires of the viewer. As has been observed from McLuhan onwards, the palpable hypnotic effect of such imaging can be as great as any religious or ideological suasion has been in the past. The demand for the original work will increase rather than decrease, following repeated exposure at an institutionally authorized site on the World Wide Web or its successor.

The exposure to images of works of art is now largely limited to slides on the screens of survey courses or on the pages of very expensive art books, both of which are beyond the reach of or inconvenient for millions of potential visitors. The provision of instantaneous and regularly updated information surrounding images of artworks will immerse the casual viewer in a world of imagination and creativity in stark contrast to the flotsam of commercial stimuli that continue to overwhelm on-line networks. That world will become increasingly attractive to an ever-more sophisticated public, and museums will be oases of originality in a virtual world. Furthermore, it will become clearer that understanding an object, if that is one goal of museum attendance, can begin on the Net while preparing for a visit, leaving one with more time for appreciation and reflection while standing in front of the work in a gallery.

THE CRIME OF REPRODUCTION

Since long before Walter Benjamin, the scholarly community has resisted "mechanical reproduction" not so much out of a fear that simulacra would replace the original experience, but that it would cheapen it. A larger question is now posed by a technological milieu making reproductions more easily accessible and visible in greater detail than the originals. It may fairly be asked: What is the crime in that? Magnification of details in a digital image will eventually permit as close a look as does magnification of the original surface of a painting, and the manipulation of the image to eliminate pentimenti, dirt, darkened varnish, craqueleure, and other unintended disfigurements of the surface can produce a version of a painting that is in physical respects *more faithful* to the artist's original intention than the current state of the work. And this can be accomplished without damage to

the object. The *Mona Lisa* could be more easily studied today in a high-resolution image over the Internet than in the galleries of the Louvre, where dim lighting, thick ultraviolet-filtered, bulletproof glass, zealous crowds, and protective guards keep us at arm's length from the painted surface. We are in effect looking at the painting through a glass screen anyway—but one that reduces its visibility rather than emits light. In a room filled with animated school groups being lectured to in three different languages, there is some question about whether quiet contemplation of that pacific image with only the whirring of a hard drive in the background of a quiet night in Iowa City is not a more unfiltered encounter with Leonardo in his studio than that to be had in the imperial splendor of the Louvre. Furthermore, the recent innovations of Java (flexible, open-ended programming language) permit the layering of ultraviolet or infrared screens over the surface of paintings at the user's command, and thereby dramatically change the potential of computer imaging at the user's fingertips.

The modeled restoration of the surfaces of sculptural ornament long exposed to the elements is both an act of hubris and an act of generosity to the maker. The guano-encrusted, calcium-carbonate surfaces that greet today's onlooker reveal next to nothing of the original texture of outdoor marble monuments, while 19th-century plaster casts, captured before the ecological ravages of the industrial revolution, allow a better understanding of the original appearance. At what point will we throw up our hands and admit that the disfigured original will not lose value through digital renovation for the benefit of scholar and student alike? As long as the version is identified much as we do translation, no crime is being committed, but rather the interpretation by someone of the probable appearance of the work in its own time—the pictorial equivalent of a thousand words.

The crux of the matter is that digital encounters will provide informational benefits, and that they will encourage curiosity about the original, but that they cannot provide the *visceral thrill* of being in the presence of the original. That simple but basic truth will be argued by those of us in the museum profession until our dying breaths. Furthermore, the thrill will be heightened by greater awareness and familiarity with the artwork as old friend, whose acquaintance we will renew over and over again through the equivalent of accounts from mutual acquaintances (ranging from label copy to monographs), snapshots, and the like. And like a long-lost relative whom we have never met, but knew so much about, the first encounter will be all the sweeter as our fondness develops from afar.

TRANSPARENCY

Among other daunting tasks the authors have set themselves is to point the way to technological needs that have yet to be fulfilled. The increasing "transparency" of high technology—its demystification and simplification—will reduce the distracting hiss and crackle not only of communication itself, but also the polemical tone that attends the debate, since the terms of engagement will be simplified as well as the ends. Transparency will involve voice recognition technology, and the reduction of drudgery in information gathering and retrieval. The advent of word processing on a mass scale in the early '80s stimulated a lively debate about the quality of writing—the assumption being that overwriting and text block substitution would make writers lazy and literature impoverished. It is difficult to qualify the net improvement or deterioration of writing as a consequence of the PC; curmudgeons will decry and converts will proclaim. The next step—voice recognition—will just as surely

lead to declarations of the death of prose. What it can mean to museums reflects what it will mean to society at large. Once the instantaneous conversion of spoken words to electronic text becomes commonplace, and once that text is indexed through hyperlinking so that portions or concepts can be retrieved by a verbal command— allowing attached text, video, and animation to be culled across global networks, both the work environment and our public spaces will be transformed.

Conservators will complete condition reports in record time, curators could extemporize about artworks as they stroll through galleries around the world, educators could instantly capture observations about the experience of the museum, scholars could undertake research and test assumptions in less formal and more easily updated forums than costly journals with minimal circulation, and the remainder of the administration could save countless hours of expensive travel and barely productive meetings by bundling this new "content" in useful streams.

The assault of documents composed from untutored and unfocused ramblings will doubtless be massive. Yet such might be said of the printing press as well, since the pool of available information before the press was shallow indeed. An ever-widening pool is only as threatening as one chooses to make it, since blathering will continue around the world with or without the Internet. The key issue is not whether voice recognition technology will stimulate an onslaught of detritus—it will—but how to go about picking out the pearls that will just as surely be revealed.

FILTERING

The arrival of radio in the 1920s heralded the beginning of electronic mass media, and in the relatively short inter-

val since then, we have become accustomed to receiving information through a handful of media: broadcast news, an ever-diminishing number of independent newspapers, cable news, and radio. In each instance—apart from the newly assaulted arena of public broadcasting—we rely upon the vagaries of the marketplace to determine who will succeed and fail. No less important, we depend upon the expertise of producers, editors, and journalists to determine what information we are to receive, and when. The coming model of communication will no longer require that a relatively small cadre of content providers determine the information streams. As of this writing, the explosion of the World Wide Web has begun to lead to new means of information gathering that actually point to a kind of global village envisioned in theoretical terms long ago. The new industry that is being spawned is the filtering industry, which is actually an old idea in new digital garb. Instead of magazine editors, we will have Webscreeners, who can protect you from the 20,000-word free associations of Uncle Fred and ensure that the best and most interesting material reaches you.

In the context of museums, the marketplace drives what we read as well. We ordinarily publish books only if we have dedicated support or we can afford to guarantee a circulation large enough to repay ourselves. The channeling of content about art will no longer rely exclusively upon the sale of exhibition catalogs to 5 percent of our visitors, but will instead be directed through networks directly to schools, libraries, and homes. And thus museums will be in a position to reach audiences never before imagined, with creatively gathered and delivered methods that the marketplace may be slower to deliver. Instead of offering an outreach program to a few dozen students at a time, we can begin work on programs that

are tailor-made for thousands of students at a time—convenient to them and their teachers. We can begin formatting our information in ways attractive to the segment of consumers who may elect to retrieve it.

One market will be scholars, who seek the best available opinions about attribution, condition, iconography, social context, and a host of other matters. With a global infrastructure in place linking art historians (and other breeds of humanists and social scientists) 24 hours a day, it stands to reason that the nature of research itself will never be the same. One convenient falsehood that we embrace is that scholarship is best undertaken in solitude—that a redundant doctoral dissertation launched in Freiburg addressing the same topic as one sitting quietly on a shelf in Pittsburgh is forgivable. But the likelihood that simultaneous translation, hyperlinking, and image transfer will make desirable the sharing of discoveries between those dissertations begs a larger question, and that is how to measure scholarly achievement. Once global networking reaches its natural capacity, the award of a doctorate may have to follow on new kinds of accomplishment. Already, the surfeit of dissertations has led to an ever-spiraling focus on the minutiae of art history—leading to the implausible rebuilding of the reputations of second-rate artists, the discovery and promotion of inconsequential facts, and the relatively parochial achievement of observing trends in a cloud chamber. While universities stand to be challenged by this evolving reality, museums stand to gain. We will welcome the arrival of a multifaceted interpretive model, offering numerous ways to enlighten our visitors about our artworks, rather than offer up a single point of view that has been traditionally held. And the quest will not be for originality, but for creative use of the ever-expanding global pool of networked information.

Another market for museums will be schoolchildren, who may find themselves learning about history with a rich diet of instantly retrievable images. The risk that fine art will be reduced to illustration is one that will be taken if it means exposure to masterpieces that might otherwise never occur. No less significant, most other fields will involve imaging—from chemistry to geology to logic—and it makes little sense for museums to stave off the commodification of images of their collections in hopes of preserving the sanctity of the original artwork, when the result is just as likely to be an increased familiarity with our holdings. This familiarity may lead to contempt in some, but will just as surely lead to admiration in others.

THE POWER OF NETWORKING

The real power of interactive technology is to be harnessed through networking. Innovations of expanded memory have allowed for image storage, processing, and retrieval. But the transfer of such imagebases over high-speed networks, with links enabling searches in any language from collections globally, is certain to transform art historical research and education. It may also signal the arrival of a mass market for the field, which has heretofore failed to materialize. The majority of North Americans do not visit art museums today, but easy access to museum collections through computer networks will permit a rethinking of humanities-based learning at the earliest levels. A new generation of potential visitors will become accustomed to studying not only art history, but history as well. And the visual literacy of millions will begin in earnest. Museums stand to become far more important to more people, and the ability of museums to attract the kind of sponsorship necessary for educational innovation will likely increase as well.

SITE LICENSING

The critical issue in ensuring broad access to digital images of artworks is one of intellectual property. There is no point in digitizing one's art collections if the next step is to hoard those images in the vain hope of striking it rich. The value of digital images will decrease in proportion to the widening of the pool of available images. Museums' battleground in the realm of intellectual property will likely be not for the images themselves, but for the ever-expanding information attached to those images. But we stand to become the losers if we forget our original mandate: to make the encounter with the originals an enriching one. The hard reality is that our invitation to others to retrieve images of our originals will only lead to a diminution in the cash value of what we can present by ourselves. And that the presentation of points of view of scholars and curators worldwide is in our future, not just the officially sanctioned and digested view. Thus we will be in a position to earn less in cash value from digital dissemination, but earn more in our value to society at large. The result should be that more people will want to visit us more often, which is what we seek anyway.

Museums must therefore move towards a model of site licensing, rather than the issuance of publication permissions on an object-by-object basis. Copyright as we know it probably will be replaced by an ASCAP-like formula gauging usage by subscribers or purchasers of content. And the sooner we recognize the usefulness of collaborating as art-collecting institutions, the sooner we will take advantage of the potential of our imagebases. Experiments are underway as of this writing, most notably that of the Museum Educational Site Licensing Project, which is being sponsored in part by the Getty Information Institute (GII). It is exploring the potential

of allowing end users at universities to navigate an undif-
ferentiated pool of images supplied by museums. The
Art Museum Network, a project of the Association of Art
Museum Directors, is an effort to implement the results
of this research (http://www.AMN.org).

THREE DIMENSIONS ON-LINE

It is one thing to disseminate slides on screens. It is quite
another to simulate the three-dimensional environments
of museums themselves. This is a next arena for design-
ers, curators, and educators. It is already permitting the
CAD (computer aided design) replication of galleries
with digitized images of artworks to challenge the hege-
mony of physical models. While foam-core models appeal
to our intuition, digital environments allow for much
speedier change, multiple points of view, and easy pre-
sentation over networks. Dropping in a donor's name to
scale on a 3-D model is one useful feature, but the sim-
ulation of sight lines devised by curators and designers
is more useful still. No less important, the virtual visi-
tor's ability to navigate through an exhibition in any lan-
guage will likely increase the awareness of such exhibi-
tions and the sophisticated capturing of curatorial inten-
tion. Serendipitous encounters and connections will be
fostered, and the interactive wall label will allow a vir-
tual visitor to click on a wall text to pull down voice-
overs, scan comparanda, and otherwise enhance his
understanding of the adjacency of originals. With 965,000
people flocking to the Monet exhibition at the Art Insti-
tute of Chicago, we might readily ask how many mil-
lions more would have paid a nominal admission charge
for a virtual visit from anywhere in the world. Their
user's fees would help defray the cost of the real exhi-
bition, but would also allow museums to assemble com-
plementary exhibitions entirely on-line. The Vermeer

exhibition in 1996 at Washington's National Gallery was an exquisite event. Capturing it in digital video makes a desirable product that virtual visitors will likely pay for. On the other hand, no such exhibition of Leonardo is likely to be undertaken, and a virtual display holds many possibilities.

The orientation galleries that we construct might just as easily be presented on-line, with panel paintings reinserted into chapels, gargoyles reattached to cathedral walls, Roman portraits repositioned on bodies in simulated public buildings. The educational value of such three-dimensional imaging will be to breathe new life into works deprived of their original context, and will make the pilgrimage to our galleries all the more rewarding.

INTRANETS

The Internet sped into our consciousness in 1993 with the growth of Mosaic and later Netscape and Internet Explorer. Museums have been slower to appreciate the utility of Intranets, or networked digital communication within their walls. No less significant for the profession, the emergence of Intranets allows museum staff to communicate with one another as never before, effortlessly sharing files, communicating seamlessly with colleagues both inside the institution and with those in other museums or institutions. The management implications are extraordinary, since the onus will shift from what it is desirable to "publish" to what information should not be made widely available.

Related to this prospect is how information management will change from "pushing" it—as with brochures and newsletters—to "pulling" it—allowing the visitor and potential visitor to eavesdrop on our activities to such a

degree that our conventional means of filtering data will begin to seem too restrictive. As museum staff, we will be challenged to share more, divulge more, and communicate our concerns with our public in new ways. An Intranet is potentially a powerful tool for the courageous administrator. He or she can choose to share unlimited kinds of digital information, including files, records, statistics, images, and other work tools that are otherwise more slowly accessible from scattered locations. The old lament of "I never got the memo" is rendered obsolete if the "memo" is a running, regularly updated account of a project's progress open to scrutiny at will. Select sets of digital information can be made available to the global public on the Internet without a need to reformat or manipulate the content.

After cost, the primary obstacle to the widespread implementation of Intranets in the museum environment is the belief of administrators that information is best carefully controlled through a prescribed hierarchy. While that may be true in various arenas—including official publications and donor budget details, as well as agreements in a state of delicate negotiation, like certain exhibitions—the vast majority of work in our museums is not sufficiently salacious to command the interest of hackers, even those on staff. And even hackers are not so difficult to track down in such a finite group of end users— easier, perhaps, than identifying the ne'er-do-wells who abuse the privilege of the photocopier. Furthermore, if museum staff rejoice in publicly undermining the institution by means of computer networks, the problem may not lie with technology but with management.

PCTV

The word "convergence" is so often used in the realm of technology that we should by now expect to have

reduced communications to the much-heralded palmtop avatar. But the convergence of the personal computer and the television is underway as we go to press. The implications are as staggering for museums as for all other entities that seek connections with a global audience. Until quite recently, information technology was almost the exclusive domain of our registrars or librarians. In the last few years, the balance of museum staff members has been jolted awake by electronic mail and the World Wide Web. But now the challenge has metamorphosed almost overnight—we are all potentially on view, and that curtainless stage is the one that lights up suburbia, high-rise condominiums, shantytowns, newsrooms, and waiting rooms alike around the globe. The era of predicting the demise of television has changed to one planning for the overhauling of that hardy medium in a matter of months, since manufacturers and telecom executives have decided to shelve "high definition" television in favor of the networked computer subversively generating content from within the TV, potentially in any definition. The viewer is realizing new options, whether by means of the "WebTV" or "NetTV," which put the Internet on the television screen by means of a phone line, or by the PC hooked up to a cable modem and receiving television on its monitor.

For museums on-line, the newest challenge will not be to elicit thousands of "hits" over the Web, but how to entice the millions wielding the remote control. While the three-dimensional imaging and virtual reality universe still beckons, the more immediate matter of vying to have a prominent stake in a family's prime-time viewing choices is a provocative opportunity. The logical direction we must address is how to research and develop innovative kinds of enrichment through digital technology in the long term while profiting from instantaneous access to server-fed content on television—includ-

ing not only Web pages but especially audio and video streaming, with all that is implied. Museum directors thus have another expertise demanded of them: television producer. And the results, if ambitiously conceived, may promise exciting rewards in reaching audiences that have hitherto seen museums as obscure or intimidating fortresses. Through astute video programming on networked Web sites, museums need no longer accede to being marginalized because of the relentless onslaught of powerful commercial interests that have directed the audiovisual stimulation of the mass audience. With networked digital technology available through the cable box or through the air, it will be a battle of wits to get our multiple messages across, as well as to cajole audiences to communicate with each other through our museums by means of wireless keyboards and, soon enough, voice recognition systems. Which will require not only a sequel to this book, but a new kind of museum.

CONCLUSIONS

These are some of the issues surrounding the effect of digitization on cognition and perception in the world of art history. Those issues are likely to change with each passing season, since the unimaginable has a determined way of appearing at a rapid pace in high technology. The growth of wired museums of all kinds may provide a younger generation steeped in this technology with more reasons to connect to us. It seems less likely that it will contribute to our eclipse as institutions than our transformation. Although we may bemoan the extent to which we are different in our contributions to society today from what we were 30 years ago, we cannot return to a time when audiences were tolerated rather than listened to, information was sporadically shared, and amenities were an afterthought. And for that we are without question better institutions.

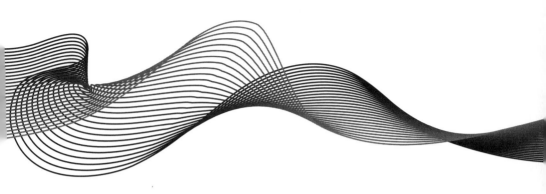

LAYING THE FOUNDATION:
THREE DECADES OF COMPUTER
TECHNOLOGY IN THE MUSEUM

KATHERINE JONES-GARMIL

Assistant Director for Information Services
and Technology
Peabody Museum of Archaeology and Ethnology,
Harvard University, Cambridge, Mass.

These are exciting times for museums. With new technologies such as digital imaging and local and global networks, it is now practical to capture and share information on collections in ways that have only become possible in the last few years. In considering where we are going and how best to get there, it is worth taking a look at the almost 30-year history of computers in museums. It has been a long courtship with technologies that only now are fulfilling the potential of the relationship.

THE 1960S

Museums began using automation technologies in the early 1960s. One of the first projects was an outgrowth of the Automated Data Processing (ADP) Committee, formed in 1963 at the Smithsonian Institution's National Museum of Natural History. The system that resulted from this project was known as SELGEM, which

stood for Self Generating Master. SELGEM used text data fields that were delimited by numeric tags and special characters. The system and the source code were provided free-of-charge to museums but with the caveat that the system could not be supported by the Smithsonian if changes were made to the source code.

In 1965, four organizations began to enter data into SELGEM databases—the Smithsonian Institution, the University of California–Berkeley, the Lowe Art Museum at the University of Florida, and the Oklahoma Inventory of Ethnological Collections. At that time, all computer systems were mainframe systems. Disk storage and processing costs were expensive. The CPUs (computer processing units) were usually owned by entities outside of the museum—for example, by a university or state agency.

Another project that has been very important to the computerization of museums began in 1967. Jack Heller, a professor of computer science at the State University of New York at Stony Brook (and devoted friend of the arts) started the Museum Computer Network. Heller collaborated with David Vance, who was working in the registrar's office of the Museum of Modern Art in New York, to organize a consortium of museums in New York City. The primary focus of the consortium was to automate information on the collections in each museum.

Previously, Heller had developed a similar program that was in use at the United Nations. This early museum application was called GRIPHOS (Generalized Retrieval and Information Processing for Humanities Oriented Studies). Like SELGEM, this was a mainframe system with data field tags and delimited records. It was made available to museums through membership in the Museum Computer Network. The yearly membership fee was

$1,000. Membership was available to institutions only, not individuals. However, each institution was allowed two official delegates at the annual meetings.

Other MCN projects followed. In 1968, MCN and IBM sponsored a conference on computers and their potential application in museums. In 1969, David Vance began a standardization project with 12 art museums. This was one of the pioneering efforts in the standardization of museum information. The project produced a data dictionary that was used by all subsequent GRIPHOS users. Changes and additions were submitted to a committee for review. The definitions and the syntax of the information entered into each field were kept to a standard so that, in theory, information could be shared among member institutions.

TIMELINE 1960-1969

- **1963:** ADP Committee formed at Smithsonian National Museum of Natural History

- **1965:** Museum data entered at Smithsonian, UC–Berkeley, Lowe Art Museum–University of Florida, Oklahoma Inventory of Ethnological Collections

- **1967:** MCN established by Jack Heller

- **1968:** MCN/IBM sponsor conference on computers and their potential application in museums

- **1969:** David Vance begins standardization project with 12 art museums

THE 1970S

Both GRIPHOS and SELGEM were used throughout the 1970s. A number of institutions adopted the systems during this period. GRIPHOS was used by art museums and other types of museums, including those with archaeological collections. The value of computerizing collections information was slowly being recognized by muse-

ums. In 1970, the Metropolitan Museum of Art held the second conference on computers and their potential application in museums.

In 1971, Robert Chenhall, who then worked for the Arkansas Archaeological Survey based at the University of Arkansas, held the first Archaeological Data Bank conference. In 1972, the Museum Computer Network was incorporated as a nonprofit organization in New York. David Vance was the first president of the board of directors. Robert Chenhall was one of the first members. Chenhall worked with Vance to further develop the GRIPHOS data dictionary for use with archaeological collections.

In Canada, the National Inventory Programme (NIP) began in 1972. This was a program in the National Museums of Canada.

> NIP was created [in 1972] to create national inventories of Canadian heritage, both humanities and natural sciences. This program, and others created at the same time, were intended to protect and preserve Canadian heritage and to educate Canadians about their heritage. The program was also created to respond to the UNESCO convention on protecting collections. (Gail Eagen, Canadian Heritage Information Network, personal communication, 1/29/97)

In the U.S., the Museum Data Bank Coordinating Committee was formed in 1972. This committee met on several occasions during its five-year existence to consider issues of computerizing museum collections. Each meeting resulted in a publication by the members of the committee, who were the leading experts and practitioners in museum automation at the time. The committee disbanded in 1977.

In 1978, for funding reasons, the Museum Computer Network decided to discontinue development and phase out support of GRIPHOS. Many GRIPHOS users, however, continued to rely on the system until viable alternatives could be found. GRIPHOS users included the Arkansas Archaeological Survey, the Florida Bureau of Historic Sites and Properties, the Museum of Modern Art, the International Museum of Photography at the George Eastman House, as well as several museums in Australia.

Annual conferences of GRIPHOS users continued and gradually expanded to include non-users who were already computerizing collections information or wanted to do so. GRIPHOS users were also sharing their ideas and needs with colleagues at other meetings, including those of the American Association of Museums. Other events taking place in the computer industry and in other museums would soon begin to change the landscape of museum automation.

In 1977, the Apple computer was invented in a Silicon Valley garage, and the era of the personal computer began in earnest. When this stone was tossed into the pool of the computer industry, museums were at the outer edges of the ripples. As with many significant advances in technology, the effects would not be felt for some time, but computers were changed forever. In the same year, the Museum Documentation Association (MDA) was formed in the United Kingdom. This group recognized the need for standards in the recording and automation of museum collections information. The MDA has since become a leader in this area of standards for museums.

In the next year, another standard for the field, compiled by Robert Chenhall, was published by the Ameri-

can Association for State and Local History. *Nomencla-ture* is a hierarchical thesaurus for naming objects based on their function. It was widely used and was later revised by James Blackaby.

In the late 1970s a system was developed for the Boston Children's Museum and used by a consortium of museums in the Boston/Cambridge area. The fields accommodated a basic inventory of the collection. The system allowed museums in the consortium to dial in to the computer at the Children's Museum to enter and access their data.

One of the consortium members was the Peabody Museum of Archaeology and Ethnology at Harvard University. Subsequent automation at the Peabody has followed the general trends in the computer industry: from the time-sharing system to an in-house mini-computer system and now a client server, networked environment using a collections management system designed specifically for museums.

In Detroit in 1979, the Detroit Institute of the Arts began a collections computerization project that resulted in a limited partnership with Burroughs Equipment Corp. and a system called DARIS (Detroit Art Registration Information System). It was used for cataloging, exhibition management, registration and object location tracking. After the first year of its development (funded in part by an NEA grant), it was decided that it would be useful for other museums in Michigan. Through an NEA grant, the system was given to selected Michigan museums, along with the hardware and dedicated, leased phone lines for data entry.

By the end of the 1970s, imaging technology was making its way into museums in the form of analog videodisc

systems. In 1979, IBM and MCA (Music Corporation of America) announced a videodisc product,[1] as did Digital Equipment Corp. and RCA. Several museums attempted to use this technology, but the projects proved unsuccessful.

In 1979, with the support of an NEA Fellowship, I visited several museums that were automating collections information. These were the Arkansas Archaeological Survey at the University of Arkansas in Fayetteville, the Arizona State Museum at the University of Arizona in Tucson, the Museums of New Mexico in Santa Fe, and the National Museum of Natural History (NMNH) in Washington, D.C. Each had taken a similar approach based on systems available in the 1960s and 1970s. Three of these were using SELGEM, and one was using GRIPHOS.

One of the most striking problems encountered at each of these institutions was the labor-intensive task of data entry. The NMNH was the only museum using OCR technology (Optical Character Recognition, commonly known as "scanning") to overcome this.

TIMELINE 1970-1979

- **1970:** Metropolitan Museum of Art holds second conference on computers and their potential application in museums

- **1971:** Chenhall holds Archaeological Data Bank conference

- **1972:** MCN incorporated as a nonprofit organization in NY; National Inventory Programme (Canada) begins

- **1972:** Museum Data Bank coordinating committee formed (disbanded 1977)

- **1973:** International Species Inventory Systems proposed

- **1974:** MCN moves to SUNY–Stonybrook

- **1977:** Apple computer emerges

- **1977:** Museum Documentation Association (UK) formed

- **1978:** MCN abandons GRIPHOS due to funding difficulties; *Nomenclature* published by Chenhall

- **1979:** Harvard Peabody Museum begins timesharing consortium with Boston's Children Museum

- **1979:** DARIS developed at the Detroit Institute of Arts

- **1979:** IBM/MCA announce videodisc product

- **1979:** DEC:IVIS system announced

- **1979:** RCA announces CED videodisc

- **1979:** Museum of Fine Arts, Boston photo videodisc project completed (2,000 images; DISCOVISION; IBM/MCA)

THE 1980S

The decade of the 1980s brought exciting changes to the area of museum automation. Desktop computers and improved storage devices became available early on. Each year brought improvements and reduced costs. Advances were also seen in database products. As the desktop revolution began, there were relatively few choices for IBM compatibles and none for the Mac. By the mid-'80s the choices were greater, and by the end of the decade there were a number of stable database applications available for both platforms.

Museums no longer needed to depend on university computing groups or special software consultants to write applications for them. Software written specifically for museum applications became available from companies that worked exclusively in the museum marketplace. One of these early applications was developed for the Dallas Museum of Art by Willoughby Associates, Ltd., in 1981. The system was called MILAM.

In 1980, work began on the *Art & Architecture Thesaurus* (AAT). Toni Petersen, Patricia Moholt, and Dora Crouch initiated the project with a grant from the Council on

Library Resources and a subsequent grant from the NEH. The goal was "to build a consistent, comprehensive, and controlled vocabulary that could be used by database developers, but that at the same time would not conflict with the working language of the scholars and researchers who would be users of the databases."

In 1983 the AAT became an operating unit of the J. Paul Getty Trust as part of its Art History Information Program. Work on the AAT continues today. In 1990, the first edition was published by Oxford University Press. A second edition was published in 1994. The AAT is now available in several electronic formats that have proven even more popular than the print editions.

By 1982, 15 museums in Michigan were using the DARIS system developed for the Detroit Institute of Arts. The data from each institution was housed on the Burroughs mainframe at the DIA in Detroit. For the first six years, six people worked full-time doing data entry. Over the life of the system, full records, each a very comprehensive 80 fields in length, were entered for about one-third of the 56,000 DIA objects. Another third was entered with a less comprehensive boilerplate record, and the last third was represented by catalog number, curatorial department, and classification. The system was used until 1994, when the DIA realized it could no longer support the entire system. The "client" museums were gradually moved off the DIA system. A new system, The Museum System (from Gallery Systems, New York), was selected to replace DARIS. Each institution became responsible for its data and managing the new system.

During the 1980s, other vendors of museum software announced systems for database management. Among these were Willoughby Associates' Quixis™, MIMSY™ and other products (beginning in 1980); Vernon Sys-

tems' COLLECTION (1984); Questor Systems' ARGUS (1986); and Oaktree's ACCESSION (1989). Systems to support membership and development, ticketing, and admissions were also available.

At the end of the decade, an MCN initiative called the Computer Interchange of Museum Information (CIMI) was launched. MCN received a PEW grant and later a grant from NEH to fund the initiative.

During the early 1980s, the National Museum Policy in Canada was changed and the National Inventory Program became the Canadian Heritage Information Network (CHIN). Its mandate was expanded to provide collections management services to museums. (Gail Eagen, Canadian Heritage Information Network, personal communication, 1/29/97)

TIMELINE 1980-1989

- **1980:** Work begins on *Art & Architecture Thesaurus* (AAT)

- **1980:** MCN sponsors North American Planning Conference on use of microcomputers in museums

- **1981-2:** CHIN formed from National Inventory Programme

- **1981:** IBM PC introduced

- **1981:** MILAM Collections Management Relational System developed

- **1981:** Clearinghouse on Art Documentation & Computerization project begins

- **1982:** Florida Bureau of Historic Sites and Properties stops using GRIPHOS, begins using Scientific Information Retrieval System

- **1982:** Fifteen museums in Michigan using DARIS

- **1982:** Getty launches Museum Prototype Project

- **1983:** University of Wisconsin's Helen Allen Textile collection database and videodisc project completed, including 12,000 records and 23,000 images

- **1983:** LOTUS 123 arrives; IBM PC sales soar

- **1984:** Macintosh introduced, revolutionizing desktop computing

- **1984:** First PCs introduced and used at Smithsonian

- **1984:** Getty sponsors International Conference on Automatic Data Processing of Art History data and documents

- **1985:** David Vance resigns as president of MCN; MCN leaves Stonybrook

- **1986:** MCN becomes an individual membership organization; total membership stands at 112

- **1987:** MCN adopts current mission statement and five-year plan; Conservation Information Network goes on-line

- **1988:** MCN hires full-time executive director, moves to Syracuse University, receives NEH and NYSCA grants

- **1989:** National Museum of American History data model accepted by CIDOC

- **1989:** MCN launches Computer Interchange of Museum Information (CIMI) Initiative, receives PEW grant

THE 1990S

Nicholas Negroponte, the director of the Media Lab at the Massachusetts Institute of Technology, recently wrote a book entitled *Being Digital*. In it, he gives an overview of pioneering efforts and current trends in digital technologies. He notes:

> There is a polarity (however artificial) between technology and the humanities, between science and art, between right brain and left. The burgeoning field of multimedia is likely to be one of those disciplines, like architecture, that bridges the gap.[2]

If we take a look at the trends of the last three decades, we see that in each case, there were important initiatives or changes in the field of museum automation that continued into or came of age in the following decade. As we move into the final years of the 20th century,

there are important initiatives to recognize and follow. Using multimedia and networking technologies, these projects will be the bridges for the museum world.

In 1992, the MCN initiative known then as the Computer Interchange of Museum Information (CIMI) completed its first phase of work. A report, written by David Bearman and John Perkins, provided an overview of standards for the electronic interchange of museum information, as well as suggesting standard protocols that would be appropriate for museums. In 1992 and 1993, CIMI began its evolution into the Consortium for the Computer Interchange of Museum Information. CIMI is now a "not-for-profit initiative to develop community standards that support the preservation of museum information in digital form and enhance the potential for information exchange."[3] CIMI membership includes museum and industry partners such as the Getty Information Institute (http://www.gii.getty.edu), the Research Libraries Group, the Canadian Heritage Information Network (http://www.chin.gc.ca/), the Eastman Kodak Company, Corbis Media (formerly Continuum Productions), the Museum Informatics Project at UC–Berkeley, the University of California Office of the President–Division of Library Automation, the Smithsonian Institution–National Museum of American Art, the National Gallery of Art, Washington, D.C., the UK Museum Documentation Association, the RAMA (Remote Access Museum Archives) consortium, the Victoria and Albert Museum, the Coalition for Networked Information, the Canadian Museum of Civilization, and the Museum Computer Network (http://world.std. com/mcn/).

CIMI recently received funding from TIIAP (Telecommunications and Information Infrastructure Assistance Program, a U.S. government program) and from NEH for

Project CHIO, Cultural Heritage Information On-line. This CIMI project demonstrates the use of two international standards—SGML and Z39.50—as enabling technologies to build integrated, multiple media, cultural heritage information resources and to make those resources available for search and retrieval over digital networks.[4] Early results of this demonstration project were first presented at the joint conference of the Museum Computer Network and the Third International Conference on Hypermedia and Interactivity in Museums held in San Diego in 1995.

Other important initiatives to recognize and keep track of are those of the Getty Information Institute (formerly the Getty Art History Information Program). These include the Networked Access Initiative, the Imaging Initiative, the Initiative for International Documentation Standards for the Protection of Cultural Objects, and the Intellectual Integration Initiative. Also important is the work done by the Art Information Task Force, which was a joint effort of Getty AHIP and the College Art Association. The task force was funded by the Getty Trust and the National Endowment for the Humanities. The result of this task force is a publication on structured categories of information used to describe works of art. A similar working group met as part of the initial work on CIMI to develop data models for cultural history collections. Data models for collections (in several disciplines including anthropology and archaeology) have also been developed by members of CIDOC, the documentation committee of the ICOM.

The Museum Informatics Project at UC–Berkeley is another project looking at data models and methods of automation for collections of all types. Its objective is to provide on-line access to information on all non-book collections at the university. The SMASCH Project (Spec-

imen Management System for California Herbaria), also
at UC–Berkeley, has developed a data model for botan-
ical collections.

The Canadian Heritage Information Network
(http://www.chin.gc.ca/) has been the main force
in museum computing in Canada for more than 20 years.
The changes in the Canadian National Museum Policy
have been reflected in the directions that CHIN has tak-
en over the last decade. According to Gail Eagen,

> In 1994-5, CHIN's mandate again changed. CHIN
> is continuing to host the National inventories, ref-
> erence database services. In its technology assess-
> ment role, CHIN is carrying out the collections man-
> agement software review. After March 31, 1998,
> CHIN will no longer be providing its collections
> management service to museums. The services it is
> now offering include the Guide to Canadian Muse-
> ums and Galleries, the Heritage Forum, Internet
> accounts and training, advice on standards among
> others. CHIN is also working towards improved
> access to heritage information through better search
> and discovery tools and documentation and tech-
> nology standards, working for example on projects
> such as CIMI. (personal communication, 1/19/97)

Many of the trends that we see in the museum com-
munity's rush to embrace new technologies have result-
ed from changes in the computer and telecommunications
industries:

> Computing is no longer the exclusive realm of mil-
> itary, government, and big business. It is being chan-
> neled directly into the hands of very creative indi-
> viduals at all levels of society, becoming the means
> for creative expression in both its use and develop-
> ment. The means and messages of multimedia will

become a blend of technical and artistic achievement. Consumer products will be the driving force.[5]

As we all know well, museums do not exist in a vacuum. We are affected by changes in the political landscape, as well as trends in the computer industry. There are a number of general political and telecommunications industry issues that we must pay attention to as we move into the next century. A primary issue that affects those of us in the United States is the shift in funding for the Internet from the National Science Foundation to the private sector. In the past two years we have seen corporate mergers and attempted mergers as private corporations scramble for a bigger share of the telecommunications pie. (Note the actions of Microsoft, Netscape, AT&T, and others in this area.)

According to Nicholas Negroponte, "When bits are bits, we have a whole new suite of questions, not just the old ones, like piracy. The medium is no longer the message."[6] Some of the issues, topics, and trends to watch in the next few years are:

Politics and Telecommunications
Information Infrastructure
- interoperability
- platform independence

Digital vs. Analog Technology
- digital imaging
- the effect on intellectual property rights
- CD-ROMs and other electronic publishing

Networks in General
- the global community
- the Internet and Intranets
- the World Wide Web
- search engines
- the use and potential of networks in distance learning

TIMELINE 1990-1995

- **1990:** MCN moves to Pittsburgh, receives NEH CIMI grant

- **1990:** Electronic Frontier Foundation founded

- **1990:** Museum Informatics Project, UC–Berkeley

- **1991:** First International Conference on Hypermedia and Inter-activity in Museums (ICHIM '91)

- **1991-94:** Art Information Task Force (AHIP, CAA with Getty Trust and NEH funding) reaches agreement on structured categories of information used to describe works of art

- **1992:** MCN Board holds planning retreat; restructures organization; develops short-term and long-term goals

- **1992:** CIMI Committee completes work; task groups begin planning for data interchange

- **1992:** Getty AHIP Networked Access initiative launched

- **1993:** MCN moves to MIT Museum; board develops five-year plan

- **1993:** Anonymous ftp site established for MCN information by David Bridge of the Smithsonian

- **1993:** Second International Conference on Hypermedia and Interactivitiy in Museums (ICHIM '93) held jointly with the Museum Documentation Association conference

- **1993:** National Information Infrastructure Agenda announced by Clinton administration

- **1993:** Getty Initiative for International Documentation standards for the Protection of Cultural Objects

- **1993:** Paleontology Museum at Berkeley publishes home page

- **1993:** Dallas Museum of Art gopher site launched with 25 images from collection (public access database with 2,000 images)

- **1994:** MCN gopher site established by MCN Program Office

- **1994:** MCN holds meeting with CIDOC

- **1994:** Getty AHIP Imaging Initiative launched

- **1994:** Harvard Peabody Museum establishes a presence for Harvard Museums on the Harvard VINE (Veritas Information Network)

- **1994:** NINCH–National Initiative for a Networked Cultural Heritage announced

- **1995:** CIMI Project CHIO announced

- **1995:** MCN home page created at the American Association of Museums annual meeting in Minneapolis-St. Paul

- **1995:** MCN registers Internet domain name (mcn.edu)

- **1995:** Dallas Museum of Art Web page launched and linked to the gopher images

- **1995:** Internet flooded with WWW pages; museum Web pages published at an astounding rate

- **1995:** Harvard Peabody Museum publishes home page, develops home page linking all Harvard museums

- **1995:** MCN establishes a discussion list for members (mcn-l), announced at 1995 annual meeting

Developments in technology change the way we work and the way we think about, retrieve, and present information on the objects in our museums and on the museums themselves. We may choose to commit our institutions to this path of emerging technology, but in doing so, we must develop new models to protect our content, fund our projects, and create information infrastructures to support technology projects.

In thinking about new information infrastructures within our organizations, it is useful to take a concrete example such as collections management systems as a case in point.

Databases are a "natural" match for the requirements of museums, which typically maintain details about thousands of items in their care. Despite the long history of collections databases, the application of information technology at museums has not paralleled the explosive acceptance by commercial organizations and consumers. One reason for this is apparent. Text databases improved the techniques for tracking items and accessing information, but they offer little more—in some regards less—than paper records in describing objects. Paper allows for the

accumulation over time of annotations, drawings, inscription notations, etc., in addition to building a patina of information.

Collections databases have long awaited practical, high-quality, digital imaging to facilitate the next generation of collections infobases. Recently both computing technology and digital imaging have reached a level that offers museums the potential to overcome many of the limitations of current collections databases. Many museums have begun to use these new technologies while taking a cautious approach to imaging. The reasons for this are most apparent to computing specialists within the museum community and recognized by museum professionals, but seldom appreciated by corporate executives and technologists outside the museum.

Museums are guardians of original artifacts. Reproductions of these artifacts have always posed a dilemma, and high-quality digital imagery represents a new security risk. Museum administrators are justifiably concerned that digital images of artifacts will be misused or reproduced without authorization, just as consumer computing has introduced its own forms of plagiarism and theft, such as software piracy. Imaging safeguards such as encryption and digital watermarking must be more widely understood and used by museums.

Now that digital technology is becoming more mainstream and available to all of us—more affordable systems, better compression, better scanners, and digital conversion—there are still a number of factors that limit the success of museum projects using the technology, such as:

■ Lack of technical expertise in the area of imaging and multimedia

■ Failure to appreciate the potential of imaging and mul-

timedia technologies and lack of understanding of the implications of using these technologies

■ Emphasis on short-term planning and no long-term investment in an information infrastructure

GENERAL LACK OF TECHNICAL EXPERTISE IN THE AREA OF IMAGING AND MULTIMEDIA

Often museum projects using digital technology are limited in scope to one portion of the collection (see timelines for the past 30 years). It is easier to obtain funding for these projects, either from internal or external sources, and they do not require the museum to commit a large number of staff members, as would be the case with a more comprehensive project. These are often considered prototypes for a more extensive project down the line.

The personnel assigned to such projects may include only one or two full-time museum staff members, consultants who are experienced with the technology and, perhaps, temporary employees. The number of people who learn about the technology from such projects is limited. Pockets of professionals including curators, registrars, and the occasional museum director learn new skills and develop an understanding of the technology of the project. After the project is completed, the curator returns to curating instead of continuing to manage the new system that resulted from the project. The consultants, of course, generally go on to other projects, as do the temporary employees.

There is an obvious advantage to having the curator or registrar get direct experience with the technology. However, the downside is that the project itself may never reach full potential because there is no dedicated support or follow-through. The curators not using comput-

er technology might feel isolated from colleagues who are doing so, and consequently may be reluctant to support further development of the project.

Knowledge of the technology is shared at a more general level with colleagues. However, beyond the occasional demonstration of the system, few people end up with hands-on experience. In cases where digital technology is employed in a gallery setting, there may be many system users but few staff to support and maintain the system.

This has been true at a number of institutions that entered the computing arena in the early days. One case in point is the Peabody Museum of Archaeology and Ethnology at Harvard University. As noted above, the Peabody Museum began automated collections management in the late 1970s. Automation of collections information has progressed over a 14-year period from a time-sharing system to an in-house mini-computer system and now a client server, networked environment. Previous systems were developed in-house, and access to the system was provided by the system managers.

In recent years, collections management systems written for museum applications have evolved to include user-friendly, graphical user interfaces that allow easy access to the information. These systems and several newer products have image management capability included in the basic package. For museums, where part of the appreciation of the object is visual, imaging is an essential component for collections management (object identification) and public access to the information (from research to general audience queries).

The Peabody administrators decided that making information available on its collections would be a priority

over the next three to five years. We felt that it would be desirable to find a collections management system with a public access component. We chose a system called EmbARK from Digital Art and Science Corporation, Inc., of Alameda, Calif. EmbARK was developed with museum partners including the Fogg Art Museum, Harvard University and the San Francisco Museum of Modern Art. Its data structure and management model reflect the way museums manage their collections. In addition, EmbARK has an easy-to-learn user interface. Image management is a primary component of the system, as is the public interface. EmbARK may be viewed in different ways by the public and the museum staff. The system has security restrictions based on users and groups; thus, limited access to information categories is provided for the public. Public access to the information is through touch-screen kiosks in the lobby or exhibit halls.

We also plan to make collections information available to a more global audience using the Internet and the World Wide Web (WWW). The Peabody Museum first published its WWW home page in May of 1995. Since then we have created and published home pages for all of the Harvard museums. The home page content and images for the Harvard museums were taken from a publication entitled *Treasures of Art and Science at Harvard University* and provide an initial Internet presence for other Harvard museums. Each of these museums may link other information to the page to provide a richer electronic document.

A later phase of the Peabody database project will include working with Digital Art and Science Corporation, Inc., to develop access to the EmbARK database through the World Wide Web. Once this is accomplished we will have interactive global access to information on our collections.

FAILURE TO APPRECIATE THE POTENTIAL OF IMAGING AND MULTIMEDIA TECHNOLOGIES AND LACK OF UNDERSTANDING OF THE IMPLICATIONS OF THE USE OF THESE TECHNOLOGIES

Several prototype projects have provided "proof of concept" for the use of these technologies in museums. However, we still do not see a widespread move toward integrating them into daily operations or taking the prototype further. If these projects were important to develop, why isn't there a broader understanding at the executive or senior-staff levels of the technology and the support needed for them? Often the director or curator has a better understanding of computer systems that are running at home than those in the museum.

There are at least four areas of museum operations where the use of digital technology has the greatest potential: curatorial applications,[7] conservation, education and public outreach, and the museum gift shop or other commercial venture. Prototypes have been done in each of these areas with good results. However, because the return on the investment is more readily apparent in areas with direct public interaction, such as education/public outreach and gift shops, these are the areas that receive the most support from museum administrators.

An understanding of the benefits of the technology for curatorial applications and conservation is perceived less often. Debate about the benefits of using digital technology for these two areas continues. However, the benefits are many and include increased access to and use of collections information by multiple audiences, expansion of research tools, reduction of object handling when an image is easily accessible, and improved interpretative ability.

For years museums have been concerned about securi-

ty for their collections, the relevant copyrights, and licenses controlling the reproduction of images of their objects. The advent of digital technology puts a new light on each of these areas. Museums are developing new strategies to deal with intellectual property in digital form. Professional organizations such as MCN, AAM, ARLIS (ARt LIbrary Society), American Law Institute/American Bar Association, and others include educational sessions focused on these issues in the programs of their annual conferences. The Getty Information Institute's Museum Education Site Licensing project is exploring the issues of copyright and fair use of images in academic communities. We all need more education in this area.

Sending information into the digital world of cyberspace is a scary concept for museums. As we begin our journeys over the data superhighway, we need a better understanding of digital imaging and multimedia, as well as networks and network security.

In the broadest perspective, museums have the primary responsibility for the cultural heritage of the world. For years they have protected this material and the information about it. Museums continue to take this responsibility seriously and have been hesitant to share even textual information about collections over electronic networks.

Each time a story of someone breaking into a computer system reaches the news, museums worry about what might happen to their information if it were "out there." However, museums cannot sit back and wait for all of the encryption and security schemes to be explored. Audiences are demanding more from museums. This demand stems from several factors: the increase in the public's use of electronic systems for entertainment, the

changes in the cable and telecommunications industries over the last few years, and the speculation on where technology will go in the future. As the children of baby-boomers grow up, these expectations will continue. Negro-ponte notes that "Disney's guaranteed audience is refu-eled at a rate that exceeds 12,500 births each hour." Museums will be pushed to incorporate educational and entertainment models from the commercial world.

It is time for the museum professionals who will have to meet these challenges—directors, curators, educators, exhibit designers, etc.—to learn more about digital tech-nology and the implications of its use. In addition, we need to hire specialists in the areas of multimedia and information management as full-time members of the museum staff.

EMPHASIS ON SHORT-TERM PLANNING AND THE LACK OF LONG-TERM INVESTMENT IN AN INFOR-MATION INFRASTRUCTURE

It is no secret that imaging and database projects require a lot of resources. If we were to look at the average costs for these projects, we would see that a relatively small portion of the budget is spent on equipment and soft-ware. A much larger percentage was allocated for imple-mentation. This includes resources that are often not counted as part of the overall cost unless the project was properly planned, e.g., the labor needed to move objects from storage to staging areas and back. We often put together budgets for granting agencies that specify these costs as an in-kind match. Planners may be totally aware of this during the writing of the grant but lose sight of it as the project gets underway.

Like Cinderella, personnel assigned to the project are temporarily transformed. As the project comes to an

end, we find only the glass slipper as evidence. Only with appropriate planning that takes into account the needs of the museum as a whole are we able to put all the pieces together and find the foot to fit the slipper.

Projects with an overview of information management needs must be developed into modular components and funded over time. Following this plan, the museum's needs would eventually be met. There would be flexibility to change priorities based on current need, and opportunities for funding would arise as the project progresses.

Without this overview, the costs of moving from prototype to museum-wide implementation are often anticipated on the basis of simple scaling. However, once the scope is expanded, the costs are often considerably more than expected, and the project is measured against the original expectation rather than viewed in relation to the benefits it would provide.

In most cases, museums have not followed the lead of businesses in setting up departments to manage their information resources. Management information systems (MIS) departments developed early in industry because corporate executives and managers could see an immediate benefit in cost savings. Immediate access to files and records was necessary for businesses, but museums could afford to take a little more time in answering a request. In addition, industry discovered that the improved service achieved through the use of computers was often greater than the value of cost savings alone.

Museums must begin to incorporate this type of information infrastructure into their operations, just as libraries have done. As private individuals and consumers, many of us have become impatient about delays when it comes

to our information needs in any area of our lives. Museums, in general, have not yet responded to this demand for information at the touch of a button. But the time is coming when this will be the expectation rather than the exception.

SOLUTIONS

Bridging the technology gap in museums will require more than just digital technology. It requires changes in the way we plan and prioritize projects. It also requires changes in the curriculum of museum studies programs so that we can raise the importance of information management in the museum to the same level of importance it holds for libraries. The solutions involve the development of true career-track positions in the management of museum automation systems.

This represents a bottom-up approach to solving the dilemma. Museums must also consider top-down solutions. Drawing from models outside the museum community, museums could benefit from in-service training on a number of topics relating to computer technology and imaging. In the health care field, for example, in-service training is generally required for hospital administrators as well as other hospital personnel at all levels. This allows an understanding of new developments, procedures, etc., to filter through all levels. In museums, in-service training would certainly provide a firmer foundation for the use and understanding of information technology.

Professional organizations such as the American Association of Museums and the Museum Computer Network offer workshops at annual meetings and at conferences and seminars throughout the year that address

these needs. For several years MCN has offered workshops on planning for museum automation, the Internet and digital imaging. Recently AAM has sponsored symposia entitled "Highways and Byteways" to provide both a forum for discussion of issues as well as answers to common questions.

SUMMARY AND CONCLUSIONS

The relatively long history of the use of technology in museums provides the museum community with a foundation for future endeavors. Along with the successes, we cannot lose sight of the failures, and we must learn from them. We see that there is a need to build more of an information infrastructure in our institutions. This infrastructure must include physical resources such as hardware and software, as well as human resources. To be effective in the pursuit of imaging and multimedia projects, staff must be knowledgeable and experienced in this area.

Administrators must begin to take a more comprehensive and long-term view toward the planning for museum-wide information infrastructures. This type of strategic technology planning will take place as more organizations representing upper-level management such as the Association of Art Museum Directors (AAMD) recognize the potential of these technologies. At the same time, we must use the educational resources of professional organizations to educate ourselves about these new technologies. In this way we will be prepared to meet the challenges that advances in imaging, multimedia, and telecommunications present to the museum profession.

ACKNOWLEDGMENTS

A large part of this chapter was included in the plenary talk given at the joint meeting of the Museum Computer Network and the Third International Conference on Hypermedia and Interactivity in Museums held in San Diego, Oct. 9-13, 1995, and published in the conference proceedings (Jones-Garmil, 1995). Other portions were originally written for the "Working Group for Digital Image in Curatorial Practice," a June 4, 1994, meeting organized by Roger Bruce at the George Eastman House, Rochester, N.Y., funded by the National Endowment for the Arts.

REFERENCES

1. These companies formed a short-lived subsidiary called DISCOVISION. DISCOVISION worked with the Museum of Fine Arts, Boston, to produce a videodisc of 2,000 images from the collection. The company went out of business shortly after. The resulting product was never distributed outside the MFA.

2. Nicholas Negroponte, *Being Digital* (New York: Alfred A. Knopf, Inc., 1995).

3. John Perkins, Consortium for the Computer Interchange of Museum Information (CIMI) home page (http://www.nstn.ca:80/cimi/), 1995.

4. Ibid.

5. Negroponte, p. 82.

6. Ibid., p. 61.

7. These applications may include collections management, archives, research, and catalog production.

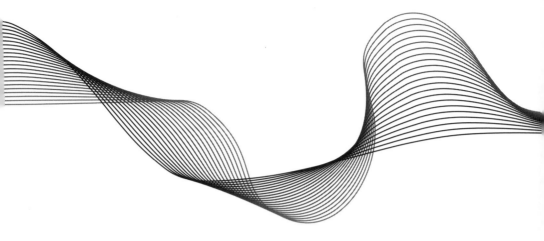

SHORTCUTS TO OZ: STRATEGIES AND TACTICS FOR GETTING MUSEUMS TO THE EMERALD CITY

GUY HERMANN

Director for Information Services
Mystic Seaport, Mystic, Conn.

Perhaps the most difficult part of working with new technology is how fast it changes. In 1964, Gordon Moore (later founder of Intel) proposed Moore's Law: that the power and the complexity of the silicon chip would double every year. His prediction has been remarkably prescient: 286s begat 386s begat 486s begat Pentiums, and all is cheaper and cheaper. After 30 years, there is no sign of this trend letting up.

How do we cope with this pace of change? How do we avoid getting caught up in a tornado of constant spending on the latest tools (or toys)? Or worse, getting left behind, flattened under the house with nothing but our ruby slippers sticking out? We want to get over the technology rainbow to all that the Emerald City promises, but how do we get there safely?

In this chapter, I will begin by looking at the changes happening in the wider world, apply these issues to areas we must address within the museum, and then recommend specific actions we can take as we make our individual attempts to become "wired museums."

I. EXTERNAL FACTORS

Unfortunately, museums cannot hope to shape technological change except in minor ways. We must adopt new technologies created for business and academic needs as they come along and then fit them to our needs. Much of what is coming to museums has already arrived in the wider world. The role of sage is vastly simplified when one need only look around in the present and not peer into the future.

But first, let's make it clear that computer technology is not going to go away. All the hype surrounding the Internet and related digital media is not necessarily evidence of its ephemeral nature. The technologies that have emerged in the last five years are going to transform the way we live and work as profoundly as other pivotal technologies, such as movable type and the telephone, changed their times. For the foreseeable future, everything digital will continue to get smaller, faster, more connected, and more affordable. Software will become correspondingly more functional, easier to use, and less obtrusive. Network access will increase dramatically both within the museum and in the outside world. And, perhaps the most difficult factor to deal with, users will be much more literate and their expectations will be vastly more sophisticated. All of these factors have been increasing exponentially for 10 years and there is no sign of that trend slowing down.

So what are the external factors important to museums? Looking at the technology landscape, the future will be: digital, connected, and information rich.

1. DIGITAL

There will be more and more digital media. The world is moving quickly from analog to digital media. Print,

film, and tape are all analog media. Perhaps the most defining characteristic of analog media in a digital age is its temporality. Analog media are linear: you read, examine, watch, or listen in one direction or in two dimensions. Analog media also degrade when they are transmitted. Digital media break down both temporal and spatial barriers. On a CD, for example, you can skip instantly from one track to another. In a 3-D display medium like VRML, you can move through (virtual) space at will. Digital media have the added virtue of maintaining their fidelity through limitless transmissions. Analog media lose fidelity every time they are reproduced. The best video tape copies maintain only 98 percent of the data copied. Over time, and with multiple copies, this information loss becomes significant.

Digital media also offers the ability to join together different media types as multimedia (a term that is quickly losing its usefulness, as we come to expect all our media to be multi). Multimedia let you study, listen, read, or watch from one display. One can have a similar experience by watching TV while reading the newspaper and listening to the radio (coffee completes the picture and the sensory loading). But coordinating those information sources is all but impossible. Digital media make it possible for all three sources to appear on one screen with a simple set of controls.

Traditional media will not go away. The book has a healthy life ahead with those of us who don't fancy curling up with a computer every night. But because of the flexibility, fidelity, and longevity (not to mention the rapidly declining cost) of digital media, it is not stretching it to predict that by the beginning of the next millennium, the delivery, storage, and transmission medium for virtually all information will be digital, and our display and playback devices will all have some kind of cen-

tral processing unit at their heart. What we now know as a Windows or Macintosh PC will gradually merge with the cable TV set-top controller and the latest Nintendo games.[1]

2. CONNECTED

More and more computers will be connected to each other and to the world. In computing circles (even more than in the wider world), "the Web" is the rage. Two years ago it was "the Internet." Before that it was "client server," and before that we went through several years of "Year of the Network." Connectivity is the common theme, but the possibility of connectivity on the scale of the Internet has forced the discussion of connectivity out of the computer room and into everyone's life. Local networks enable limited communication. Global networks like the Internet enable almost unlimited communication.

The Web is exciting because it enables global communication. To museums it is even more compelling because in using its standards, information delivery can take on much richer forms. We are not limited to ASCII text as we were with earlier Internet manifestations. The potential of the Web goes well beyond "a picture is worth a thousand words" because it allows for integrated design. Text, images, and other media combined in an easy-to-use form by an experienced designer can compress a tremendous amount of information into a compact space, much like having a newspaper with a third dimension. On the Web, this third dimension is the depth of material that is available, rather like the Sunday *Times* linked to the National Archives, the Louvre, and your local town hall. The array of information available from multiple sources, its clear presentation in multimedia formats, and the relatively low cost of access make the Web compelling in

ways no other technology has been since the telephone.

3. INFORMATION RICH

The amount of information readily available will increase dramatically. As our system capabilities develop, we will begin to use them for more than simple "data process-ing." The backbone of the work computers do is still data processing: the managing of transactions and lists, structured, logical information like catalog cards where the relationships are clearly defined and the end prod-uct—monthly reports, mailing labels—is predictable. But as systems become more capable, we are beginning to see applications where the end product is unpredictable, where we use computers not simply to quantify but to provide us with real food for thought, with information and, potentially, knowledge.

How is information different from data? Where a data processing system provides facts, an information system answers questions. Information is contextual; it lets us see the broader picture. Where a catalog record in a data processing system might tell us the name of an object, its maker, and the time period, an information system will let us ask questions such as: "What can you tell me about where this comes from?" or "What else is impor-tant to know about this period, person, style, genre?" Information systems define relationships: "What others things are like this? Where are they? What attributes do they share?" These questions might be loosely defined as questions a curator could answer. A computer won't replace a curator's skill in organizing and presenting information, but good information systems can help the curator in her tasks and can help us begin to derive meaning on our own.

Understanding the nature of information is critical because information is a product museums can deliver

in the digital/connected world. While our collections are, of course, our primary asset, we cannot deliver them over the Web. But we can deliver information about those collections if it is in digital form. As such, the rich array of information we possess about our collections, and their relationship to our cultural heritage, is our primary asset in the wired world. In this new world, information becomes a strategic asset. Managing and exploiting that asset is a critically important task if museums are to retain a significant voice in our cultural discourse.

II. STRATEGIES FOR GETTING TO THE FUTURE

So what do we need to do to get to this digital, connected, information-rich new world? I see six strategies:

- Recognize that technology will change
- Pay close attention to standards
- Get connected
- Plan for interoperability
- Collect digital information
- Experiment!

RECOGNIZE THAT TECHNOLOGY WILL CHANGE

The pace of technological change continues to accelerate. The solution being pitched today by the latest hot software vendor demands new hardware with faster processors and more memory. That new hardware is obsolete before it is out of the box. Then the software needs to be upgraded before we've had a chance to learn all the features of the old version. This constant whirlwind of change is extremely disruptive. People want to get their jobs done, but end up spending time trying to separate the hype from the important changes.

How do we cope with this flux? First, we need to accept that the system we have today in all likelihood will not

be the system we have five years from now. The only parts
likely to be the same are the network connections (pos-
sibly) and the information itself (if we have paid atten-
tion to the next point).

By planning for the next generation of systems while
still implementing the current one, we can simplify the
transitions. To do this kind of planning, we need to pay
attention to standards.

PAY ATTENTION TO STANDARDS

Adhering to standards—the rules we use for organizing
and presenting information—is perhaps the most diffi-
cult part of implementing new technology.

Standards allow us to cooperate. They also require com-
promise. Museums, museum departments, and museum
professionals are notoriously individualistic. This char-
acteristic is a virtue in developing vital and exciting col-
lections and programs. But creating, implementing, adher-
ing to, or even advocating standards in this context can
be quite difficult because of the compromise frequently
required. The individual must see his or her needs as
less important than the museum's needs, or perhaps
even the museum community's needs. With so many
other demands on a museum staffer's time, building con-
sensus about the compromises inherent in standards can
be seen as one more impediment to getting the job done.

If standards are difficult, why do we need them? We
need them because standards enable cooperation, com-
munication, and information exchange. Perhaps most
important, they protect the long-term value of our infor-
mation. Jane Sledge formulates this case well in terms
of databases:

> Probably the most compelling reason for using stan-
> dards is protecting the long-term value of data. The

largest investment in building a database is not the cost of hardware and software, or the consultant, system analyst, or programmer; it is the cost of assembling the data and the time required to enter them into a system. All technology will change eventually, and sooner or later systems will need to be upgraded or the data moved to different hardware and software. Data standards not only ensure that a database is internally consistent so that it can be managed effectively, but also permit data to be formatted and stored so they are easier to "export" to other systems.[2]

Standards are important in storing our information. They are equally important for communicating. In a connected world, a non-standard information source will be an unconnected information source. A museum with a non-standard, or proprietary, system risks being an unconnected museum. The very real risk here is that of being bypassed by the railroad. The Internet will be able to "stop at" museums with standards-based systems. Those without them will likely be left to fade away in the middle of the prairie.

What kinds of standards are important? A few years ago, it was necessary to standardize hardware and software in order to work together, but the advent of clear data and communication standards has begun to relegate hardware and software to the status of simple display mechanisms. In this context, the choice of hardware is a short-term management decision and has little long-term strategic importance. As long as a system can connect to standardized information and communications sources, the hardware doesn't matter. Converting all of a museum's PCs to the latest iteration of Windows or the MacOS might provide an environment that is easier for the IS staff to manage, but it does not

provide any long-term value to the museum. Hardware and software standards are bound to change as the next generation of operating system or processor comes along ("Windows New Millennium"?). "Standardizing" hardware won't help manage your critically important information assets more effectively.

Information and communications standards, however, are critical to the success of an information system. These standards are likely to change much more slowly than hardware standards, primarily because the incremental cost of changing them is so high. We can easily replace a PC; we cannot so easily convert all of our data or replace all of our cable. Because of this high cost of conversion, making the right choice of data and communications standards can be profoundly important. By choosing to adopt non-standard (or proprietary) information formats, although these might better serve its immediate needs, a museum risks isolation from the wider community. It also faces high conversion costs down the road.

Which information and communications standards are important? There are several that bear discussion here. Other resources can give you detailed information about specific standards important to museums.[3] Of broadest applicability is the Computer Interchange of Museum Information (CIMI) project. CIMI has adapted international standards to create a set of protocols that museums can easily use to share information about their collections. CIMI holds promise because it allows museums flexibility for managing their information in individual ways while still providing a solid framework of internationally accepted standards. The Getty Information Institute has also been very active in creating and promoting standards for description and categorization. These include the *Art & Architecture Thesaurus, Union*

List of Artist's Names, and the *Thesaurus of Geographic Names.*

The library community has long been standardized. Several of their standards are applicable to museums. These include the MARC format for creating and exchanging catalog information and the Library of Congress (LC) subject headings. Also important are other data storage standards in use by businesses, like SQL (for databases) and SGML (Standard Generalized Mark-up Language, primarily for text documents and at the center of CIMI's efforts). Internet information standards are still evolving, but these promise to be important as well because of their wide adoption, especially the HTML (Hyper Text Markup Language) format for text documents and JPEG (named for its creators as the Joint Photographic Experts Group) as an image storage and compression format.

Unfortunately, there is still little widespread acceptance of these standards in the museum community. The acronyms seem even more cryptic because of their unfamiliarity.

What about communication standards? Fortunately, these are much clearer than information standards. Structured LAN (Local Area Network) cabling standards and Internet communication protocols are both widely accepted and can be easily adopted for museum use. More on these standards in the next section, "Getting Connected."

How does a typical museum stick with standards? Perhaps the simplest way is to insist that software vendors implement and adhere to them. It is tempting for vendors to ignore a standard because they can often deliver more features by doing so. But if the museum community as a whole lets software vendors know that standards are critical, they will listen, or lose customers.

Implementing standards is difficult, not least because they are complex. Perhaps there is a new role in museums for an "information manager" who is charged with caring for the museum's information. The information manager should know standards, understand how they can be implemented for each museum system, and, most important, advocate their use within the museum. Few, if any, museums have a staff position with this title now, but the function will become increasingly important as we integrate information systems into our daily work. Perhaps it will become another hat the curator wears. Even in smaller museums, the information manager function needs to be assigned to someone, perhaps a curator, perhaps an IS staffer, perhaps the director (and probably the person reading this book).

However the message gets across, understanding and implementing standards is perhaps the most critical part of becoming a wired museum.

GETTING CONNECTED

Establishing connections among computers is the third critical step. Networks are the plumbing of the wired museum. Networks provide the essential infrastructure for exchanging information. They are the common denominator on which all the other technology rests because they allow computers and computer users to communicate with each other. As such, they become the foundations for the future digital communities we are only beginning to understand.

A network connects computers together so they can share information and resources. With a network, users can access information stored on other computers, transfer information to other computer users, share printers and other peripherals, and take advantage of connections to more powerful computers for sophisticated pro-

cessing. With a network connection, a user can begin to take part in the digital world.

Without networks, information cannot flow from one computer to another. A computer user is still productive, but she is isolated and unable to communicate. The registrar might have a file on his computer listing the objects in a collection an exhibit designer needs. Without a network, he might print that file out and mail it to the designer. With a network, he could still mail the file, but he could also e-mail it, allow the designer to access it directly on the registrar's system, or place it on a third system to which both have access. Any of these approaches is quicker and less resource-intensive (recycling digital bits, not paper) than printing and mailing the file. As digital communications become more prevalent, a computer without a network connection will seem like an office without a phone and fax machine—comfortable, but relatively useless.

We need to get connected both internally and externally. The technologies are still different for each. Internal connections on Local Area Networks (or LANs) will collect and deliver information to and from desktops and patron workstations. External connections on Wide Area Networks (or WANs) will tie our desktops and patrons to the wider world of the Internet and its successors. A LAN connects computers at one site with one kind of cabling and one network protocol. A WAN connects LANs together across greater distances. The Internet is one big WAN. A private WAN may be necessary when a museum has multiple locations. While LANs are relatively simple, WANs can become quite complex, depending on the systems that need to be connected and their distance apart.

Fortunately, the standards for networks have become quite clear in the past few years. As you might guess,

adhering to network standards has all of the same virtues of adhering to other standards. The most important network standard for internal connections is an approach to wiring called "structured cabling." Structured cabling is a standardized way of installing cabling in buildings that allows multiple network topologies (i.e., Ethernet, Token Ring) to run on the same kind of cable and connectors. With a structured cabling approach, every part of the cabling system is standardized so that the devices that attach to the cabling (i.e., hubs and computer interface cards) can also be standardized. Structured wiring is relatively inexpensive to install and easy to troubleshoot and maintain. With the cost of cabling for a network ranging from $100 to $300 per workstation, this flexibility is important. For more details on structured wiring, contact any of the major cabling vendors for free educational materials.

While cabling is a critical first step in building a network, the other pieces are equally important, but grow more from the decisions made about implementing particular applications. A good network consultant can help ensure that everything works together and provides a working base for the future.

While a discussion of the technologies available for making external connections is too complex a subject to cover in detail here, it is clear that the Internet and its successors will be key technologies. In the meantime, getting connected to the wider world via a commercial service (America Online, *et al.*) or other method[4] is critical to begin to understand, and thus make educated decisions concerning the Internet's role in your museum. Ideally, you should connect the museum's network to the Internet so that every user can have equal access and thus participate fully in discussions and decisions about the museum's digital direction.

The capabilities that network connections give us continue to evolve. One of the most interesting new ideas is the notion of an *Intranet*—the use of Internet technology to facilitate sharing information *within* an institution. The exciting part of Intranets is that they hold the promise of allowing one-stop access to *all* of a museum's networked information.

A simple Intranet consists of a World Wide Web server for use within the museum. It can be used to share commonly needed and frequently updated documents such as phone books, policy manuals, training schedules, daily weather reports, meeting minutes, and events schedules. Staff members get to the documents using the Internet browser tool (e.g., Netscape) they already use to surf the Net. This approach allows the sharing of formatted documents among many different kinds of computers without translating into different formats or converting to text. Documents can be centralized for easy management and are easily updated. With information thus centralized but still managed by its owners, time and printing cost savings can be substantial.

But sharing electronic documents is only the beginning of an Intranet's potential. Relatively simple software tools are available that allow developers to provide Web interfaces to databases, text and image archives, and any other information that can be stored in digital format. While these Intranet tools will not take the place of the dedicated software tools a curator might use to access a research database, they will vastly simplify and standardize the presentation of much museum information.

Perhaps the most intriguing aspect of Intranets is that they mirror the functionality of the larger Internet. When a museum is ready to share information with the outside world, a flip of a software switch will let the Internet

community access museum information as easily as museum staffers do. In this way, the investment in Intranet technology packs a double whammy: it facilitates information sharing within the museum, and it develops the skills and technology to deliver effectively the information to the rest of the world.

Of course, the magic of the Internet works because *standards* make it work. The Internet is built on international cooperation and standards development initiatives. An Intranet simply leverages the power of that cooperation.

While digital connections are crucial, getting connected to *people* is equally important. Contact with other museum professionals who are discussing information and technology issues is essential in order to make the best use of the physical infrastructure we are building. While AAM is working to provide more information, the Museum Computer Network, an organization of museum information professionals, is an even better forum for discussing and understanding the full range of issues coming down the pike.[5]

PLAN FOR INTEROPERABILITY

In earlier generations of computing, the way to leverage a museum's investment in technology was to centralize applications on one minicomputer or mainframe. As PCs have proliferated on every desktop, however, a new paradigm of distributed applications has emerged. While it might be ideal for everyone to use the same kind of computer with the same programs, users have become increasingly independent and expect to have substantial control over their own applications. This is perhaps especially true in a museum where expertise is distributed throughout a diverse staff. Curators expect to have control over their own information. Similarly, operations personnel

expect to have access to their information in ways they find useful and effective.

It would be wonderful to find one simple "magic bullet" software system that would give users the needed control and access to information while letting information technology staff standardize the programs everyone uses. Unfortunately, it seems that either we have strict standards or we have happy users, not both, a conundrum that exists in every complex organization. The problem becomes even more complex when we spread it across institutions: "My museum would like to exchange information with your museum, but we use different systems, so. . . ."

The solution is to look for several discrete systems that satisfy the needs of individual end users and that can use standards to interoperate on some level. The result might be several different software systems: one for the library, one for collections, and another for finance. If the systems can exchange data on a standards-based network, some of the efficiency and utility of a centralized system can be achieved while still giving users the flexibility they need.

Distributed systems on this model can be easier and cheaper to implement because they affect fewer people. They also help hedge your bets in technology. If one software package proves to be a dog, you don't have to replace the system for the entire institution. Distributed systems can also be more difficult to manage, but that is balanced by the benefits of adhering to information and communication standards that can help ease both the management headaches and the inevitable migration to new systems.

In this distributed but interoperable scenario, *standards*

are the magic bullet. They will allow us to have our cake and to eat it too.

How might this work in a real museum? While having separate library and collections systems is a simple example, interoperability can also play out in more complex and interesting ways.

Say you have a collection with three different types of objects: paintings, reference books, and archaeological fragments. From a management perspective, you need to know what you have, where it is located, and where it came from, among other things. A researcher might want to know the history and the context of the objects and the subject of the books. A visitor might just want to see paintings. One approach is to buy one program that promises to serve all three users (the magic bullet approach). Since the most critical need is to manage the collection, typically, the collection managers will choose the software. It will likely serve their management needs very well. But forcing that system to meet the needs of the researcher and the end user might compromise its utility to the collection managers.

Instead, the museum could link the collections management system to a database providing contextual information, a second database with detailed information about the books, and to a Web site with images of the paintings. By standardizing the numbering and field definitions and the storage conventions across these three sources, linking the information among them is relatively easy. If the information exists on a standard network, or shares a common database, integration is even easier. A visitor interface could also be added with a painting browser linked through the Internet, again using standard naming and storage systems.

Here, the use of standards is the glue that binds our sys-

tems and our information together. As interoperability becomes a routine consideration in software selection, it will become easier to build organizational systems that truly work together, satisfying individual needs for flexible information management and wider needs for information access.

COLLECT DIGITAL INFORMATION

Information is critical to museums. After objects, it is our most important asset. Using digital media to manage that information asset will provide substantial benefits.

While the phrase "digital media" perhaps sounds esoteric, in fact we create digital information constantly— we just haven't learned to value its digital form. Any information that can be saved to a computer hard disk is digital information. Our databases and financial systems are, of course, digital. But so are word processing documents, spreadsheets, Web images, and e-mail messages. We need to understand the value this form of information has, and actively *collect* and *manage* digital media just as we collect and manage our paper and other media in files, archives, and iron mountains.

Paper and microfilm are still the archival media of choice. But digital media reproduce with no loss of quality, offer faster and more flexible access, are more versatile, more compact, more transportable, and may prove, in time, to be more durable. They deserve the same consideration and respect we give to our other files.

The databases we all have been creating in various forms for the past 10 years are, of course, a fundamental resource. They provide us with the core information we need about our collections, our members, our finances. But we already have much more digital media than our databases. And we will have even more in the

future. The drawers and drawers of files we have in the registrar's office with information about our objects offer researchers a rich resource and provide a link to other resources. While digitizing all of this information would be a Herculean task, simply creating a directory or folder to store the word-processed letters created by museum staff members in the acquisition process will begin to create a digital archive with half of the story. A researcher could make a fast search of this file using a text search engine and find information that would have required hours of thumbing manually through file drawers. Similarly, a searchable digital archive of word-processed responses to visitor research queries would allow curators answering future queries to search for ways others have answered these questions in the past. Following these suggestions could increase efficiency, but only if we have thought ahead to collect and manage the information in its digital form. By recognizing that we have already created substantial bodies of digital information, we can begin to exploit that information.

Such simple text archives should be the beginning of a broader strategy to archive all the digital information the museum creates: important e-mail messages, grant proposals, budget spreadsheets, research reports, exhibit plans, educational materials, departmental databases, the text of books and catalogs, etc. As we begin to edit photographs, film, and audio digitally, these too become potential subjects for our digital archives. All of these can provide rich sources of information to future researchers and digital publishers.

In order for such archives to be truly useful there are crucial issues to be worked out concerning security, access, storage media, data format, and migration. But these will be worked out in time. If we begin building dig-

ital archives now, when we work out the other issues, we will have a rich basis of information to which we can apply our solutions.

The bottom line here is that we can usefully archive virtually *any* digital information. The cost of storage media is so low as to be only a minor consideration. Even a box of carefully labeled floppy disks can be a useful, if not perfect, digital archive. The digital archivists of the future will be able to make the hard decisions about what is kept and how it is organized. For us, the job is simply to recognize the value to the future of what seems ephemeral today.

EXPERIMENT!

All of the technology we are working with is still in the broadest sense experimental. Change is the operative term, and only the lucky (not even the wise) will choose the "right" technology today to ensure them a worry-free digital future. In this sense, everything we are doing now is an experiment. We can leaven our experiments with liberal doses of standards to hedge our bets (and mix our metaphors), but even with this check, it is likely that what we do today will not be exactly what we want tomorrow. The cautious approach would be to wait until everything settles out and we can "do it right" the first time. But the opportunity we have now (and perhaps the responsibility) is to learn from the mistakes experiments inevitably spawn and to use those lessons to move forward.

Experiments do not need to be big and expensive—and neither do the mistakes. In fact, experiments are best kept small. The huge museum-wide networking project might indeed be a good investment, but we will learn more from networking a department. The comprehensive collections database may provide invaluable infor-

mation across collections, but several small databases may teach you more about the ways individual collections can most usefully manage their information. Big projects get the headlines (and often the funding), but small projects pave the way to understanding how technology works and how it can be most useful to the individual museum.

It is a cliché to say that when experimenting, we need to be prepared to try and to fail. Failure, however, has an ugly taste to it. Perhaps we should recast this chestnut and say: When working with technology, we need to be prepared to try and to learn.

III. PRACTICAL STEPS FOR MOVING AHEAD

Managing the changes wrought by technology is at best like herding cats. At one point you might get all the cats into one room, but you are unlikely ever to get them to march in a row. One of them is bound to escape and, at the worst moment, several will decide to have kittens. Where traditional project planning stresses managing every detail and anticipating every contingency, a plan to herd cats must be short on specifics. Similarly, technology solutions and user needs are both likely to change directions before even the shortest-term plan is fully implemented. Given a technological future of constant change, random pitfalls (and pratfalls), and general uncertainty about next year's technology, how do we still manage to make new technology an integral part of what we do?

The key is to look at how technology can help the museum at its most fundamental level—how it is tied to the museum's mission. At Mystic Seaport Museum, we have focused on adapting Internet technologies because we think that technology will help us reach a broader

audience in new ways. This decision has helped us focus our decisions about what hardware, software, and networking systems we will use, and has allowed us to gradually develop new systems based on developing Internet standards. Other museums will have other goals perhaps linked to different parts of their mission.

In addition to a broad mission-derived focus, we need also to look closely at the areas where technology can help *people* do their jobs better, more easily, and faster. The question we need to continually ask is: How can we best use these new tools to help our staff do their jobs?

We can help people do their jobs by establishing standards that will allow systems to work together, and then giving users as much latitude as possible. In order to find a tool useful, everyone must learn to use it in his own way. If we try to impose solutions on people, they will adapt. If we let people choose their own solutions (within a standard framework), they will flourish, invent, and adapt the tools to their own needs. It is these same digitally enabled users who can best make the decisions about how technology can empower a museum and help it achieve its mission.

If we put the users first, the big bang approach is to be avoided at all costs. New technology is not a capital project like a new building, where you invest once and rebuild in 20 to 40 years. New technology is new tools. As such, the investment is really an operational cost that needs to be selected, installed, updated, managed, reconsidered, replaced, and paid for on an ongoing basis.

How do we get the tools in front of people so they can learn from them and use them effectively? We need to do four things:

- Provide equipment to staff
- Link that equipment together
- Make sure it works
- Train, train, train

PROVIDE EQUIPMENT TO STAFF

First, we need to get computers in front of staff members. Every person who has a desk needs to have a functioning, useful, not-too-out-of-date computer on that desk, preferably with active network and Internet connections. As the museum becomes more reliant on technology, particularly with networks, providing "access" to a computer in another room, or on another desk, does not allow the staff member to integrate computer use into her ordinary routine. Access to a computer is a good place to start, but the goal should be a computer on every desk and easy access to computers for those without desks.

LINK THAT EQUIPMENT TOGETHER

Second, we need to connect the computers together and then connect them to the outside world. Bob Metcalf, the inventor of Ethernet, proposed Metcalf's Law: "A network becomes more valuable as it reaches more users." A museum network will be most useful if it connects *everyone*. A small network is useful for sharing printers and files, but it becomes more valuable as it reaches into more parts of the museum and enables cross-departmental e-mail and similar services. The network becomes critical as it connects people to the world.

Again, the big bang approach is not necessary with networking. Simple, slow-speed networks using old wiring will give much the same raw functionality (at a small cost in speed and reliability) as sophisticated, high-tech systems that cost far more.

Managing an older network can be difficult, however, and the big bang approach to networking—cabling the whole museum in one fell swoop—does have its virtues if you can raise the cash. The complexity of networks has decreased radically in the last few years as the standards have become well established. This is the one area in the museum where, I believe, a big capital investment can pay off in functionality, ease of use, and long-term utility.

MAKE SURE IT WORKS

Making sure a system works is perhaps the most misunderstood part of implementing new technology. This is because we define "working" for a computer like we define "working" for a TV set. Does it turn on? Is the picture crisp? Can you change channels? Well, then it works! Unfortunately, there is often nothing on. Similarly, a computer can function without actually allowing its user to do any real work. Simply turning on is critical, but if there is nothing to "watch"—no way the computer actually helps a person do her job—it will be an awkward, ugly paperweight.

How do we make computers work? By emphasizing utility ahead of technology. Too many computer software decisions are made by technology people. To a technology person, "good software" is defined as that which has the most features—the most "power." Features are useful to "power users," but most "real" people are more concerned with simple usability than with counting buttons on floating palettes.

I have seen any number of museum and other business databases created by end users. The *useful* databases have virtually all been built by staff members with easy-to-learn database programs like Q&A or FileMaker. Professionals pooh-pooh such programs as "lacking the pow-

er" of more sophisticated databases like dBase or the latest SQL variant. But these simple databases solved problems, were easy to learn and use, and didn't require the intervention of a technology expert to get useful work done.

In contrast, databases built using powerful programs like dBase, often put together by volunteers, interns, or departed staff, are uniformly condemned by the staff members still struggling to use them as difficult to understand and in need of replacement.

The distinction here might best be characterized by what we "could" do versus what we "can" do. Fancier tools give you more possibilities (and certainly do have their uses in the right hands), but simpler tools let you get a lot of functionality quickly and easily.

With simpler tools you have not risked much and can always upgrade to something more sophisticated later (especially if you have remembered to standardize the data!). The mistake too often made here is again focusing on the technology instead of the museum's and the user's needs. Users can make good decisions about the tools they use, but they need to have had the tools in front of them first and to understand that the KISS ("Keep It Simple, Stupid!") principle is especially important when making technology choices.

TRAIN! TRAIN! TRAIN!

The last critical ingredient is training. Computers are not yet appliances. While we may be able to count on most new staff members having acquired word processing skills somewhere, most other computer skills are not widely distributed. If we want to make the tools as useful as possible and if we want to make sure people understand the tools and the ways they can apply them to

their jobs, we must commit to continual training. Users need to be taught about new technologies gradually, continually, and persistently.

IV. CONCLUSION

Given all the complexity and challenge presented by new technology, the key to moving ahead is to avoid looking for the one big-bang solution. Rather, we must think in terms of lots of little bangs—incremental steps that help build a useful understanding of the coming wired world. We need to understand the long-term strategic value of technology and information. We have to implement standards-based systems, install more computers, upgrade connections, and collect more digital information. Perhaps most important, we can't count on the man behind the curtain to come up with a solution for us. Rather, we have to let our staff (curators, exhibit designers, clerks, and directors) use the technology, let them learn its virtues and pitfalls, and then let them participate fully in decisions about how it can best be used in the museum.

Only if we open our hearts to embrace the new digital landscape, have the courage to let our systems evolve organically, and exercise the brains of all our staff, will we avoid the poppy fields, steal the witch's broom, and make real the shimmering promise of the Emerald City.

REFERENCES

1. Nicholas Negroponte's book, *Being Digital* (New York: Alfred A. Knopf, Inc., 1995), is perhaps the most compelling exposition of the transition from "atoms to bits."

2. Jane Sledge, revised/dernière mise à jour: 29 July 1996, ed. Jim Bower and Andrew Roberts. Available at:
`http://www.cidoc.icom.org/stand1.htm.`
Original brochure © 1995 The J. Paul Getty Trust. All rights reserved.

3. The "Standards for Museum & Cultural Heritage Information" page is a great starting point.
`http://www.uampfa.berkeley.edu/onlineres`
`/standards.html`
The Berkeley Museum Informatics Project Standards page has well-organized resources.
`http://www.mip.berkeley.edu/mip/`
`standard.html`
The CIDOC pages also have a great deal of useful information.
`http://www.cidoc.icom.org/`

4. See Diane Zorich, "Getting Hooked," *Museum News*, January/February 1996, pp. 56-57.

5. MCN's Web address is
`http://world.std.com/~mcn/`

IMAGING IN MUSEUMS: ISSUES IN RESOURCE DEVELOPMENT

LESLIE JOHNSTON
Information Resource Specialist for Art
Stanford University Museum of Art, Stanford, Calif.

Imaging enhances analysis by providing a tool for the visualization of information. The future of research and scholarship depends upon networked access to materials in digitized format, and museums feel increasing pressure to make their resources available on-line. Dial-up document and image resources have long been the cultural heritage community's dream—which may become a reality for many institutions, thanks to advancements in scanning, storage, and intelligent search and retrieval. Ten years ago museums considered the scanning of images from their collections to be their final goal. Now they're aiming for cooperative interconnectivity, allowing access to and the interchange of information and images. Imaging applications allow users to alter an image to prove a hypothesis and bring together physically disparate pieces for comparisons that otherwise would not be feasible.

Museums have jumped on the multimedia bandwagon with enthusiasm and, in most cases, without regret, and are now using imaging technologies in many areas: collections management and preservation, education, public access, and extended access via the Internet. This

chapter will present a basic introduction to the technical aspects of digital imaging, as well as provide some thoughts on the present and future applications of images in the museum community.

GENERAL CONCEPTS IN DIGITAL IMAGING

A digital image is composed of pixels (short for picture elements), similar to dots or grains in a halftone or photographic print, arranged in columns and rows. Each pixel represents a portion of the image in a single color or shade of gray. The number of pixels in both height and width defines the resolution, or clarity, of a digital image. The display resolution is expressed as a ratio of pixels, such as 750x600, and is combined with a measurement of print resolution to determine the clarity and detail of an image. The number of possible colors or shades of gray that each pixel can represent is determined by the image's dynamic range. This dynamic range (also referred to as bit-depth) is taken from a pre-set palette of colors (the two most commonly used are the 8-bit and the 24-bit palettes). The specific colors in a palette are predetermined by the system displaying the image, and the same 256 colors (the System Palette) are used for all images.

An image may be viewed on a monitor or printed on a sheet of paper. A monitor, like a television, displays images as a combination of three colors—red, green, and blue—referred to as an RGB display. The color of a pixel in an image displayed on the monitor is determined by the relative values of red, green, and blue, as well as the level of intensity, from white (red, green, and blue combined) to a fully saturated color. Monitors vary and are capable of displaying anywhere from 256 to more than 16 million colors. The resolution that a monitor can display also may vary. If a monitor is set for a low-

er resolution than an image, some of the detail will be re-interpreted. These variations on a viewer's monitor can change the apparent quality of the image.

An image is acquired through either a scanner, a direct digital camera, or a video digitizer. With a scanner the image is read (scanned) in a process, similar to photo-copying, in which light reflects off or through the image onto light-sensitive diodes. Each diode reads the level of light it is exposed to and converts the reading into a digital value, which it then transfers to digital storage. With a digital camera, an item is placed on a stand and the camera is adjusted to fit the material within its field of view. This allows the direct scanning of originals in different sizes and formats rather than the scanning of a surrogate image such as a slide or a transparency. A video digitizer (or frame-grabber) is a circuit board placed inside a computer that allows the attachment of the computer to a standard video camera. Anything that can be filmed with a video camera can be directly digitized to a hard drive or other storage device hooked up to the same system. The use of the direct digital camera or video digitizer may allow direct capture of an object, but requires handling a possibly fragile item and exposing it to strong light.

Once the image is acquired, it is formatted for storage. Image files include not just the image data but descriptive technical information related to the image—its format, color palette, and compression, for example—which is stored in the file's header. There are many standards for image storage, including TIFF, GIF, PICT, and PhotoCD. Because not all image formats can be interpreted by all viewers, images must be stored and distributed in a single format, which makes administration easier, or in multiple formats, which support broader access through multiple viewing applications.

A full-color, full-screen image can take anywhere from five to 70 MB to store. Even with the drop in costs of storage media, it would be quite expensive to store 250,000 20-MB images, not to mention the difficulty in delivering and retrieving such large files over a network or the Internet. This is where compression comes in. Methods include the abbreviation of information that is repeated in the image data, or the permanent removal of detail. When "lossless" compression is used, the image is restored to its original condition upon decompression. When "lossy" compression is used, the image permanently loses some of its original data upon decompression, although it may be too fine for the eye to discern. The two most commonly used forms of compression are JPEG (lossy) and LZW (lossless). Compression can not only cause a loss of image data but can inadvertently create image "artifacts"—unexpected additions to the image such as shadows or lines. Compression should only be employed when it is certain that the user will be able to retrieve the compressed image without incident.

Because image files are so large, the construction of a networked imagebase will significantly affect system resources. Trade-offs between storage cost and capacity and access speed must be carefully examined. Options include magnetic tape, writable CD-ROM in a jukebox, very large magnetic hard disks, or Redundant Arrays of Inexpensive/Independent Disks (RAID).

Delivering images to a user from a central server raises issues regarding compression and transmission. If it is necessary to compress images for storage, they must be decompressed at the user's end. Plans must support decompression software at every user's workstation. In order to avoid transmission bottlenecks, one could consider multiple networked image-servers or redundant copies of the database stored in multiple networked sites,

so that an access request goes to the least busy server. Neither is an optimal solution, as splitting the database onto multiple machines will require complex routing of queries; multiple copies of the database will complicate the process of managing system and data updates.

The very broad issue of standards is of the utmost importance for access in the museum community. This encompasses two broad topics: technical standards (capture technology, data storage, and transmission) and descriptive standards (cataloging item content and image "surrogates" of original items). There are many proven standards for capture, storage, and transmission, but the community has not reached a consensus on which to use. Data and images that do not reflect the consistent use of technical and procedural standards are not easily shared.

There is a real need for the implementation of documentation standards. Data structure standards include the *Categories for the Description of Works of Art* developed by the Art Information Task Force, or the *Common Agenda* project led by the American Association for State and Local History. There are vocabulary standards such as the *Art & Architecture Thesaurus*, Chenhall's *Nomenclature*, *ICONCLASS*, or the *Library of Congress Subject Headings*. Data sharing and access standards include those under development by the Consortium for the Interchange of Museum Information (CIMI).[1]

Documentation is not limited to text. Of increasing concern is documentation of the process used to create digital images. As procedures and equipment vary over time, future usability will require records of the hardware, software, calibration systems, file formats, and compression methods used to create and manipulate a digital image. File-format standards need to be expanded to include technical data. A consensus is needed on the data ele-

ments that constitute a minimal image description, similar to the process that is currently underway with international discussions on a series of elements known as the "Dublin Core," tentatively to be applied to Internet resources using a syntax and guidelines known as the "Warwick Framework."[2] Such a description should be bound to image files in their headers to ensure that the files can be accurately identified, in the same way that descriptive information will be tagged into Web resources. Keeping records of this information during the creation of digital image files will assure both that users at other institutions will be able to use images when they are shared, and that future users at the developer institution can continue to take advantage of the imagebase that it so painstakingly created.

The process of imaging should never be driven by one specific application or usage, as the requirements for an image in one program will rarely be the same for another program. You will lose time and money if you have to scan in another version of an image for another use at a later time. Instead, always create an application-independent archival image that can be copied and adapted for multiple uses.

ACCESS ISSUES

Developments in software for navigating the Internet and the World Wide Web have made it possible to offer wide access to an imagebase. Providing access using these tools requires that the image file formats (such as GIF and TIFF) match the capability of the browsers, and that the accompanying data be available in Hypertext Markup Language (HTML) or Standardized General Markup Language (SGML). International public access to images and data requires very careful tracking of the associated intellectual property rights.

It is certain that Internet access will eventually merge with the local imagebase and text database. Current World Wide Web browsing tools have limited query capabilities and lack most of the functional capabilities of local databases, but new generations of these tools are appearing every four to six months.

Browsing through a large number of images is impractical. Text must be associated with the image files to provide access points to the images, ranging from basic descriptive information (maker, title, date) to metadata (information that describes the data that has been recorded about a physical item), involving anything from an object or structure to information about the visual content of the image. Different users will use different criteria to retrieve images, so a needs analysis must be undertaken before creating any textual database with which the images will be associated. The accessible fields may be pre-determined by a software package, so the needs analysis is necessary before reviewing any database or imagebase system to see if it conforms to your users' needs.

Systems are currently in development that provide access points based upon visual content, such as IBM's Query by Image Content (QBIC) system,[3] the Art Image Browser developed at the School of Information and Library Studies at the University of Michigan, or the Picture Indexing and Retrieval System (PIRS) developed at the Wharton School of Business.[4] These current systems are unwieldy, requiring that descriptors be manually entered into fields or extracted from pre-existing textual description. Research into pattern recognition may provide a more efficient methodology for the creation of records that will allow the retrieval of images by colors, shapes, or other elements within an image.

There are also many legal issues associated with the use

of images. Intellectual property rights are very complex; before access to an image database is allowed, many questions must be answered relating to the rights to reproduce or to broadcast an image, as well as a user's rights to download or print an image. This also affects the creation of the image for the application, as it may require either the embedding of a digital watermark or a textual copyright notice into the image file. When an image is converted to digital form and becomes accessible, the right to reproduce it electronically must be verified or acquired, or the public domain status of the work must be verified. The conditions under which users may print or download each image must be determined, and the rules must be policed and enforced. Restrictions on use should be prominently displayed so that no user can claim ignorance of the law.

There are no simple technological means of protecting widely accessible images and the integrity of data. Some users may be limited to viewing only certain images. For instance, students might only have access to images for a class they are taking; others may be bound by license agreements to use images only for certain purposes or for a set period of time. One particular project testing solutions to these problems is the Museum Education Site Licensing project, currently underway at seven museums and seven universities.[5] Software can be used to restrict access to authorized users and limit the ability to alter or delete data. These issues are not unique to image management—they are concerns that the greater information management community has been facing in the networked environment for decades.

APPLICATIONS AND RESEARCH AGENDAS

Numerous institutions have had automated collections management systems in place for well over a decade, but

these systems manage only information about items in a collection: their provenance, cataloging descriptions, physical locations within the museum, and their state of preservation. Many museums are now scanning surrogate images and linking them to their data records to improve both internal tracking and researcher access. If surrogate images are available as a part of the record query, users can view these images in place of handling the original objects. Only after viewing a selection of surrogates might a researcher need to see an original item, reducing the wear and tear of moving items in and out of storage. Many institutions have found that such imaging projects have allowed them to discover connections among diverse portions of their collection as they scan in images and review their curatorial information.

Once images have been captured for archival or collections management use, they can be adapted for any form of multimedia application. Museums are creating multimedia presentations on temporary exhibitions both for use in the gallery and for sale to the visitor; CD-ROMs on certain aspects of a collection or a topic that reaches across multiple institutions' collections; and interactive guides to a museum and all its collections. They are also providing public accessibility to images, including the ability to obtain digital copies. A multimedia system can guide the visitor through topics with text and images that, due to limitations of space, are not included in an exhibition. The visitor gains a broader awareness of the subject matter than can be gleaned from the exhibition alone. An imagebase can bridge the gaps among collections management, exhibitions, and education.

Museums are frequently employing imaging in the public access arena. Many institutions have set up kiosks with multimedia systems that provide information ranging from hours of operation to membership opportuni-

ties to information on collections. Some museums have implemented the use of a "virtual museum" kiosk with information on hours of operation, staff, the architecture of the building, floor maps, and collections. With multimedia kiosk applications it is possible to greatly expand the quantity and range of information that is potentially available to the visitor. A vast array of information is available through a variety of interactive modes matched to various levels of need within the audience.

The concept of public access has been expanded beyond the physical visit with the placement of museum resources on the Internet. Many museums have a site on the World Wide Web that provides information on operations and collections, and includes virtual exhibitions. Some sites include topical pages that not only present materials from the institution's collections, but include research information such as bibliographies and links to other museums and on-line resources. Other museums maintain gopher and Web sites from which educational applications may be downloaded. It is becoming just as important to make information available electronically as it is to keep a museum physically open to the public or to make its collections available to the scholarly community. It is hoped that this foray into the electronic world will raise public awareness of the importance of museum resources. The goal is simplified access to images and text together, for improved information access and increased interactivity.

The development of these resources requires a new understanding of a museum's visitors and scholarly users. Understanding the user requires an understanding of the subject area and function of the use, from a specific academic discipline to museum collections management to student research needs. Specific uses are associated with specific requirements, such as image quality, search

capabilities, and access points, or a required hardware or software environment. Images can be used and re-used for any and all of the following: CD-ROM publications, print publications, Web sites, collections management databases, or public access systems.

The intended use of an image will determine its required resolution and dynamic range. A conservator needs a far more detailed image than an image meant for a Web site, and an image for a print publication must be of much higher quality than one for a CD-ROM. The needs of each potential user must also be examined. Will a registrar, collections manager, or conservator need to display images in conjunction with records from a collections management system or an on-line reference database? Will they require browseable images or full-screen images? Will they need to annotate the records associated with the image? Will a user need an image that can be incorporated into a desktop publication or a word processing document? Will she need to manipulate that image? Will images be accessible over the Internet or through other networked applications that require security measures? We need to provide the level of information required by all of our audiences.

The academic audience has already been the focus of studies on the research requirements for images.[6] Such studies are quantitative, identifying the needs of the art historian, how those needs relate to what can be supplied digitally, and what quality of image would support those same needs. As well, the conservator's needs have been the subject of experiments, from international digital "videoconferencing" to the use of digital retouching of images to preview the results of a procedure.[7]

Imagebases must be integrated with an institution-wide automation plan that takes into consideration project

priorities, hardware, software, and networking. The number of users (including room for future growth) and the location of those users (in one or many structures, as well as those off site or connected via the Internet) also must be taken into account. Methods of distribution must be considered, from client/server applications to CD-ROM distribution to Web-based delivery. Most museums want to integrate their images with an existing or planned collections management system, electronic publications, or multimedia systems. Methods for sharing images among such diverse applications must be carefully examined. Each institution needs to determine the quality of images that is acceptable for its users and measure it against the cost of acquiring, storing, and delivering those images. Such decisions will likely require the creation and storage of multiple images with varying resolutions and dynamic quality for constituents' different needs.

Museums developed in-house management systems long before they considered public access. These systems in some cases evolved into OPACs (on-line public access systems), providing both a direct access resource and the content for CD-ROMs, multimedia applications, and Internet resources. Internet resources have in many instances replaced the more static CD-ROM and multimedia kiosk for broad outreach. Web sites can be more current and extensible, and information standards such as HTML and SQL-based relational databases promise better flexibility and longevity. This does not mean that CD-ROMs or kiosks are unimportant. The CD-ROM, in particular, is an engaging, tangible, educational, and discrete object that the museum viewer can take away, and kiosks are an excellent method for disseminating information about the museum.

In 1993 there were a few hundred Web sites around the world covering all topics. In 1996, there are 3 million,

including thousands of museums. Why? Because the Web is one of the most effective information dissemination and retrieval systems ever developed. For the museum, the Web can combine research with outreach, and is the nearly complete solution for information distribution.

Locating image resources within a networked environment remains a critical problem. How does a user find an image that may exist anywhere on a world-wide network? It is necessary to develop new locator tools and a union catalog of images and collections. Access to these resources and development of new tools requires the development of standards for referring to a file's location on a network. Perhaps it will be the emerging Universal Resource Names/Numbers (URNs), which refer to a file owner's name or number rather than to the address of a file on a server. The cultural heritage community must recognize that standards developed in the mainstream information management and computing world are relevant for their applications. Museums should adopt these standards as they become well established. Organizations such as the Getty Information Institute are developing a research agenda of the questions raised by the conversion of cultural heritage information to digital form and its transmission in a networked environment.[8] Museums should include more substantive content in Web sites because increasingly sophisticated search capabilities make it easier for the user to identify his needs and browse the museum's intellectual capital resources. These new access tools will permit museums to include deeper knowledge infrastructures on their sites.

The Web can become an invaluable outreach resource for a museum, not only for general public information, but as a virtual library on the collections for scholars. While

most institutions currently have only a handful of images available, others have thousands. Even more exciting for the scholar is the burgeoning number of "virtual museums" whose on-line collections represent the holdings of many institutions. More often than not, they operate outside the purview of copyright and without the holding institutions' blessings, but the clamor for that form of access to images and information keeps them alive nonetheless. The success of these virtual collections, even though their creators have no formal credentials, has established a standard that valid institutions should set out to equal and surpass. Given the economics of publishing, on-line distribution is fast becoming the only affordable method of providing access to a broad range of materials.

Scholars and students alike are currently looking to the Web for access to textual and visual information. Some universities are now promoting the creation of multimedia papers, theses, and dissertations that include not only digital images but direct links to on-line resources. Scholars are now publishing their research as a part of on-line periodicals and Web sites, presenting their work as a changeable, multimedia creation in the place of a static paper publication. The Web by its very nature promotes collaboration and interactivity in the scholarly works created with on-line resources.

The implication of this trend in on-line research and publishing is that the museum, as content provider, must now start looking towards providing information on their holdings. They must take the place of the sometimes un-scholarly virtual museum Web sites that provide unverified data. Museums have to plan for a visual component that is not just decorative but carries core information. There is a wealth of context associated with each image, and the museum needs to frame its Web-

published images with substantive text. Of course, while a few museums are exploring the use of audio and video, establishing text and image as complementary and equal elements in the Web infrastructure would be a major advancement. Many museums are beginning to exploit these opportunities; they deserve recognition as leading-edge practitioners of networked multimedia publishing. The techniques that museums are pioneering today will contribute to the best practices for on-line publishing in the future. The combination of high-quality images and substantive commentary on the works and their context are the key goals for the best museum Web information infrastructures.

Ultimately, we will see elaborate virtual exhibits become the norm. Some of these will accompany physical exhibitions, while others will be developed expressly for the Web, including references back to CD-ROM publications and museum in-house informational multimedia kiosks. A good deal of multimedia content, including video segments, may already exist at an institution and can be in part converted for on-line applications.

CONCLUSIONS

This need for speedy access to images and information isn't new—news agencies have been delivering wire photos via analog methods for decades with proprietary hardware and software. What is unprecedented is the profusion of sophisticated non-proprietary methods of access that have become available to the entire world. The goal might well be described as a diffusion so broad that a single image can simultaneously reach thousands of users who could capture it and its underlying descriptive text for a myriad of uses from class presentations to print publications.

It used to be that the answer to the question "Why digitize?" included references to deteriorating photographic collections, avoiding physically unwieldy and potentially harmful access to objects, and the potential integration of images with text databases. The more accurate answer now (which may change at any time) is that an image is truly multicultural and multilingual,[9] and with the advent of international access to networked cultural heritage resources, an image and its associated data and metadata have taken on the qualities of an almost living entity. The analogy of digitized images to a species within an ecosystem[10]—each with many possible significant relationships, some predictable and some not—is becoming increasingly apt.

The museum community is fully aware of how imaging can make collections accessible, and of how digitized material provides an immediate sense of the veracity of the textual description. Imaging has changed the way that objects are researched and exhibited and how information about them is conveyed. What is necessary is a mechanism for museums to make their digital information available to the educational and academic communities. The real value of these image resources is that they allow comparisons among seemingly interchangeable objects. The Web may provide that mechanism, providing a means to reach horizontal integration of resources from many geographically disparate and multi-platform institutions.

REFERENCES

1. John Perkins, "CIMI and CHIO: Cultural Heritage Information Online—The Short and the Long of It," *Spectra* 22, no. 3 (1994-95): 10-14.

2. Online Computer Library Center, The Dublin Core Metadata Element Set Home Page, 1997.
http://www.oclc.org:5046/research/
 dublin_core/

3. Bonnie Holt, "Query by Image Content: The QBIC Project's Application in the U.C. Davis Art and Art History Program." Presentation at the Visual Resources Conference, January 1995.

4. Charles Patch, "Tell Me a Story: A System for Thematically Querying a Multimedia Archive." *Spectra* 22, no. 2 (1995): 33-37.

5. Geoffrey Samuels, ed., *Sample CD-ROM Licensing Agreements for Museums* (Washington, D.C.: American Association of Museums/MUSE Educational Media, 1996). See also Jennifer Trant, "The Museum Educational Site Licensing Project (MESL): An Update," *Spectra* 23, no. 2 (1996): 32-34.

6. Michael Ester, "Image Quality and Viewer Perception," *Visual Resources* 7, 4 (1991): 327-352. See also Michael Ester, "Digital Images in the Context of Visual Collections and Scholarship," *Visual Resources* 10, 1 (1994): 11-24.

7. Donald Garfield, Susannah Cassedy, and Evan Roth, "The High Tech Museum," *Museum News*, July/August 1992, pp. 36-43, 74-75.

8. Getty Art History Information Program, *Research Agenda for Networked Cultural Heritage* (Santa Monica: Getty Art History Information Program, 1996).

9. Ester, "Digital Images."

10. Victoria Wyatt and Ged McLean, "Imaging Databases in Research and Teaching: Global Perspectives and New Research Technologies," *Visual Resources* 10, no. 1 (1994): 41-48.

OTHER RESOURCES

Bearman, David. "Museum Strategies for Success on the Internet." *Spectra* 22, no. 4 (1995): 18-24.

Bearman, David, and John Perkins. *Standards Framework for the Computer Interchange of Museum Information.* Silver Spring, Maryland: Museum Computer Network, 1993.

Besser, Howard. "User Interfaces for Museums." *Visual Resources* 7 (1991): 293-309.

Besser, Howard, and Jennifer Trant. *Introduction to Imaging: Issues in Constructing an Image Database.* Santa Monica: Getty Art History Information Program, 1995.

Donovan, Kevin. "Anatomy of an Imaging Project." *Spectra* 23, no. 2 (1995-96): 19-22.

Duffy, Robert. "Art Museums and High Culture on the World Wide Web." Strategic Communications White Paper, 1995. http://www.strcom.com/webzeumz/artmintr.htm

Economou, Maria. "ELISE: An Experiment for a Networked Electronic Image Bank." *Spectra* 22, no. 4 (1995): 3-5.

Franklin, Jonathan Adlai. "Image Control." *Museum News*, September/October 1993, pp. 36-39, 53-56.

Rinehart, Richard. "The Museum Information Access Continuum." *Spectra* 23, no. 1 (1995): 28-29.

Schmitt, Marilyn. "The Siren Song of Cybermedia." *Museum News*, July/August 1994, pp. 37-39.

Screven, C. G. "Computers in Exhibit Settings." *Spectra* 19, no. 1 (1992): 7-12.

Christine Steiner. "Controlling Your Images—The Museum and the Licensing of Imaging Products." *Museum News*, July/August 1992, pp. 62-64.

Wallace, Brian, and Katherine Jones-Garmil. "Museums and the Internet: A Guide for the Intrepid Traveler." *Museum News*, July/August 1994, pp. 32-36, 57-63.

Wallace, Jim. "Project Chapman: The Direct Delivery of Digital Smithsonian Photographic Images Via the Internet." *Visual Resources* 10, no. 1 (1994): 57-60.

Weinstein, William. "Designing an Image Database: A Holistic Approach." *Visual Resources* 10, no. 1 (1994), pp. 49-56.

ON-LINE RESOURCES

THE CONSORTIUM FOR THE INTERCHANGE OF MUSEUM INFORMATION

http://www.cimi.org/

A consortium of numerous international organizations working on the development of interchange standards and tools. Includes information on the CIMI Standards Framework and the Cultural Heritage Information Online (CHIO) Project.

GETTY INFORMATION INSTITUTE

http://www.gii.getty.edu/

The Getty Information Institute works to enrich the content of future computer networks by encouraging those concerned with preserving the cultural heritage to collaborate in building a cultural information infrastructure. Their site includes information on the Getty Imaging Initiative, the Museum Education Site Licensing Project (MESL), and the National Initiative for Networked Cultural Heritage (NINCH), the Categories for the Description of Works of Art, and controlled vocabulary resources such as the *Art & Architecture Thesaurus*, the *Union List of Artist Names*, and the *Thesaurus of Geographic Names*.

THE MUSEUM COMPUTER NETWORK

http://world.std.com/~mcn/

A professional association for individuals and institutions working with automation in museums. This site includes information on on-line resources of importance to museums as well as a directory of on-line museums.

THE RESEARCH LIBRARIES GROUP

`http://www.rlg.org/`

RLG is a not-for-profit membership corporation of institutions devoted to improving access to information that supports research and learning. The site includes information on the Task Force on Digital Archiving, which is addressing questions of long-term preservation of digital records.

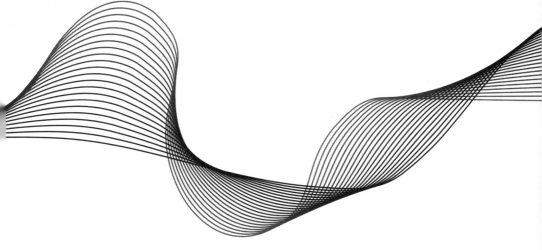

THE CHANGING ROLE OF PHOTOGRAPHIC COLLECTIONS WITH THE ADVENT OF DIGITIZATION

HOWARD BESSER

Visiting Associate Professor
School of Information Management & Systems,
University of California–Berkeley

Digital images are becoming more and more commonplace. Vendors offering "stock house" services have cleared the rights for hundreds of millions of digitized photographs, and more than a handful of these companies are currently delivering digital images to clients. Tens of thousands of World Wide Web sites regularly display digital images to the general public. Some of the most popular areas of services like America Online and CompuServe are collections of digital images from cultural repositories such as the Smithsonian.

The implementation of digital systems for viewing surrogates of photographic images housed in museums, archives, and libraries will have a significant effect on those collections and their use. How this is likely to help preserve delicate collections and increase public access has been explained elsewhere,[1] as has the likely effect on various museum departments.[2] Major issues surrounding increased access and its effect on scholars, the public, and the museum and its staff are outlined below.

This chapter hypothesizes about potential effects of widespread photographic digitization on the museum, on scholarly research, and on the general public. It explores areas like the possible erosion of authority of the museum and its curators as more and more people access representations of museum objects without physically entering the museum itself. It identifies critical issues that will emerge concerning authorship and authenticity, and also begins to examine issues related to the commodification of images.

A WORLD OF NETWORKED DIGITAL INFORMATION

Our world is rapidly being transformed by the proliferation of information resources available through new distribution channels. Just as the dissemination of videotaped films drastically altered the way people consume one form of culture (leading individuals to new habits of viewing in private spaces and at times of their own choosing, closing movie theaters, and significantly altering the economics of the entertainment industry), the dissemination of networked digital information is likely to promote revolutionary changes in both institutions and in personal habits relating to other forms of culture and scholarship.

As digital representations of photographic images proliferate, we can expect to see sweeping changes in public response to photographic images, in the institutions that house them, and in the role of their caretakers and interpreters.

DIGITAL PHOTOGRAPHS ARE PECULIAR ITEMS

Traditionally photographs have been tangible items. They have a physical dimension, and we can assert owner-

ship by means of possession. We can hold them in our hands and look at them without any external aids other than ordinary light. In contrast, digital photographs have no physical aspect to them other than megabytes. We cannot look at them without the aid of relatively complex external viewers.

Photography has always seemed different from most previous art forms because multiple prints may be made from a single negative, giving many people the impression that these prints are identical to one another. Yet there is an artistry involved in creating photographic prints from negatives, and those involved with art photography recognize that two photographic prints from the same negative are seldom identical. But digital photographs can be quickly and easily copied, and each copy can be absolutely identical to all the others. In fact, reproduction of digital photography produces far more consistent copies than the manufacturing of dolls, cars, or other types of commodities. Due to the ease of mass production, the concept of physical ownership of a digital photograph becomes subordinate to that of ownership of the intellectual property rights to duplicate the image.

How does this intangibility affect how people relate to digital photographs? In the near future we will see a substitute physicality, as individuals will be able to hold up a CD-ROM and claim that they actually possess images it contains (even if they can't see the images without a viewing machine). But as we move more towards networked access to images, even this substitute physicality may disappear.

Will the ease of reproducibility make collectors of digital photographs reluctant to let others view their photographs? As Walter Benjamin has pointed out,[3] original artifacts actually grow in value because they are the

only original of which numerous copies exist. But with digital photography, originals are indistinguishable from copies. So collectors of originals who let others view (and possibly copy) them run the risk of possessing what amounts to "just one more copy."

EFFECTS OF INCREASED ACCESS

An inevitable result of widespread digitization will be increased access as more and more people are able to view surrogate images. While many institutions with photographic collections currently don't provide public access to works not currently on exhibition (and only allow a limited group of scholars to view the originals), most will choose to provide viewing access of electronic surrogates to anyone who enters their doors. Many of these institutions will decide to make at least some electronic surrogates available to an even wider public through the Internet or on CD-ROMs. Paradoxically, increased access to surrogates may lead museums to further restrict access to originals, allowing only the most advanced scholars to view them.

Increased access (at least to surrogates) is likely to have a significant democratizing effect, particularly if/when the institutions allow access to these from outside their walls (via networks or CDs). Current constraints (limited hours, admission fees, and the display of only a limited number of works) that limit access to images will disappear. The new ability to view surrogate museum images on nights and weekends offers an experience not unlike the instant gratification characterizing more entertainment-oriented art forms such as videotaped films. This easy path to satiation can further distance one from what Benjamin[4] calls the "aura" or specialness of the object, and lead the viewer to treat it like just another commodity.

Benjamin also pointed out[5] that providing opportunities for viewing art in a setting other than a museum helps open up art to the masses. Of course, living near the end of the 20th century, we are already used to determining the setting for our own appreciation of culture. We don't have to go to a concert hall to listen to music; we can listen in the comfort of our homes, or even while jogging.

But one level of democratization that Benjamin did not anticipate is the ability to interact with the artwork (or rather its image) through computers. Interactivity offers many different opportunities for participation. With the ability to zoom in and zoom out and to compare close-ups, spectators can begin to make their own juxtapositions at various levels. This includes placing close-ups side-by-side, as well as juxtaposing whole objects and discovering new relationships among them. By creating these new comparisons, the spectator is able to participate in activities that previously were almost exclusively within the domain of curators and other professionals. These interactive processes engage viewers and encourage them to function more like participants than spectators. Additional processes such as image processing techniques (which allow the viewer to alter and combine images) offer even further engagement and raise critical issues of authorship of the altered image (explained below).

SCHOLARLY RESEARCH

With the advent of computers and networks, some of the scholarly research of images that (because of cost or functional difficulty) has had to take place within repositories may soon be done remotely. Repositories will help to construct scholar's workstations, incorporating tools that allow the user to analyze digital images, combine

them in different ways, create new juxtapositions, and explore scholarly text-based information about individual photographs, photographers, their subjects, etc.[6] When the scholar's workstation is combined with databanks of digital photographic images, researchers will have powerful tools.

But much work remains in identifying and developing tools to aid the photographic researcher. For example, there has been only one significant set of studies to date of image quality needs of scholarly researchers.[7]

GENERAL PUBLIC'S CONFUSION OF SURROGATE IMAGE AND ORIGINAL

Increased access to images may lead the general public to confuse the on-screen image with the photograph that it represents. Eventually, the image may not be regarded as merely a temporary substitute for the original but as a permanent replacement. In this day and age, when time appears so scarce, people are less likely to make a special trip to a museum to see an original object if they can see a quite reasonable facsimile at their home workstation—especially if they can "play" with it. Over time, people increasingly may forego the experience of looking at actual art pieces because it's so much easier to view images on a screen. What they will miss is part of what Benjamin called the "aura"— the viewing of a unique object within the same context and setting as everyone else. Those viewing the image only on-screen will be missing a presence that cannot be reproduced or adequately expressed in words. It is the same kind of unquantifiable experience that is rapidly disappearing from so many facets of modern life (like the feel of being completely alone in the wilderness, or of watching a truly wild animal glimpse her first human being).

As a result, caretakers of a collection may decide to provide coarser surrogate images (i.e., lower resolution, fewer colors). In a sense, a poor surrogate image of an object could be considered preferable to a good one because it calls attention to the fact that it is a representation of the original. A better representation, on the other hand, tends to mask the fact that it is merely a reproduction, and for many people it will be seen as a one-for-one substitute for the original. Yet, once the general public becomes used to the quality of images that will be delivered to their home via high-definition television (HDTV), will they be willing to look at coarse images?

CHANGING ROLES OF MUSEUMS AND CURATORS

By offering access to surrogate images of most of its materials (instead of simply those on exhibition), the museum becomes less like a traditional archive and more like a library. Museums are likely to act less like repositories that offer visitors a passive experience primarily through exhibitions and publications, and more like institutions that encourage visitors to take an interactive role. The general public may view culture less as something to consume and more as something to interact with.

When the patron no longer has to visit the gallery or museum in order to see a particular image, the authority of the institution will likely begin to erode. And when members or the general public have (from their own home) access to a wealth of digitized images and scholarly information, many will begin to make their own links and juxtapositions among these images. This may further erode the authority of the curator as the leading figure who places images within a context. A possible result may be an erosion of high culture in general, with the curator's role becoming somewhat akin to that of a film critic.

PROLIFERATION OF IMAGES, PAYING FOR ACCESS

Activities underway at companies like Bill Gates's Corbis Corporation and the telecommunications corporations planning to construct the information superhighway will lead to the widespread dissemination of images in digital form. These will be easy to copy and will lead to a proliferation of images throughout our daily lives. When technology makes it quick and easy to make copies, people often do so indiscriminately. We have seen this with word processing (which promised to use less paper but actually created more), photocopy machines (which created an atmosphere where people don't hesitate to copy documents they are only slightly interested in), and computer disk files (where people keep endless copies of many drafts of old documents that they will never look at). How will this tendency affect curators? Will they collect more digital photographs (or more versions of the same photographs) just because it is easy and they have the space to do so? How will this affect museum patrons or the general public? Will they indiscriminately collect images like some people collect pennies?

The proliferation of images (as we are beginning to see on CompuServe, America Online, and the Internet) may have a profound effect on the "specialness" of any image. If we are constantly bombarded with images and can see any image we want instantaneously, the distinction could blur between "good" (artistic) images and "bad" ones. Or, the increased exposure could help the general public develop a more cultivated eye and lead to increased connoisseurship. Benjamin points out[8] that increased access to identical reproductions of originals increases our "sense of the universal equality of things." Similar to an effect that Duchamp's ReadyMades had on popular perception of art, people may begin to blur the distinction between art and everyday things.

We are seeing the creation of huge image data banks oriented toward uses such as advertising. From the comfort of their offices, publicity departments will soon be able to scan through thousands of photographs of butterflies, birds, trees, etc., and incorporate them in advertisements. This is likely to mark the end of commercial photography as we know it today.

The development of "for fee" data banks of images has interesting implications. Companies licensing digital reproduction rights from photographic repositories are likely to contract for the institution's entire holdings. With market forces driving such efforts, these companies are likely to "cherry pick" (or "skim") the collections, and make only the most lucrative images available in digital form. More esoteric works (or those with a smaller audience) will either not be publicly available, or will be very costly to obtain in digital format. This is similar to the current inaccessibility of videotapes of independent, documentary, and "art" films.

Furthermore, in a market-based economy, if images that have been "improved" will sell well, aren't they likely to become widely available like colorized films? Instead of encouraging individuals to alter pieces of work in their own creative ways, we may end up with a few people who have the power to control alterations in ways governed solely by what can be marketed to the public. While Frank Capra was aghast that his film, *It's a Wonderful Life*, was colorized, Ted Turner claimed, "I own the films I can do whatever I want with them. . . . Besides, I like things in color. We see in color. Why didn't they make *The Sting* in B & W if they're so concerned about historical authenticity? I don't see their point."[9] Is the likely result that art will become just another commodity like shaving cream, baseball cards, or pantyhose? Will art be reduced to its lowest common denominator, like music in elevators?

Another important impact of "for fee" image banks is how they will affect user access habits. "No fee" arrangements (as we saw in the early years of the Internet) encourage exploration. Users will look at things "because they are there" and will tend to make serendipitous discoveries. "For fee" arrangements give people the incentive to focus their attention on what they already know they want, or to look for well-known items previously recommended by others. In "for fee" environments, researchers tend to follow more traditional paths of discovery and seldom explore totally unexpected avenues. Yet, throughout history, many of the most interesting discoveries have evolved from following unconventional routes. (Indeed, Thomas Kuhn makes the claim that, even in the hard sciences, real breakthroughs only come from following unconventional routes.)[10]

QUESTIONS OF AUTHORSHIP, COMMODIFICATION

The ability to change a photographic image on-screen can diminish the authority of the original artist, essentially forming a new creation out of a synthesis between the artist's work as originally conceived and the user's changes. In the spirit of post-modernism, every photographic image becomes a potential ingredient in a new piece of art.

But in an era of widespread access to existing images, the general public may make small changes to downloaded digital photographs and incorporate them into new pieces that they will call art. This is similar to what we have seen with clip art. Rather than creating something from a concept, one could say, the individual would merely react to a previously packaged piece, almost like filling in the colors in a coloring book. In the future, the general public may refer to this as "creativity" in the same

way that heating a pre-packaged meal in a microwave oven is called "cooking."

Altered images raise interesting curatorial questions, some of which affect most post-modern art. Primary among these are authorship and authenticity. Who is the author/creator—the original photographer or the person who digitally altered the photograph? When we retrieve photographs from digital image banks, how do we know that the images haven't been altered (or haven't been altered beyond the particular altered version we were seeking)?

With the authority of the artist and the sacredness of the original removed, does art then become even more a victim of the marketplace? In this age of commodification, art might become even more of a consumer product.[11] How will the general populace relate to photographic images sold alongside other commodities on the information superhighway?

ACKNOWLEDGMENTS

Discussions with Lester Weiss of the UC–Berkeley University Art Museum and Rena Diamond contributed significantly to the refinement of the ideas presented in this chapter. Maria Bonn assisted in editing. This chapter was originally written for the "Working Group for Digital Image in Curatorial Practice," a June 4, 1994, meeting organized by Roger Bruce at the George Eastman House and funded by the National Endowment for the Arts. Slight additions and updates were made in late 1995. Many of the ideas were excerpted from "The Changing Museum," a paper the author wrote for the 1987 *Proceedings of the American Society for Information Science*.[12]

REFERENCES

1. Howard Besser, "User Interfaces for Museums," *Visual Resources* 7 (1991): 293-309. See also Besser, "Visual Access to Visual Images: The UC Berkeley Image Database Project." *Library Trends* 4 (Spring 1990): 787-798.

2. Howard Besser, "The Changing Museum," *Proceedings of the 1987 Annual Meeting of the American Society for Information Science* (Medford, N.J.: Learned Information, 1987), pp. 14-19.

3. Walter Benjamin (1892-1940), "The Work of Art in the Age of Mechanical Reproduction," *Illuminations* (New York: Schocken, 1978).

4. Ibid.

5. Ibid.

6. Howard Besser, "Adding an Image Database to an Existing Library and Computer Environment: Design and Technical Considerations," in *Studies in Multimedia* (Proceedings of the 1991 Mid-Year Meeting of the American Society for Information Science), ed. Susan Stone and Michael Buckland (Medford, N.J.: Learned Information, 1992), pp. 31-45. See also Besser, "The Changing Museum."

7. Michael Ester, "Image Quality and Viewer Perception," *Leonardo*, Digital Image-Digital Cinema, Supplemental Issue (1990): 51-53. See also Michael Ester, "Digital Images in the Context of Visual Collections and Scholarship," *Visual Resources* X (1994): 11-24.

8. See Benjamin, "The Work of Art."

9. "Ted Turner Defends Coloring Classics," *San Francisco Chronicle*, October 24, 1986.

10. Thomas Kuhn, *The structure of scientific revolutions* (Chicago: University of Chicago Press, 1962).

11. Debora Silverman, *Selling culture: Bloomingdale's, Diana Vreeland, and the new aristocracy of taste in Reagan's America* (New York: Pantheon, 1986).

12. See Besser, "The Changing Museum."

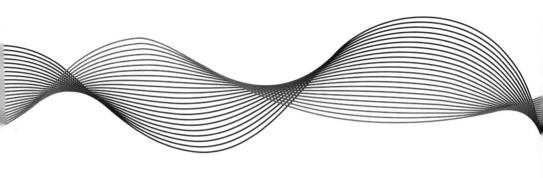

MOVING FROM EXPERIMENT TO REALITY: CHOICES FOR CULTURAL HERITAGE INSTITUTIONS AND THEIR GOVERNMENTS

LYN ELLIOT SHERWOOD

Director General
Canadian Heritage Information Network, Hull, Quebec[1]

At many recent museum conferences, participants have demonstrated exciting projects presenting cultural heritage knowledge in digital form, whether as on-line resources or fixed support products such as CD-ROMs. Presentations have outlined the technical challenges that participants have overcome, and have explored the specific content that has been assembled. But it is striking to note how few speakers address either the business issues involved in the decisions to create such resources or audience response to the products. Jean-François Chougnet, director of editorial and commercial services for France's Réunion des Musées Nationaux, has observed that we are now moving from the experimental phase to an ongoing reality.[2] If this is true, then we will need to grapple very soon with the economics of this new cultural industry and with the underlying business dynamics.

At present, the cultural heritage community appears to be dividing its efforts equally between the publication of individual multimedia products (i.e., authored infor-

mation, generally presented in a fixed support format but increasingly available over networks) and the creation of more general digital holdings (i.e, non-authored information retrieved and organized by the end-user, generally in an on-line environment).[3] Because these activities have been largely experimental up to this point and frequently underwritten by governments or other sponsors, institutions may have had little incentive to worry about a reasonable return on investment.

In a series of brainstorming sessions with museum directors held by the Canadian Heritage Information Network in March 1995, however, participants declared that their objectives for undertaking such projects included making their collections better known, reaching new audiences, *and generating new revenues.* The latest projects take for granted that we are on the threshold of a wonderful new universe in which a wealth of cultural heritage knowledge will be available in digital form. We need to ask ourselves, however, what conditions will need to apply for that vision to be realized. In the current environment, we have a few scattered and random examples. What will it take to make comprehensive electronic cultural heritage resources available to various publics? And how can we realize the return on investment that would make this feasible?

These objectives of the cultural heritage community will depend on, *inter alia*, cost-effective production, the availability of professionals with the skills to take advantage of electronic media's potential, effective intellectual property regimes, the resolution of important technical and standards issues, access to efficient distribution and sales channels, and markets willing to purchase the services or products. In short, the community needs access to a stable multimedia industry prepared to invest in cultural heritage products and services.

The multimedia industry, however, currently exhibits all of the standard characteristics of any emerging industry: a plethora of players; high variability in production expertise; inadequate distribution and sales channels; and dynamic pricing. The industry for fixed support products is slightly more mature than the industry associated with on-line services, but both are still volatile, with radical shifts in ownership and approach predicted in the near future. Greater stability may well result from the anticipated industry restructuring. But the question remains as to whether cultural heritage products and services will yield the return on investment normally expected by the commercial sector or whether government or philanthropic intervention will be required to support the availability of this material at least in the short to medium term.

Traditionally, we have separated the commercial objectives of the for-profit cultural industries from the sociocultural objectives of the heritage sector. A number of factors, however, suggest that we should begin thinking of these as two sides of the same coin. To name but a few of the issues: the likelihood of whether a viable knowledge industry can center on cultural heritage without efficient access to broadly based digital information as raw material; the convergence of delivery mechanisms; the development of software utilities that will enable the swift creation of authored products; the cost of creating large-scale digital resources; the increasing reliance of museums on non-governmental sources of revenue; concern about how global networks and wide-reaching political/economic agreements will affect the preservation of national cultures; and increasing emphasis on continuous learning as a fundamental underpinning of a knowledge economy. Addressing these issues will mean finding synergies between commercial objectives and the objectives of cultural heritage institutions.

How will we progress from the experimental phase of presenting cultural heritage knowledge in digital form to an ongoing reality? To answer this question, let's first assume that:

- access to information about cultural heritage, particularly in the era of global networks, is essential to nation-states and their citizens as they seek to interpret the past in order to understand the present and shape the future;

- although some cultural heritage knowledge can be easily commercialized, achieving access to such knowledge on the scale envisioned is unlikely to be self-sustaining, at least within current market structures; and

- in the absence of self-sustaining activity, it is in a nation-state's interest to explore other means of supporting the availability of this knowledge.

At the same time, governments around the world are wrestling with national debt and diminished state intervention in the economy. Achieving widespread access to cultural heritage knowledge will require innovative solutions that recognize these constraints.

Many of the examples provided in the following analysis are drawn from experiences of the Canadian government, which has a long tradition of public intervention in culture and heritage through both investment and regulation. This intervention has been driven by the desire to ensure the presence of "Canadian voices" in the context of two domestic linguistic markets, neither of which is large enough to sustain competitive pricing for Canadian products in an open market. The Canadian experience is not dissimilar to that of other countries with relatively small populations. Even in larger coun-

tries such as the United States, however, institutions are finding that the development of cultural heritage knowledge cannot be left entirely to market forces. This point has been cogently argued in "Humanities and Arts on the Information Highway: A National Initiative," a 1994 report prepared by the Getty Art History Information Program, the American Council of Learned Societies, and the Coalition for Networked Information.

If the cultural heritage community is to engage in a dialogue with governments and other relevant stakeholders to ensure that its objectives are met, it will need to understand how the dynamics of commercial cultural industries might affect the presentation of cultural heritage knowledge in multimedia formats. Because our digitization projects have been largely experimental up to this point, we have had little reason to consider the economics of making knowledge available through the new media. To accomplish the transition from experiment to reality, however, we will need to be concerned about all aspects of the cultural industry "chain": markets and sales, distribution, production, and intellectual property rights. Equally, we will need to understand where governments might choose to intervene and the nature of the choices they will face.

MARKETS AND SALES

Key to moving towards a self-sustaining activity will be markets whose demand for cultural heritage products meets as closely as possible the cost of development, production, and distribution. At recent conferences, however, audience reactions or sales have rarely been mentioned. We lack an in-depth understanding of audience requirements for knowledge presented in the new media, generally bringing to our products an extrapolation of

assumptions drawn from more traditional media, particularly printed texts or structured databases. Our experiments to date have focused on developing our *technical* knowledge of how to generate information in digital form, rather than on gaining a more fundamental insight into how learning may be enhanced through the new possibilities offered by multimedia presentation—or even which approaches will prove most satisfying to various audiences.

At present, market or audience testing tends to be extremely rudimentary and is often limited to non-interpretive numerical indicators of sales or use at the very end of the development process. We have not yet begun to adopt on a widespread basis more sophisticated means of measuring the impact of our products and services, either during development or through post-purchase/post-use follow-up testing. We will need to know, for example, why consumers have chosen our products or services: for entertainment, for education, for themselves or their children, for professional or personal use. We will need to know how well the products met their expectations and served the desired purpose, and whether they would consider purchasing similar products. At present, we are able to capitalize on the fact that a relatively limited number of products or service offerings are available. This, however, is not an enduring state of affairs.

Research such as the Getty Information Institute's project on points of view promises to help us structure on-line information holdings or other interactive resources in a manner more congruent with how audiences actually seek to acquire knowledge. More research of this nature, both academic and through actual audience feedback, will be necessary if the purposes for which we are developing and presenting our information holdings are to be realized and if we are to establish significant and

stable markets for our products and services. Recent research suggests that we will need to construct information holdings capable of responding to a far greater range of assumptions about context and relationships among information elements than our current structured environment.

One of the most basic indicators of whether products or services meet user needs is whether the audience continues purchasing what we are offering at a reasonable market value. In the on-line environment, we are only beginning to experiment with priced service offerings. Our current use of the Internet environment is more promotional than substantive, and, despite the novelty of the medium, users are already beginning to ask "Where's the beef?" and to experience frustration when they must move sequentially across diverse sources to locate specific information.

At the same time, some industry watchers are predicting that World Wide Web use will decline when the mainstream business world finds it cannot function profitably in the new environment.[4] If there is indeed such a drop and a concomitant diminution in the research necessary to make it a more sophisticated medium capable of responding to consumer needs, the heritage community will need to assess whether it wishes to continue using the Internet to reach broader audiences. And it will need to determine how it will address the barriers that consumers have identified, which can also prevent a reasonable return on investment.

In 1995, the Canadian Heritage Information Network began to market subscriptions for collective information services developed by its members to audiences beyond the cultural heritage community. The overhead involved in managing subscriptions is clearly beyond the reach

of any single institution unless there is either an extremely large audience or a knowledge product or service for which a limited number of subscribers is willing to pay a very high rate. "Pay-per-use," an alternate approach on the verge of realization in the context of the Internet, will probably only be successful where the service represents a known value to the consumer rather than a means to capture casual "surfers."

The issues surrounding a profitable market for cultural heritage knowledge in fixed support formats (CD-ROMs, CD-Is, or laser discs) are equally complex. Production costs seem to average close to $300,000 and are beginning to be much higher for more sophisticated products. At a retail price of $50, at least 12,000 copies of a title must be sold to break even, assuming a wholesale price of approximately $25.[5] If current trends towards lower pricing continue, higher sales volumes will obviously be necessary. In addition, that break-even point is based on the relatively low production values of many current titles. The demand for more sophisticated products, combined with the development of discs capable of holding more content, will continue to increase production costs, suggesting that even higher sales volumes will be needed to break even. The question for the heritage community will be whether the required larger markets exist and whether, therefore, cultural heritage will be a commercially attractive area for investment in multimedia development.

Will producing this material in electronic form expand the market that currently exists for the same material in printed form? Within approximately a year, a CD-ROM titled *Le Louvre: The Palace and Its Paintings* ($50)—which obviously capitalizes on the tourist market as well as on a market interested in the inherent subject matter—sold close to 60,000 copies, with a guaranteed dis-

tribution contract in Japan for an additional 27,000 copies. In roughly the same time frame, however, the Louvre's equally attractive but less widely appealing *Voyages de Delacroix au Maroc* (approximately the same price) sold fewer than 10,000 copies despite its very high production values. The CD-ROM produced to capitalize on the blockbuster Barnes exhibit, *A Passion for Art* ($54), apparently sold relatively poorly in museum shops but somewhat better in a bookstore chain. While some technophiles who would never purchase an exhibition catalog may choose to buy a CD-ROM, expanding the market may require both achieving price points that are not feasible for traditional media and exploiting the new media's potential to present information in innovative and exciting ways that will draw new audiences.

Before fixing on the book industry as the most appropriate model for distributing multimedia material, the cultural heritage community might want to examine the film industry, which emphasizes rentals rather than sales. This model might ultimately prove profitable and also create new audiences for heritage knowledge by reducing the financial risk associated with exploring new material. It could have a particular appeal in terms of technical developments enabling "rental" or one-time use via the Internet or its successor technologies. In the longer term, the concepts of rental and purchase may actually begin to converge in the context of electronic delivery.

One of the major challenges for the cultural heritage community will be creating demand for its products and services, whether fixed support or on-line. It might be useful to examine the role governments could play in supporting this effort, while noting that they are traditionally less likely to intervene on the demand side of the equation than on the supply side. For example, there are various ways in which governments could intervene in the

educational markets, particularly elementary and secondary schools. Equipping academic institutions with Internet accounts or CD-ROM players could increase demand for content, thus stimulating supply.

Taking this one step further, market opportunities for cultural multimedia products may arise in those jurisdictions where governments shape school curricula. Topics involving local or national history or the natural sciences may create demand for cultural heritage institutions' products, as would general courses involving the history of art or science. Governments that traditionally require only domestically produced textbooks to be used in schools may be more inclined to use similar standards for the multimedia equivalent.

Vouchers, tax credits, or similar measures that reward consumers for purchasing particular products or services have also been introduced at various times by different governments to stimulate demand, but such incentives probably won't persuade consumers to purchase products they don't think they need. There may also be opportunities for heritage institutions and governments to collaborate in campaigns that draw attention generally to cultural heritage (combined, perhaps, with tourism campaigns) and specifically to heritage institutions represented in electronic form.

DISTRIBUTION AND MARKETING

The cultural heritage community will also need to concern itself with the distribution channels necessary to reach its markets. For fixed support products, we must determine whether the companies with whom we are dealing can expose our products and services to international markets while offering prominence within the domestic market where the interest may be greater. For

on-line services, the regulatory environment adopted by governments may affect the ability of cultural heritage institutions to establish the conditions under which their services will be made available.

For products such as CD-ROMs, the museum shop may not effectively achieve sales large enough to break even. For example, the Art Gallery of Ontario sold only five copies of the Barnes CD in the five months after the exhibition. The Metropolitan Museum of Art, which invested 4,000 hours of staff time and $150,000 in the production of the CD catalog for "Splendors of Imperial China," sold 100 copies a day during the exhibit (at approximately $25) but, at the time this chapter was written, had no firm plans to distribute the product following the exhibit. Until the heritage community regularly secures distribution agreements as an integral part of production plans, we will remain at the experimental level of this new medium. Some traditional cultural industries believe that for every dollar spent on production, an equivalent amount should be spent on distribution and marketing. A distribution agreement may also be a source of venture capital at the production stage. A distributor may levy a distribution fee or receive 15-40 percent of the wholesale price, significantly influencing the revenue institutions receive for each copy. The increased sales volume, however, should offset this impact.

Many governments will be examining domestic ownership of distribution undertakings for fixed support products. This may be of particular importance to institutions whose products are of primarily local rather than international interest. A domestic distributor may be more likely to add such a product to its list but may be less successful at securing "shelf space" (depending on the conditions governing access by international dis-

tributors to, for example, bookstores). International distributors, on the other hand, may have greater opportunities to place products widely but be less interested in promoting an item with low international sales prospects. In either case, however, the distributor should have a large enough business volume to ensure that its efforts can be "amortized" over a cost-effective number of titles. Such distributors may be in a position to require either a lower percentage of wholesale price in a distribution agreement or a lower up-front payment.

At present, securing access to on-line distribution opportunities is not difficult for cultural heritage institutions: buy a server, install the software, and launch the site. A number of emerging trends, however, may provide both challenges and opportunities for the community. Most immediately, there is the issue of securing visibility among a growing number of sites vying for consumer attention. Participation in various directory and gateway services can help in this effort.

Governments are currently attempting to deal with the increasingly complex array of regulatory questions surrounding service provision on the information superhighway. A particular focus of attention is the traditional distinction among broadcasters, cable operations, and telecommunications carriers.[6] In attempts to secure favorable regulatory decisions enabling them to provide a full range of interactive multimedia services, cable companies and telecommunications carriers are creating inducements such as navigational menus offering particular prominence to culturally significant sites or similar services. This may become the on-line equivalent to favorable shelf space in the market for fixed support products. Distribution measures hitherto adopted for more traditional cultural industries in some countries include national content requirements such as screen quotas for

films or programming requirements for broadcasters. The cultural heritage community might want to examine equivalent measures appropriate to the new networked environment to see how it could benefit from service providers' attempts to position themselves in the regulatory context.

In the slightly longer term, the demand for the higher bandwidth necessary to support high-resolution images, full-motion video, and sound may significantly reduce the number of service providers and limit conditions of access. In this more sophisticated environment, will providers be treated as common carriers, distributors, or publishers? In a May 1995 paper, Fred M. Greguaras and Philip D. Porter argue that "individuals or small companies will likely have only indirect access rather than direct access to broadband interactive networks."[7] Institutions will need to determine whether emerging technical, economic, and regulatory issues will create an environment in which cultural heritage knowledge is accessible only through commercial service providers. Such a prohibitive environment could limit their access to markets and their return on investments.

DEVELOPMENT AND PRODUCTION

Developing and sustaining markets for cultural heritage knowledge will be critical to the long-term effort of making heritage collections better known, reaching new audiences, and generating new revenues. In the shorter term, will institutions still be able to underwrite the costs of entering this new arena? Current experimental projects have generally been financed by diverting institutional resources from exhibits or other forms of publications, or through one-time-only sponsorships, commercial investment, or government grants or loans.

In the case of fixed support products, commercial investors usually find that cultural heritage titles are not yet profitable. Institutions may question whether relatively low product sales warrant continued diversion of resources from more traditional activities. On-line ventures have rarely been undertaken with an expectation of direct financial return, but many institutions are realizing that the cost of maintaining dynamic sites is considerably higher than anticipated. These costs will probably continue rising in light of the demand for more in-depth content.

Within this context, cultural heritage institutions in some countries are lobbying their governments to support the availability of cultural heritage knowledge through the new media. To date, most government investment in the information superhighway has targeted the creation of the infrastructure and has been predicated on the *Field of Dreams* theory: "If you build it, they will come." In fact, many of the original funding programs established by governments specifically excluded content digitization as eligible projects. This is changing gradually, although content funding is still sporadic and avoids an ongoing commitment to generating a critical mass of heritage knowledge. Nor is the funding necessarily designed to address the very real technical, conceptual, intellectual, and economic issues that David Bearman argues must be resolved if we are to create the desired "cathedral of human knowledge and memory."[8]

When governments do elect to fund content development, they will choose among a variety of instruments: direct subsidies (such as grants or contributions, repayable contributions, loans, loan guarantees, or contracts); or indirect subsidies (such as tax expenditures, whether as write-offs or tax credits). In lobbying for content development support, the cultural heritage community will

need to assess which support approach is most likely to help create an effective economic model for the ongoing production and consumption of high-quality products. Different market structures may require the adoption of different solutions.

Direct subsidy in the form of project funding, whether provided to cultural heritage institutions or to domestic multimedia industries, may unintentionlly shield participants from market realities if it covers 100 percent of project costs. The heritage community will more likely reach its long-term goal of stable markets if the demands of those markets are considered during product development. If project funding is channeled to the commercial sector, particularly in an emerging industry, it may encourage short-lived companies dependent on project financing and therefore subject to significant cash-flow problems. If, as Michael Ester has suggested, long-term market success is more likely with the production of series than isolated titles,[9] it is in the community's interest to support funding models more inclined toward financial stability in the commercial sector.

Similarly, indirect subsidy in the form of tax write-offs against investment (rather than tax credit against profit) may significantly broaden the investment base. If the level of write-off is too high, however, the resulting environment of limited risk might not encourage the production of high-quality products. When the Canadian government applied a 150-percent write-off to investment in films, for example, the investment base broadened to include a significant number of individuals with no inherent involvement in, or commitment to, the film industry. The result was a series of low-quality productions that satisfied neither socio-cultural nor commercial objectives. Marc Pachter has argued convincingly that the strategic advantage of cultural heritage institu-

tions in the world of multimedia production is their per-
ceived authoritativeness and quality.[10] Long-term posi-
tioning, therefore, would suggest that it is in the com-
munity's interests to ensure that these qualities are not
diminished.

In the current environment, the aforementioned issues
may apply more directly to fixed support format prod-
ucts than to the development of on-line services. In some
jurisdictions, however, governments are also beginning
to make significant investments in large-scale digitiza-
tion projects accessible over networks. For the museum
community, many of these projects now focus on automat-
ing collections records through structured databases with-
out relation to other information holdings within the
institution. Will this emphasis satisfy audience demands
for more substance? Will it lead to widespread support
for further government funding and/or board autho-
rization over the longer term? More market-driven
approaches may both satisfy collections management
objectives and broaden public interest. Equally, "top to
bottom" digitization of all information holdings within
an institution may be premature given the unresolved
issues that hinder effective use of such material. The-
matic projects that draw on a variety of institutional
information holdings and that appeal to audiences may
create more meaningful results, at least in the short to
mid-term.

INTELLECTUAL PROPERTY

At a July 1995 industry copyright seminar in New York,
participants were advised not to bother with material
for which museums held the rights because such insti-
tutions were notoriously inefficient and unprofessional
to deal with in this respect.[11] Resolving this issue may

require collective undertakings devoted to the management of rights. Until then, institutions may not realize significant revenues from the licensing of digital representations of their collections.

Collective efforts involving consultations with commercial interests might help determine appropriate pricing for the use of heritage materials. For example, many institutions have developed individual approaches for the use of photographs to illustrate printed material, but have not yet developed appropriate pricing strategies for image use in multimedia products that may draw on many sources. Frequently, institutions' expectations of revenues are unrealistic, particularly when commercial producers are equally willing to use easily accessible stock-house materials.

Efficient transactions will also depend on institutions' ability to provide potential licensees with access to catalogs of available materials. Internet sites can provide such information, so long as they include appropriate display, search, and transaction utilities. Commercial producers are unlikely, however, to be willing to search sequentially across several sites to identify items. Here, too, collective action would yield more cost-effective results than isolated efforts by individual institutions.

Initiatives such as the Getty Information Institute's Museum Educational Site Licensing project offer interesting models of heritage institutions working with markets (in this case academic institutions) to provide cultural materials for many uses. At the time this book was published, it was too early to tell whether this experiment had established a fair market price, encouraging large-scale implementation of the concept. But such cooperative market trials, whatever their outcome, are essential to making heritage knowledge accessible.

Existing intellectual property legislation is under review in many jurisdictions. Of particular concern to the heritage community are the treatment of databases and definitions of fair use or fair dealing. The regime proposed by the European Community in 1995 would limit rights in databases to a fixed term and be subject to exceptions by member states with respect to fair use or educational use provisions. This may require new approaches to the creation of large banks of heritage knowledge to ensure continuing protection of information elements. More generally, in view of the importance of the educational market for cultural heritage knowledge, the community will need to consider its position, both as a provider of information and as a user, with respect to provisions covering educational use of all types of copyrighted material in digital form.

In the interest of generating revenue, some heritage institutions have sold digital rights to their collections to commercial interests, either outright or for fixed licensing periods. Because these commercial undertakings are often outside the country, some governments are growing concerned about the alienation of cultural property. Regimes similar to those protecting material property might ultimately be introduced to ensure that domestic audiences can still enjoy access to their patrimony. The growing trend towards non-exclusive licensing arrangements may provide institutions with the opportunity to exploit their holdings without jeopardizing either their stewardship of a nation's heritage or their future commercial opportunities.

MAKING THE TRANSITION

If institutions are to make the transition successfully to full partnership in a new cultural industry in which cultural heritage knowledge plays a key role, they will need

to develop new skills. During the transition, there may be tensions between a commercial partner's populist approach to production and an institution's desire to preserve its traditional hallmarks of authoritativeness and quality.

Institutions may not be accustomed to commercial developers' fast pace or their need to define project parameters precisely during contract negotiations. The knowledge that curators may wish to impart could be at odds with what audiences demand. Learning to work with partners whose objectives differ from those of the institution may well be the first lesson. Material such as the model contracts or template agreements for licensing multimedia information developed in the United States, Canada, and Great Britain will provide assistance to both sides of the partnership during the learning curve.[12]

In developing a critical mass of knowledge with appeal to a wide range of consumers, heritage institutions will need to take a more holistic view of their information holdings. Structured databases containing basic collections documentation cannot meet market demands except, perhaps, for specialists seeking comprehensive inventory information. In order to meet audience demands and keep costs down, institutions must find new ways to capture interpretive information developed over decades and traditionally published in such formats as exhibition catalogs (or perhaps still residing as notes in curators' personal files).

In addition to learning to work with commercial partners, heritage institutions will need to work with each other. They need to share experiences in order to diminish the collective learning curve, and they need to take advantage of the opportunities offered by collective action—either in assembling information to create knowl-

edge or in conducting efficient information transactions. Conceptual and technical work will be essential in linking information across institutions. While museums may hold information related specifically to their collections, other heritage institutions may hold materials that can provide the essential interpretive context. Together, they can respond to the range of interests that audiences will bring to heritage knowledge in the digital environment.

The opportunity exists to make the transition from today's experiments to tomorrow's reality. None of the issues raised in this chapter are insurmountable, but addressing them will take concerted action on the part of the heritage community as part of a broader effort involving commercial partners, governments, and consumers of heritage knowledge.

REFERENCES

1. The views expressed in this chapter are those of the author and not necessarily those of the Canadian government.

2. Jean-François Chougnet, Directeur des services éditoriaux et commerciaux, Réunion des Musées Nationaux, at the International Conference on Hypermedia and Interactivity in Museums, San Diego, Oct. 13, 1995.

3. The distinction between authored and non-authored products is adapted from a 1994 publication by the French Ministère de la Culture et de la Francophonie, "Industries Culturelles et Nouvelles Techniques: Rapport de la Commission presidée par Pierre Sirinelli, professeur à l'université de Paris-XI."

4. For example, Geoffrey Rowan, "World Wide Web called house of cards," *The Globe and Mail*, Dec. 27, 1995, pp. B1-B2.

5. This calculation assumes the involvement of a distributor who will receive between 15 percent and 40 percent of the wholesale price or levy a distribution fee.

6. Many of the existing regulatory distinctions limit the types of services that can be provided by carriers: telecommunications companies, for example, may not provide broadcasting services in many jurisdictions. New regulatory decisions will hinge on the question of how multimedia services are defined (as broadcasting or as telecommunications) and on whether interconnection or cross-ownership is permitted between types of carriers (e.g., cable and telephone).

7. Fred M. Greguras and Philip D. Porter, "Legal Environment for Broadband Interactive Services." Presentation at the Developers Forum for Cableport (TM) Technology, hosted by the Cable Products Division, Intel Corporation, May 22, 1995.

8. David Bearman, "Museum Strategies for Success on the Internet." Paper presented at the Science Museum, London, May 10, 1995.

9. Michael Ester, conversation with the author, San Diego, Oct. 10, 1995.

10. Marc Pachter, presentation to the Museum Documentation Association Conference, Edinburgh, Nov. 9, 1995.

11. Remark made by Barbara Zimmerman, president of BZ/Rights and Permissions, Inc., to participants in the Institute for International Research Conference on Licensing, Copyright and Distribution of Electronic Content, New York, July 25-27, 1995.

12. See, for example, Geoffrey Samuels, ed., *Sample CD-ROM Licensing Agreements for Museums* (Washington, D.C.: American Association of Museums/MUSE Educational Media, 1996), and Canadian Heritage Information Network, *Sample CD-ROM Licensing Agreements for Museums, Canadian Common Law Edition; Licences de CD-ROM pour les musées Accords types, édition canadienne conforme au code civil du Québec.*

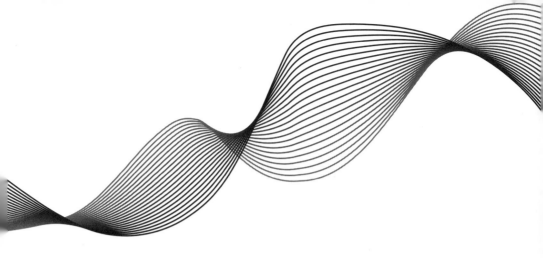

THE TRANSFORMATION OF THE MUSEUM AND THE WAY IT'S PERCEIVED

HOWARD BESSER

Visiting Associate Professor
School of Information Management & Systems,
University of California–Berkeley

New technologies are beginning to cause significant changes in the way museums perform their functions and in the way they are perceived by the public. The rapid conversion of text and images into digital form will affect work processes within the museum. Coupled with the advent of high-speed digital networks, this convergence will permit the museum to provide more information to a wider general public.

This chapter explores how technology is likely to transform museums in the coming years. It looks at multimedia exhibits delivered over the Internet as well as other effects of widespread adoption of digital images, multimedia, and high speed networks. It examines how the adoption of these technologies is likely to cause a convergence between computing systems used for exhibitions and those used for collection management, as well as cause paradigm shifts in what constitutes a collection, how the public views museums, and how scholars do research. This study is grounded in an exploration of

the library, a cultural institution that is approximately a decade ahead of museums in the transformation process.

A CHANGING WORLD OF NETWORKED DIGITAL INFORMATION

New channels for distribution of information are rapidly transforming the social and cultural landscape. First the television and later the VCR have changed how people consume culture. This has led to a transformation of cinemas and a gravitation towards consumption of culture within personal environments where users have more control over time and pacing. The widespread dissemination of networked digital information from the cultural arena is likely to have a similar effect on other forms of culture, moving them into personal spaces where the user asserts more control over how quickly and when the interaction takes place.

We are already seeing a transformation in the world of librarianship. Libraries are becoming less important for the materials they collect or house, and more important for what kind of material they can obtain in response to user requests. This movement from collecting material "just in case" someone will need it, to delivering material from elsewhere "just in time" to answer a user's needs, is a profound shift for the library as an institution. This shift is a direct result of the recent proliferation of digital networking in an environment where standards for description were already well established.

Along with the changes in libraries as institutions have come changes in the roles of librarians. With the proliferation of networked digital information, the librarian's role is shifting from caretaker of a physical collection to someone who identifies resources in collections housed

elsewhere. This is currently evident in most major research libraries where librarians spend much of their time creating (World Wide Web-based) electronic pointers to resources on the Internet. Efforts like this are likely to greatly increase in the foreseeable future.

As museums embrace networking and convert their information into digital form, we can expect to see similar sweeping changes both in the roles of museum employees and in how the public views cultural repositories.

AUTOMATION-ENABLED TRENDS

Recent technological developments have created new capabilities for information repositories. These capabilities in turn will serve as agents that will enable major transformations within these repositories. This section examines some of the trends that emanate from new technologies, and (after reviewing how these are affecting libraries) speculates as to how they are likely to transform museums.

LARGE FILES, MORE DETAILED REPRESENTATIONS

Since the mid-1980s file storage capacity has increased and storage cost has decreased at a phenomenal rate. The 20-megabyte hard drive that was considered "large" in the mid-1980s cannot even be purchased in the mid-1990s (when 500-megabyte disks are considered small). This increase in storage capabilities has enabled the widespread digitization of large bodies of textual information, and will soon enable the digitization of images and multimedia on a massive scale.

Information repositories are in the business of creating representations of original objects, often in the form of

cataloging or collection management records. This trend towards massive digitization has meant that repositories can create more and more detailed representations (or "better abstracts") of originals.

Library indexing and abstracting services began by providing titles and index terms on-line. As storage costs diminished, they added searchable abstracts. Most recently, many added full text of articles. Similarly, library catalogs began with bibliographic descriptions and subject headings, then some added table of contents information, and today some are adding full text or page images.

Since the early days of museum automation efforts, text-based collection management records have served as abstracts (or stand-ins) for the objects they represent. As storage costs have fallen, museums have begun to add digital images to their collection management records. In their initial forays into this area, most museums planned to only use images for identification purposes. But museums that have begun on this path are increasingly realizing the utility of using larger images for a variety of purposes.

Because constraints on file size will continue to rapidly diminish, they will no longer prevent a repository's use of digital images. In the near future we are likely to see significant increases in the use of digital images and multimedia by cultural repositories.

NETWORKING SERVICES AND ACCESS FROM MULTIPLE LOCATIONS

Until the 1970s, computing was viewed as a service that was offered at a particular physical location; user transactions had to be carried on punchcards to the computer. The development of telecommunications capabilities and multi-user systems has allowed interactions to take

place from remote locations, opening up a host of new applications.

Networking developments have changed the landscape of computing. The 1960s and 1970s notion of users operating dumb terminals and of all services residing on a central computer has been replaced by the concept of distributed computing and individual user workstations. The ability to have processes on a user's workstation interact with services from a centralized fileserver has led to the phenomenal growth in World Wide Web activities, services, and use. Web browsers run decompression and formatting programs on files from remote servers, and the text layout and display of images would be slow or impossible without software running on the individual client.

For libraries this trend has meant that users no longer have to go to a single centralized card catalog in order to view the library's holdings; all holdings are usually available in each branch library or even from home workstations. Indexing and abstracting services that were distributed in print form (and usually housed in only one location) are now mounted on fileservers and available from remote workstations.

As network speeds continue to increase, more and more individuals will access information and entertainment from their workstations at home or work. Still images, moving images, and multimedia will become available as networked services. And as individuals access more and more of these resources on-line, cultural repositories will be under increasing pressure to distribute in this arena. Although it is currently a nightmare vision for most museum directors, it is very possible that many individuals will become less interested in traveling to sites where they must wrestle with parking and limited

hours, and will only visit cultural repositories if they can do so any time of the day or night from the comfort of their home workstation.

BETTER USER INTERFACES AND A DIMINISHING ROLE FOR INTERMEDIARIES

The advent of graphic user interfaces has made it possible to operate many computer applications with little or no training. In libraries, this has meant that many users will explore bodies of information directly themselves, without asking librarians for guidance. And this has meant that many libraries have reallocated staff positions, putting fewer resources into directly answering patron queries and more resources into development and maintenance of on-line services.

Libraries have begun to explore the storage of user profiles and preferences (such as "only show me material in English" or "display the items retrieved in chronological order, most recent first"). And research laboratories are exploring the development of "intelligent agents" that know about the user's preferences (including content and level of detail desired, amount willing to pay, and time willing to wait) and troll the Internet to bring back only the material that meets the user's criteria. These agents, their developers believe, will replace many of the jobs that today are devoted to helping people locate information.

The intuitive user interfaces of World Wide Web browsers have shown that when interfaces are easy to use and the cost of information is not expensive, users will explore all kinds of new information resources. Cultural repositories should learn that this can mean a great increase in the number of people exploring the information that they generate.

STANDARDS AND PROTOCOLS: MORE RESOURCES AVAILABLE

The development and adoption of standards and protocols have led to an exponential growth in resources available on the Internet. Information cannot be passed from one system to another without some kind of agreement on data formatting and delivery. Z39.50 standards have allowed people to use their own familiar query syntax to access library and other information resources around the world. Standards for URLs (Universal Resource Locators) and HTML (Hyper Text Markup Language) have allowed World Wide Web browsers to proliferate. MIME and other standards for multimedia formats and compression have led to wide availability of images and sound on the Internet. New industry standards (such as VRML, Java, and Shockwave) promise to extend functionality to the desktop, allowing users to interactively explore three-dimensional environments (eventually including interactive exhibits) and quickly and conveniently display complex multimedia information on their desktop.

The proliferation of resources available on the Internet has provided museum personnel with access to a wide variety of information. In addition, more and more museums are using the Internet to provide informational resources to other museums and to the general public.

In addition to the enormous amount of information available on the Internet, standards development has led to increased cooperation among institutions. This is most evident in libraries where standards have led to cooperative efforts in interlibrary loan and collection development. Much of the current museum standards development and implementation is centered in the CIMI Project (Computerized Interchange of Museum Information) and particularly in Project CHIO (Cultural Her-

itage Information Online). The successful widespread adoption of results from these projects is likely to encourage more cooperative relationships among museums.

COLLECTION MANAGEMENT AND EXHIBITION: INCREASING CROSSOVER?

Historically, most museum automation efforts have been driven by the need for record-keeping and inventory control and have resulted in collection management systems. A smaller set of automation efforts has centered in museum education departments and has focused on interactive exhibits. The vendors, software, tools, and platforms for computers used in collection management have been very different from those in interactive exhibitions. (For a summary of the differing characteristics between the two, see table on next page.) This split was due to technological limitations, but recent advances are likely to promote the convergence between these two camps.

Collection management systems have historically handled very complex information but have had poor user interfaces and been extremely difficult to learn to use. User interfaces for these systems were very slow to even incorporate underlining or font changes, and not until the mid-1990s did these systems make widespread use of a mouse and a graphic user interface.

Multimedia exhibitions, on the other hand, have used graphic, point-and-click interfaces since the mid-1980s. Because there is no chance to give even a short "how-to" lesson to a museum visitor, these user interfaces had to be intuitive and easy to use.

Collection management systems are object-based, and most data within them refers to a particular object.

Though they can reflect complex relationships among objects, this is usually limited to situating an object within a set (a group or a collection). The relationship between an object and other objects, people, or theories (usually a key element of an exhibition catalog) is seldom reflected in a collection management system.

Multimedia exhibition packages, however, primarily offer a narrative structure; they essentially tell a story and situate the objects in some relationship with other objects, people, and theories. They also offer a coherent view of some domain, unlike collection management systems that focus on individual objects. In this sense they are much closer to an exhibit or exhibition catalog than to a collection management system.

INTERACTIVE MULTIMEDIA EXHIBITION PACKAGES	COLLECTION MANAGEMENT SYSTEMS
Designed for explanation and access	Designed for inventory control, record-keeping
Good user interface	Poor user interface
Narrative-based	Object-based
Offer coherent view of some domain	No overall view of domain
Records are limited and carefully selected	Unlimited records; all are available
Frequently no database	Usually a powerful database
Limited user navigation	Unlimited user navigation
Always single-user	Single-user or multi-user
Closed-box system	Open or interoperable systems
Static	Dynamic

Collection management systems attempt to create and store records for every object in the museum. Interactive exhibits, on the other hand, usually store only a select-

ed group of records and images—just enough to tell a story. And while the records in the exhibition system may be derived from records in the collection management system, they are often enhanced and have always been stored in a separate location.

Collection management systems usually incorporate a powerful database and let users pose just about any possible query to it. Interactive exhibit systems seldom contain a database. Though on the surface these exhibit systems appear to give users a variety of options, usually these are limited to multiple-choice branching, and the user can only follow branches conceived by the system designer.

Collection management systems have tended to be relatively open; for the most part vendors have recognized the need to import records into these systems and export them to other systems, and in recent years have provided tools so that even inexperienced users can perform these functions. Interactive exhibit systems, on the other hand, have almost always been "closed-box" systems. They see themselves as stand-alone systems that have no need to share information with other applications (except perhaps during the early stage of a project when developers might take text or images from other sources).

While collection management systems have always been dynamic (with system tools oriented towards handling data that is constantly growing and being updated), interactive exhibits have tended to have static contents. Like publishing media, interactive exhibits have mostly captured growing and changing information and frozen it at a particular point in time, and systems have seldom provided tools for updating.

A number of technological limitations have shaped interactive exhibit systems in this way. Until recently, the

vast storage needs for digital multimedia had led most developers to favor analog videodisc systems for exhibits incorporating images or multimedia. Because good tool-kits for developing graphic user interfaces were only available in the mid-to-late 1980s on single-user systems (like the Macintosh at that time), most interactive exhib-it developers employed single-user systems. Developers chose to store their text and images in whatever format would help them achieve the highest performance, ignor-ing standard formats (which frequently diminished mul-timedia performance). They also discovered that they could simplify their work if they chose to limit the total amount of information and control the types of ques-tions that could be asked. And because most developers saw their work as ending with the installation of the interactive exhibit, few considered implementation of a function to export images or text.

Collection management systems were first implement-ed on mainframe computers, then on early PCs—both platforms that were slow to adopt graphic user inter-faces or incorporate images or multimedia. System ven-dors have seen their role as handling complex informa-tion about and relationships among objects (in groups), and until recently ignored technological developments bringing graphic interfaces and multimedia to their plat-forms.

Thanks to technological developments, collection man-agement systems and interactive exhibits now share more in common characteristics. The advent of faster processors, higher capacity digital storage, and more effi-cient compression algorithms will soon eliminate some of the major performance concerns that have led inter-active developers to avoid standards and store text and images in formats that are inaccessible from other appli-cations. This, coupled with the development of plat-

form-independent multimedia authoring systems, will likely lead developers away from single-station, closed-box systems.

The advent of robust graphic user interface toolkits and software for handling multimedia is making it easy for collection management systems to develop better user interfaces and incorporate forms of multimedia. As they do this, on some levels they will begin to resemble the interactive multimedia systems.

But the recent development that holds the greatest promise for the convergence between interactive exhibition systems and collection management systems is the World Wide Web (WWW). The widespread deployment of WWW browsing tools essentially creates tens of thousands of multimedia-capable "clients." This large "market" will provide incentive for interactive developers to abandon closed-box, single-station systems in favor of producing "servers" designed to deliver to multiple clients—something that just wasn't possible before the number of clients had reached a critical mass.

The WWW holds the promise of combining an overall narrative view of a domain with a database of individual items. A museum could create WWW documents out of narrative essays from an exhibition catalog and link these directly to text and images from a collection management system that is constantly updated. Thus, instead of the frozen snapshot that characterizes most catalogs and interactive exhibits, the WWW exhibit would be dynamically updated as collection management records changed.

Furthermore, designers of a WWW interactive exhibit could allow users to view any non-protected text or image within the collection management system and to ask

almost unlimited questions—a radical departure from the limited questioning available within current interactive exhibits.

Although this approach hasn't been fully exploited yet, it holds great promise in integrating the advantages of both interactive multimedia exhibition tools and collection management systems while eliminating many of their respective drawbacks.

BROADER TRENDS

Information technology will cause broad changes in museums and in how the general public perceives cultural objects. There is no way of accurately predicting what these changes will be, but we can certainly identify major areas of concern and ask relevant questions. Another chapter in this volume ("The Changing Role of Photographic Collections with the Advent of Digitization") speculates about the effect of democratized access on how people view cultural objects, and examines issues of authorship, ownership, and intellectual property. The section below raises questions about basic changes to research and scholarship, as well as impending changes to museums and how they're perceived.

CHANGES TO SCHOLARSHIP

In the past, scholarly examination of books, photographs, and other material generally took place only in specialized environments such as museums, archives, and libraries. As tools are developed to analyze works from personal computers, and as more of the works are available digitally through networks and CDs, scholarly research will shift to homes and offices. This is likely to change both the way scholars work and the view of research institutions as specialized environments.

A scholar's workstation can provide tools that allow the user to analyze digital images, combine them in different ways, create new juxtapositions, and explore scholarly text-based information about individual images, artists, subjects portrayed, etc.[1] For example, viewers can examine images of a work of art both before and after restoration, and decide whether the restoration was appropriate. Or a user can compare three translations of an ancient manuscript, looking at them all on the screen side-by-side. The scholar's workstation will provide powerful tools for research when it can access databanks of journals, other textual information, and digital images.

Though we can identify a variety of aids that might be desirable in such a workstation (bibliography handling, finding tools, image sorting, image processing, multivalent documents, etc.), much work still needs to be done to identify and develop tools to help the researcher. Even in the field of imaging there has only been one significant set of studies to date of scholarly researchers' image quality needs.[2]

But the world of information at the scholar's fingertips carries with it the potential for recasting scholarship. If user behavior on the WWW is any example, when a huge body of multimedia information is readily available it is possible that scholarship may shift its focus from discovering new knowledge within objects to discovering connections and themes among them.

CHANGES TO MUSEUMS AND HOW THEY'RE PERCEIVED

As more and more museum information (images and text about objects, on-line exhibits) becomes available across the Internet, will people begin to forego the experience of actually visiting a museum? When a large number of museum visitors can visit an exhibit without phys-

ically entering the museum premises, how does that change the public's perception of the institution? Does the museum's authority increase (because more people actually see its exhibits)? Or does it decrease (because it's being delivered through a channel adjacent to "Home Shopping")?

When a museum begins to service more people electronically than in person, will more resources be put into on-line exhibits than into physical exhibits? How will services to the public change? Will sources that currently base funding levels on the number of people who enter the museum premises change their accountability measures to include on-line visits? If so, will the ability to track how often viewers look at each individual part of an on-line exhibit affect the types of items and themes covered (causing a focus on high-visitation areas)?

At this point in time, the building blocks for most World Wide Web exhibitions are relatively small files of descriptive text and images joined through links from a set of master files that provide the narrative coherence to the exhibit. As museums create more and more of these building blocks of images and descriptive text on-line, will disputes develop over the rights to use them in different ways? Will commercial enterprises develop their own exhibits that incorporate links to hundreds (or thousands) of these building blocks in museums? Will the public's ability to link to these building blocks begin to erode the authority of the curator as the only one who can visually present themes and juxtapositions?

As the general populace begins to visit more on-line exhibits, will a museum become more notable for the strength of its on-line presentation than for the contents of its collection?

ACKNOWLEDGMENTS

Some of the ideas here are excerpted from "The Changing Museum," a paper the author wrote for the 1987 *Proceedings of the American Society for Information Science* (see first reference below), and from "The Changing Role of Photographic Collections With the Advent of Digitization," a discussion paper he wrote for the Working Group for Digital Image in Curatorial Practice that met at George Eastman House on June 4, 1994 (organized by Roger Bruce).[3] An expanded version of one section of this chapter appeared as part of the proceedings of the 1997 Museums and the Web conference under the title *Integrating Collections Management Information into Online Exhibits: The Worldwide Web as a Facilitator for Linking 2 Separate Processes*. Julie Herrada assisted in editing this chapter.

REFERENCES

1. Howard Besser, "The Changing Museum," *Proceedings of the 1987 Annual Meeting of the American Society for Information Science* (Medford, N.J.: Learned Information, 1987), pp. 14-19. See also Howard Besser, "Advanced Applications of Imaging: Fine Arts," *Journal of the American Society of Information Science*, September 1991, pp. 589-596. See also Howard Besser, "Adding an Image Database to an Existing Library and Computer Environment: Design and Technical Considerations," in *Studies in Multimedia* (Proceedings of the 1991 Mid-Year Meeting of the American Society for Information Science), ed. Susan Stone and Michael Buckland (Medford, N.J.: Learned Information, 1992), pp. 31-45.

2. Michael Ester, "Image Quality and Viewer Perception," *Leonardo*, Digital Image-Digital Cinema, Supplemental Issue (1990), pp. 51-53. See also Michael Ester, "Digital Images in the Context of Visual Collections and Scholarship," *Visual Resources* X (1994): 11-24.

3. Howard Besser, "The Changing Role of Photographic Collections With the Advent of Digitization," in *Selected Papers from the Working Group for Digital Image in Curatorial Practice*, ed. Roger Bruce. George Eastman House, June 4, 1994.

```
(gopher://gopher.tmn.com:70/11/
     Artswire/GEHIMP)
```

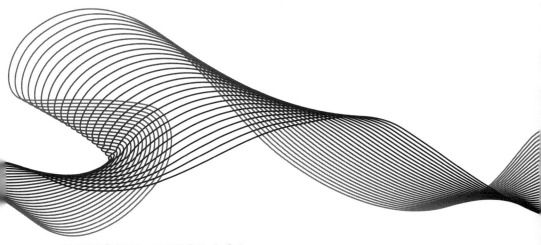

BEYOND BITSLAG*:
INTEGRATING MUSEUM
RESOURCES ON THE INTERNET

* "Bitslag": The useless dross one has to cull through
on the Internet to get to a useful "ore" of information.
(*Wired*, December 1995, p. 60.)

DIANE M. ZORICH
Museum Information Management Consultant
Carlsbad, Calif.

The Internet is an embarrassment of riches in both a complimentary and pejorative sense. It offers tremendous potential as an information delivery mechanism, but it is a chaotic environment that requires users to wade through its vast resources. Tapping into Internet resources is, to use the colorful metaphor, like trying to drink water from a firehose.

New applications and programming languages on the horizon will help alter the Internet's current operational paradigm and move it in a more "user-friendly" direction. However, technical enhancements alone won't spur a paradigm shift because the Internet's underlying problem is sociological. The Internet offers a wealth of information with a dearth of context, and information delivered in this manner is difficult to assimilate. It can be compared to weather reports by state that give little sense of nationwide meteorological trends. People continue to place their content on the Internet at record pace with-

out integrating it with resources that already exist in this environment. The Internet is developing into a massive information resource that yields data, not knowledge. Its chaotic nature will worsen until content providers place their information in the context of a larger (or smaller) subset of related information.

As more museums become content providers on the Internet, they need to ask what they can do to offer context that will add true value to their content. How can museums usefully contribute information in a networked environment? How can they participate in a way that distinguishes them from other providers? What are museums currently offering on-line? Will these offerings need to change? How will participation in a networked environment change museums? The answers to these questions suggest that museums can fill a unique niche on the Internet as context providers for cultural heritage information.

WHAT MUSEUMS CURRENTLY OFFER ON-LINE

A museum's mission and operations focus on housing, protecting, and interpreting collections. Museums always have been insular in these activities, perhaps because title to collections is vested within individual museums, perhaps because museums have a philosophical perspective that treats objects as "unique" entities. Whatever the reason, museums might best be described as (to borrow a term from the computer industry) "standalone" institutions that function independently from one another. Their staff attend professional meetings to discuss common issues and belong to professional organizations that represent common museum interests. But institutions do not operate collaboratively.

As museums venture into a networked environment, they continue to do so as "standalone" institutions. The

irony here is that the Internet is steeped in traditions of partnership, cooperation, and community among groups. It is a collaborative medium. By situating themselves in this environment with such independence, museums greatly underutilize the networking capabilities of the Internet. To coin the terminology made popular by Nicholas Negroponte,[1] museums are transferring themselves from the world of atoms to the world of bits. But are they distributing those bits in the most parsimonious manner across the networks?

As more museums develop an on-line presence, the novelty of the experience is giving way to fundamental questions about the role of museums in a networked environment. Enough time has passed and enough museums have gone on-line for distinctive patterns to emerge among museum on-line sites.

At a fundamental level, museums use the Internet as a marketing tool. On-line presence is a de facto method of promoting a museum's collections, programs, and other offerings. In this respect, the site functions as a networked version of a museum's general brochure. Museums have been very successful at using their sites for promotional purposes. Their rich content (audio, visual, textual) makes for some of the more attractively designed sites on the World Wide Web, and museums have been cited as a model for the corporate sector in this regard.[2]

Another distinctive characteristic of museum sites is their use of a "tour" metaphor to provide an experience equivalent to a visit to their institution. Images of collections and some associated documentation are arranged in a manner that gives a visitor the opportunity to browse through the highlights of a museum's collections. Some museums extend this metaphor by providing "virtual

tours" where entire galleries are presented, giving an impression of being guided through specific rooms in a museum.[3]

More recently, museums are offering information and materials that support their pedagogical mission. Many sites now contain educational materials for users[4] and curricular materials for teachers.[5] A move towards more interactive (rather than referential) sites also is apparent. The most common means museums use for achieving interaction with users include discussion lists, on-line guest books, and chat forums. A few museums support and foster the creation of new material by offering artists or students "digital venues" for developing and exhibiting their work.[6]

All these efforts have helped museums reach new audiences on the networks. Indeed, museum sites are among the most popular of all on-line sites, and are routinely the recipients of on-line awards programs.[7] The popularity and reach of museum sites, as evidenced by direct comments and site usage statistics, have surprised even seasoned museum professionals.[8]

WHAT MUSEUMS NEED TO OFFER ON-LINE

The success museums have experienced in their on-line forays is deeply satisfying and provides powerful evidence of worldwide interest in and audiences for museums. But museum sites still follow a "standalone" model that may not succeed much longer in the on-line environment. As more individuals and organizations become information providers on telecommunications networks, the power of any single site risks diminution. Each site continually must offer a "fresh look" and new information to lure visitors. Users' expectations of sites are rapidly rising, as reflected by a slew

of new jargon that disparages "stale sites" and "dead links."[9]

Futurists tout the Internet as an environment where "every user can be a producer." The reality behind this aphorism is that information of questionable value receives the same space as valuable information, and a potentially harmful backlash is emerging as a result. "Filters" are being developed to prevent certain groups from gaining access to certain information. Employers are monitoring their employees' on-line time and site usage.[10] A series of books and articles have appeared questioning the value of the "information superhighway" and the trends it is following.[11]

This backlash is symptomatic of the problems that the Internet's exponential growth and development have created in terms of information overload. As economist Herbert Simon notes, information "consumes the attention of its recipient. Hence a wealth of information creates a poverty of attention, and a need to allocate that attention efficiently among the overabundance of information sources that might consume it."[12] Perhaps this is why "browsing" the Internet has been the modus operandi of users to date. Browsing is an effortless undertaking in an information-rich but organizationally poor environment.

Searching, on the other hand, requires real tenacity because the process is cumbersome and serendipitous. There are two basic search strategies on the Internet. In the first, a user identifies a pertinent site (discovered by "surfing" or hearsay) and browses through it to find links to other potentially useful sites. The second strategy is to use one of the popular search engines that are available on the Internet (e.g., Lycos, WWW Crawler, InfoSeek).[13] These engines use different search algo-

rithms and cover different data sets, but all of them initiate their search with user-submitted keywords and return a list of sites that contain those words. The user culls through the query results to identify those sites with potential, and visits each of the candidate sites to look further for information. Often the search results are ambiguous and the user must visit all the sites listed to determine their relevancy. Occasionally a user arrives at a particular site listed in the search results and finds even more links to other sites that were not identified by the search engine.

This entire process is time consuming, redundant, and distracting. Users often find they have viewed so many sites that they cannot remember how they arrived at any particular place in the process. A meandering search path may be tolerable in libraries or archives, where the amount of material is smaller and the pace of searching is less disorienting. But in a networked environment, where information is abundant and delivery is instantaneous, the process becomes so overwhelming that it hinders information access. How can this problem be rectified?

Cyberspace pundits might answer that the Internet is missing the appropriate "killer app" (short for "killer application") that addresses a need with indispensable functions and features. E-mail has been given this appellation, and, more recently, the World Wide Web. Certainly these applications have had an enormous effect on the growth of the Internet and are important to those who use them. But as the Internet grows exponentially, the real "killer apps" will be those that gather unstructured information (like the documentation on most museum collections) without regard for location and bring this information to users without requiring them to

search across dozens (or hundreds!) of sites. The holy grail for the Internet over the next few years will be applications that integrate on-line resources.

Internet resources currently are "linked" rather than integrated. Users navigate the links one at a time to get to a given place. Links are a useful mechanism for tying together information, and in this sense a "web" (as in World Wide Web) is an appropriate analogy. But to get information from the entire web, a user must search each strand. With the increasing growth of information on the Internet, this strategy will no longer be feasible. Not only will relevant information be missed, but the time-consuming nature of the task will outweigh any possible benefits received in the results.

By contrast, integrated Internet resources would allow users to search across sites without navigating through each individual resource. Instead of a web, a fabric would be a more appropriate analogy. Each warp and woof of a fabric is interwoven, and the entire piece is examined to identify relevant segments. Because users wouldn't search "link by link" across sites, the process would be less time consuming and less disorienting. Users would not move from site to site to get information; instead, information would come to them from a universe of sites. They wouldn't need to visit or even know where the information physically resides.

INTEGRATING ON-LINE RESOURCES: THE POTENTIAL

Integrating on-line resources would yield enormous benefits for museums and the communities they serve. Outlined below are some scenarios that illustrate where the benefits could be realized.

BENEFITS FOR MUSEUMS

Exhibitions are a major function of museums that consume considerable financial and human resources. The entire exhibition planning process could be accelerated and streamlined if exhibition staff had access to integrated collections information. Designers could identify materials from other collections to complement their own work on a planned exhibition, or could identify institutions for collaborations in joint or traveling exhibits. If exhibition schedules were integrated, institutions could organize their own schedules to take advantage of complementary exhibits occurring elsewhere. Integrated access to exhibition histories would allow staff to obtain better background information before developing their own exhibits. In short, exhibitions could be organized and developed in a broader sphere that takes advantage of economies of scale and offers better planning to attract larger audiences.

Exhibit staff also could be the primary agents in integrating museum information on the networks by developing on-line exhibits in collaboration with other institutions. Exhibits that could not take place within a museum because of overriding logistical and financial complications could be offered in this new environment. On-line audiences could gain entrée to these on-line exhibits at one site and view materials that actually exist in many locations. Consider exhibitions like the recent Johannes Vermeer exhibit at the National Gallery of Art and the Mauritshaus.[14] This exhibit was so popular because it brought together Vermeer's works for the first time in a retrospective show. Unfortunately, comprehensive exhibits of this nature are prohibitively expensive and administratively difficult; thus they are relatively rare. A Vermeer enthusiast has already created an on-line exhibit of the Dutch master's work.[15] Although no one would

suggest that viewing the art on a computer screen compares in any way with seeing the real thing, on-line exhibits of this nature undertaken by groups of museums could be an occasional alternative to the costly enterprise of mounting and traveling such exhibits to various venues. And by bringing together works under a common theme, on-line exhibits help integrate similar resources from different institutions.

Museum catalogers also would benefit from access to integrated museum information on the Internet. Cataloging is a time-consuming activity that requires research and identification. If catalogers could search for similar objects from other collections, they could accomplish their own tasks by gleaning the collective knowledge in museum catalog records. The entire level and quality of the field of museum cataloging would improve by sharing resources.

Museum research also would benefit. Perhaps the biggest stumbling block for research involving museum objects or records is identifying and locating appropriate materials. When relevant materials are identified, they often are distributed across wide geographical areas. If researchers could identify relevant materials by conducting their initial searches across collections information on the Internet, they could reserve their limited financial and time resources for on-site work at institutions shown to have the most essential materials for their project. Research projects that might have been shelved because of cost and time factors could become viable again if integrated access to collections information increased the pace of research and decreased its costs.

Conservators, too, would benefit from integrated access to collections information. Access to conservation treatment plans from other institutions, which often become

part of the object record, would help conservators when they confronted unique problems with particular collections. And access to disaster recovery information and assistance could prevent the dire consequences that often follow emergencies.

Museum educators could develop programming that draws on the collections of the world's museums to round out and highlight their own institution's holdings. For educators in small or isolated communities, integrated access to collections information would help bring the world's cultural and natural heritage to their audience in a way currently not possible. Educators serving ethnically diverse populations could have broader access to collections that reflect various heritages and thus offer richer programming opportunities. Museum educators in Los Angeles, for example, could develop programming for their Latino communities using resources from museums in Mexico. Educators in San Francisco could serve their local Asian communities by "using" collections in Asia and the Pacific Rim. Geographic distance and limited resources currently prohibit such opportunities, but if museum collections could be searched integratively on the networks, they would become commonplace.

A chief advantage for curatorial staff would be greater accessibility to worldwide collections. The role of curator, as traditionally defined, requires an awareness of related collections at other institutions for collection development, context, and interpretation. Curators currently gather such knowledge through experience and hearsay. If they could easily search collections resources on the Internet, curators would have access to a more comprehensive pool of knowledge.

These scenarios offer an admittedly optimistic vision of how museums could profit from integrated on-line

resources for their own operations and activities. In each case, integrated access to museum information on the Internet would leverage museum staff and financial resources. The collective knowledge of museums could help develop and expand each institution's activities. The economic incentives might also spawn a proliferation of collaborative activities among museums that could belie their reputation as standalone institutions.

BENEFITS FOR AUDIENCES AND CONSTITUENCIES

Museum collections are underutilized by teachers unaware of their existence and availability, and museum staff cannot support the outreach needed to "teach the teachers." Even teachers who routinely use the Internet to locate materials for their curricula rarely use information from museum sites. According to one mentor teacher involved in the Global Schoolhouse Project,[16] teachers do not know what museums have made available on the Internet and do not have the time to search extensively to find out. If this is true, the dispersed nature of museum information on the Internet is a liability for museums who wish to encourage the use of their collections in school curricula. Integrating this information throughout museum sites would be a useful service that could yield increased use of collections in classrooms.

As more students turn to the Internet to gather information for their studies, museum collections could become important primary source material. Access to museum information in an integrated rather than piecemeal fashion would encourage students to use museum information in their studies. Students who use museum resources on the Internet might also be motivated to visit museums to see the actual objects they cited in their studies.

There is reason to believe that the general public would benefit from better integration of museum resources. As many on-line museums attest, the response of the general public who visit museum sites is surprising. Feedback and follow-up questions are voluminous, suggesting that the general public wants additional or different information than museums currently offer in their programming. In 1995, one popular site reported over 600 follow-up requests per month from individuals who visited it on-line.[17] Museums need to cultivate such a level of sustained interest if they want "repeat" visitors. Integrating an institution's offerings with related resources on the networks may be one way to nurture and sustain this interest.

The media and publishers use museums for information and would likely use them more often if they could be assured of a better return from their inquiries. Publishers favor stock photo houses because they allow users to access large collections of images through a single source. If the media and the publishing industry could access museum collections in a more integrated fashion, cultural institutions might reap greater exposure, use, and increased revenue.

Another area of unexplored potential is interdisciplinary studies. Every museum has anecdotal stories about individuals from various disciplines conducting illuminating research on institutional collections. If museum information were more accessible on the Internet, interdisciplinary collaborations of all sorts would likely emerge as people found new uses for it.

INTEGRATING ON-LINE RESOURCES: THE PROBLEMS

Several important issues must be addressed by the museum community before it can realize the potential of inte-

grated access to on-line resources. Some of the more important challenges are:

1) AGGREGATING A CRITICAL MASS OF DIGITIZED COLLECTIONS INFORMATION

The museum community has no mechanism in place for comprehensively converting collections information (both text and image) into digital form. Individual museums that are converting their content into digital form do so for specific internal operations or institutional programs. As a result, digitized museum information exists only in disparate, isolated batches. Until the museum community undertakes a systematic digitization project, collections will be available on-line only in a piecemeal fashion.

Two projects currently are underway that explore options for developing a critical mass of digitized collections information. The Museum Educational Site Licensing Project (MESL), a joint effort of several museums and universities,[18] is testing one model—the licensing of museum images—to generate demand and revenue that could be used to finance the further digitization of museum resources. The Library of Congress's National Digital Library Program, an effort to identify and digitize a large corpus of the library's holdings, is exploring another model that relies on resources procured from the federal government and the private sector.[19]

The museum community needs to examine these projects closely as they progress. In particular, the community needs to give greater consideration to public- and private-sector support in this age of diminishing federal funds. Support from the federal endowment programs has provided seed money for digitization in individual museums, but they have not offered a comprehensive program that addresses the larger, community-wide need. The

task falls squarely upon the museum community to find an economic model through partnerships and collaborations that will provide the resources for developing digital content.

2) DEVELOPING AND IMPLEMENTING STANDARDS FOR EXCHANGING MUSEUM INFORMATION

Standards protect the long-term value and investment made in data from the vagaries and forces that affect hardware and software development. They ensure that data can be migrated to new systems when old ones become obsolete, and that data can be exchanged across heterogeneous systems for purposes of sharing information. For museums to share information in a networked environment, standards are required in the following areas:

Data Structure: Unstructured or diversely structured sets of information cannot be directly exchanged without errors and confusing results. Anyone who has ever transferred data from one type of database to another has experienced firsthand some of the problems that surface. Rather than impose one structure onto all museum information (an unrealistic and limiting solution), information should be formatted according to a technical framework that allows exchange in a networked environment.

The Consortium for the Computer Interchange of Museum Information (CIMI), a group that is working to solve problems relating to the electronic interchange of museum information, has adopted Standardized General Markup Language (SGML) as the technical standard best suited for structuring museum information. Widely used in the publishing industry, SGML allows museums to structure text and images so they can be searched like a database and presented in myriad ways. Museums

do not need to alter their information to store it in SGML format, and information formatted as a SGML document can be exchanged without regard to hardware or software setups at either the user's or receiver's end.

Using a common standard like SGML for structuring museum information is critical if museums are to develop and share integrated resources. But a standard for cohesively exchanging information across systems is only part of the solution. Museums also must be able to search across databases without having to access—or even know about—the hardware and software that support those databases. For example, a user should not need to know Paradox database commands to access information in a Paradox database, or use an IBM computer to search for information stored on a IBM computer. CIMI has adopted another technical standard, ANSI Z39.50, as a means of searching and retrieving in a networked environment without regard for the hardware/software used to store or access information.

The CIMI Consortium is demonstrating SGML and Z39.50 in a pilot program entitled "Project CHIO: Cultural Heritage Information On-line." This project, slated for completion in 1997, will incorporate multiple data types using a single interface that allows access to collections data regardless of the hardware or software systems used. The consortium is using folk art collections from its member institutions as testbed data, and is reporting its progress on this project on its World Wide Web site.[20]

Data Values: Data value standards identify the terminology and/or formats used to record data in a particular category. The format for recording a date (e.g., December 25, 1995, 12/25/95, 25/12/95), or the terms used for recording an honorific (e.g., Ms., Mr., Dr., Rev., etc.) are two examples of how data value standards are

applied. These standards enforce terminological consistency within and among databases and thereby support information-sharing among institutions. Unfortunately, most museums have not considered data value standards used by other disciplines. This oversight means that museum information cannot be easily integrated with the data now being placed on the Internet by other disciplines. Museums inadvertently may be locking themselves out of opportunities to enhance their information resources with content available from other non-museum sources.

More important, the function of data value standards is expanding now that museums are placing information on networks. These standards can provide integrated access to the dispersed information resources of museums. Data value tools such as authority lists, thesauri, and classification systems can be used as mediating search tools on the networks. A user's query can be run through an intermediary authority file, thesaurus, etc., where equivalent search terms are selected and used to send multiple queries (one for each synonymous term identified) to the source databases.[21] Users need not know a "proper" term to get information from a source, and information sources do not need to be cataloged according to "proper" terms to be searched. Queries could be made using everyday language.

For museum professionals who have labored over data value standards, this new function would eliminate many of the problems that have hindered standards projects in the past (i.e., disagreements on classification systems or object-naming conventions) and that have prevented successful information retrieval. Synonym identifications could be a powerful and less political way to access information. More pilot projects that use data value standards for network information retrieval are

needed to test these assumptions on museum information sources.

3) UNDERSTANDING THE AUDIENCES FOR MUSEUM INFORMATION

Museums need to have more information than the user demographics that most Internet surveys reveal. They need to know what questions people ask of museums, how they search for information, and how they wish to see the results presented. Information requirements vary by constituency, and museums must learn who their online constituencies are in order to prioritize and scale their information accordingly. If museums don't learn what users' needs are, primary audiences will conclude that museum information is not useful and won't visit museum sites.

The Getty Information Institute, in collaboration with CIMI, has begun investigating these issues. Their project, "Points of View," is investigating whether solutions developed for public access to museum information will, in fact, satisfy the public. The project will gather information about the questions audiences ask of museums, determine what people use museum information for, assess the tools currently used to search cultural heritage information, and explore the relationship between user expectations and their understanding of museum resources.[22]

The National Museums of Scotland's "Catechism Project" reports that the current presentation of museum information is too structured and theoretical, and that this setup discourages access by the general public.[23] Collections databases, for example, are invaluable to museum staff but do not convey information in a format that satisfies general audiences. To meet the needs of an increasing number of on-line users who wish to search

for (rather than browse) information, museums need to know much more about the questions that their network audiences ask and how users want information presented.

RECENT EXPERIMENTS THAT INTEGRATE MUSEUM RESOURCES ON THE INTERNET: PROOFS OF CONCEPT

The issues that must be resolved before museums can successfully integrate their on-line information are complex and daunting. Nevertheless, the heritage community has launched several projects to test the feasibility of integrating diverse information sets and accessing them in new ways. Some of the more innovative projects currently underway are discussed below.

1) THE GETTY INFORMATION INSTITUTE'S "A.K.A." TOOL

`http://www.ahip.getty.edu/aka`

The Getty Information Institute's "a.k.a." tool uses the structured vocabularies in the *Art & Architecture Thesaurus* (AAT) and the *Union List of Artist Names* (ULAN) to search across four of the institute's databases of bibliographic and research data in art and architectural history. It uses these data value standards as intermediary tools to simplify and enhance searching across disparate information sources on the networks.

Using a form available on the institute's World Wide Web site, users search for information in any or all of the databases using terms of their choosing. By using a suite of tools, the system matches the user's search terms to any of the matching terms in the controlled vocabulary resources (i.e., AAT, ULAN). The end result is that users can initiate a single search using their own terminology to retrieve information from four large and disparate databases. The user's search terms are "filtered" through

the structured vocabularies to yield a better search result than would have been possible if the tool had searched solely on the user's terms.

One of the added benefits of Getty Information Institute's "a.k.a." model is that non-experts may search "specialist" databases more effectively since they do not need to know specialist terminology. A great deal of "intellectual capital"—the ideas and research contributors have provided over the years—is invested in specialist databases. Thanks to such tools, databases are easier to use, become accessible to new audiences, and leverage this intellectual capital in new ways.

The "a.k.a." is an important experiment that tests the concept of whether and how diverse information resources can be integrated across the networks. It uses several tools—the World Wide Web, WAIS (Wide Area Information Service), vocabularies, and databases—in a unique attempt to improve access to diverse information resources that exist in this environment. The Getty Information Institute plans to continue this experiment by testing whether more structural tools, such as the *Categories for the Description of Works of Art*,[24] can be used as filters or overlays to yield even more useful results when searching among scattered network resources.

2) THE CANADIAN HERITAGE INFORMATION NETWORK'S (CHIN) NATIONAL INVENTORY PROTOTYPE

http://www.chin.gc.ca/

The Canadian Heritage Information Network is an agency in the Canadian government's Department of Canadian Heritage. Its mission is to develop a comprehensive inventory of Canadian museum collections and provide services that assist Canadian museums in using information technologies to broaden access to their information. CHIN maintains the Canadian National Inventories, which com-

prise three major databases in the humanities, natural sciences, and archaeological sites. Over 25 million objects and 80,000 archaeological sites are represented in these databases. CHIN also has developed and maintained a series of reference databases widely used by museum professionals and others in the heritage community.

Although CHIN has been providing integrated resources of Canadian museum collections to its clients since its founding in 1972, it has done so as a centralized service bureau. (Information was collected from Canadian museums, and access to this information was provided to clients through a centralized computer system.) Recently CHIN reviewed its programs and adopted a new mandate to "broker access to Canadian and international heritage information for public education and enjoyment and for the collective benefit of Canadian museums."[25] As part of this reorientation, CHIN is now distributing its integrated resources on the Internet and has begun a development program that experiments with tools that will make these resources more accessible in a networked environment.

CHIN clients now access the National Inventories and other reference databases from the Internet using standard Web browsers instead of database language. Like the Getty Information Institute, CHIN is exploring the use of tools such as structured vocabularies (e.g., AAT), search engines, and context studies to provide better access to their information. One goal is expanded use of the information in the National Inventories beyond collections management into areas such as public programming, education, and research. As a result of its new mission and reorientation, CHIN is switching its focus from data to tools that enhance access to data.[26]

CHIN's on-line site illustrates the potential of distributing resources on the Internet. The National Inventory

Prototype is a CHIN project that will demonstrate common access to distributed information. As currently planned, the prototype will be a collective resource concerning Canadian museums, their collections, exhibits and events, and information relevant to the international heritage community. The current prototype with text and images has two linked sections: the Humanities National Database and the Guide to Canadian Museums. The former allows access to museum object information in collections across Canada; the latter offers information on Canadian museums, their collections, and their activities.

Unlike the Getty's "a.k.a." project, CHIN is not integrating disparate databases that already exist on the networks. CHIN's databases are integrated by virtue of design and evolution from a centralized system. Rather, CHIN is using the Internet's distributed network model to develop a collective resource of Canadian heritage. And, like the "a.k.a," CHIN is exploring new ways to access information, with the goal of making their resources more accessible to traditional and new audiences. This strategy not only expands audiences but leverages the investment Canadian museums have made in constructing these resources in the first place.

3) THE FISHGOPHER, FISHWAIS, AND MUSESERVER PROJECTS

```
gopher://gopher.keil.ukans.edu/11/
      fishgopher
http://muse.bio.cornell.edu/taxonomy/
      search_fish-wais.html
http://muse.bio.cornell.edu/taxonomy/
      fishsearch.html
```

The natural history collections community has been an advocate of integrated access to biological databases for years.[27] Several museums and repositories recently have

collaborated in projects that integrate ichthyological collections databases using the network capabilities and tools of the Internet. The MUSE Project, along with the National Science Foundation and participating museums, has been the impetus for these projects and continues to sustain them in varying ways.

The FishGopher Project uses gopher, an Internet lookup tool that allows users to retrieve select information via menus. FishGopher fans out searches to 11 databases on fish collections at various institutions. The results are returned to the user in menu form, with each menu item "hyperlinked" to a specimen's catalog record.

FishWAIS uses WAIS (Wide Area Information Service), another Internet tool that searches across databases like gopher. But WAIS is more powerful because it does the searching for the user and brings the results back to her. (Gopher requires the user to search through a series of menus to locate relevant information.) FishWAIS searches text versions of the databases of eight ichthyological collections and returns the results en masse.

MUSEServer provides real-time searching of ichthyological databases located at four repositories. Each of the participating repositories has cataloged its holdings in MUSE, a software program developed for natural history collections. MUSEServer uses the World Wide Web as a seamless delivery vehicle for queries and search results. MUSEServer sends the query to each of the institution's in-house servers, gathers the results, and presents them to the user as if only one search took place. Thus, to the user, the four databases appear as one. Although the search results clearly identify which institution contributed the information, users do not have to search each of the four databases and combine the results—MUSEServer does this for them.

Search results consist of catalog records that are further hyperlinked by specimen number or field number. These "links" allow a user to retrieve more data on a particular specimen, or search for additional specimens retrieved from the same collecting event (e.g., site, expedition, etc.). One MUSEServer search option (by genus and species) even plots the results on a map of the United States, providing an immediate visual representation of where the specimens were collected.

These three projects present "staged" levels of access to multiple ichthyological collections based on an institution's information technology resources. Because it is easier to make a database available via gopher, 11 repositories have done so. MUSEServer requires more capabilities; consequently, only four of these repositories participate at this level. As an institution develops its own internal resources, it can migrate to a higher-level access tool.

Each of these projects uses different Internet tools to provide simultaneous access to large data sets. Of the three projects, MUSEServer is the most powerful because the databases are designed according to a similar data structure, and the information is delivered using the World Wide Web. In addition, MUSEServer offers a value-added component to the information in its map-oriented display of genus/species search results. This innovative feature provides the user a new way (via a visual representation) of comparatively interpreting information from disparate sources.

SUMMARY

In an age of diminishing support by governments and citizens, the Internet offers a way to revivify cultural institutions and elevate the world's cultural heritage to greater prominence. To use this medium effectively, museums

must begin to integrate their cultural heritage information on-line. Doing so lets museums leverage their diminishing financial and human resources by giving them access to the collective knowledge that has accumulated around their holdings. They will broaden their audience and expand the potential of their collections' information. Equally important, they will create a shared resource that offers unprecedented access to a large portion of the world's cultural heritage.

Museums offer collections, information, and context to their audiences. These are desirable assets on the Internet. But as Internet usage expands and more individuals and institutions become information providers, there is an increasing need to integrate the wealth of information that is available on-line. Museums could position themselves to do this for cultural heritage information and thereby carve out a useful niche on the network frontier. Unfortunately, in their initial forays into a networked environment, museum on-line sites have concentrated on presenting institution-specific information. This approach will not be tenable for long. Users of on-line information are demanding better (versus more) information, and Internet usage is moving from "browsing" to "searching." Accessible, integrated resources will be in demand as these trends continue.

Museums need not fear that their institutional identity on the Internet will be compromised in the process of developing collaborative relationships with their peers. For years, libraries have cooperatively integrated their resources without diminishing their institutional importance. Indeed, integrating resources has not only helped libraries leverage resources, but has given them a unified voice that is well respected in educational and political arenas. For museums, integrating networked

resources is an opportunity to use their status as cultural icons to forge a larger role as purveyors of cultural heritage information. Museums must seize this opportunity, or it will assuredly be undertaken by those who diminish the purpose and ignore the potential of cultural heritage to society.

ACKNOWLEDGMENTS

The author thanks Katherine Jones-Garmil of the Peabody Museum of Archaeology and Ethnology, Harvard University; James Bower of the Getty Information Institute; Gail Eagen, Bruce Williamson, and Patricia Young of the Canadian Heritage Information Network; and Dr. Julian Humphries of the Cornell Vertebrate Collections and The MUSE Project for advice, discussion, and comments on select portions of this manuscript.

REFERENCES

1. Nicholas Negroponte, *Being Digital* (New York: Alfred A. Knopf, 1995).

2. Robert A. Duffy, "Art Museums and High Culture on the World Wide Web." Paper based on presentation at the National On-line Meeting, New York, May 1995. On-line version available at

```
http://www.stratcom.com/webzeumz/
      artmintr.htm
```

3. See the Michael C. Carlos Museum

```
http://www.cc.emory.edu/CARLOS/
  carlos.html
```

for an example of a museum that has set up an on-line "tour."

4. See the Palmer Museum of Art

```
http://cac.psu.edu/~mtd120/palmer/
```

or the Science Museum of Minnesota

```
http://www.sci.mus.mn.us/
```

for some examples of museums that have developed on-line educational activities.

5. See the Minneapolis Museum of Art

`http://www.artsMIA.org/`

the National Museum of American Art

`http://www.nmaa.si.edu/deptdir/edusub/`
` learning_mat.html`

or the Franklin Institute of Science

`http://sln.fi.edu/tfi/units/units.html`

for some examples of museums that have developed and placed curricular materials on-line.

6. See the Whitney Museum of American Art's Artists World Wide Web Projects

`http://www.echonyc.com/~whitney/WMAA/`
` weblinks/webart.html`

or the Computer Museum's Computer Clubhouse

`http://www.net.org/clubhouse/index.html`

for some examples of museums that support and foster the creation of new material on their Web sites.

7. See the "Best of the Web" awards at

`http://botw.org/`

GNN's "Best of the Net" awards at

`http://bin-1.gnn.com/gnn/wic/botn/`

and Point Survey's "Web Awards" at

`http://www.pointcom.com/`

8. Joan Stahl, "Pointing and Clicking to NMAA: One Museum's Experience with a Consumer Network," *Spectra* 22, no. 2 (1994): 16-18.

9. A "dead link" is an obsolete hypertext link to another information source or site. A "stale site" is a site with information that is out of date.

10. Laurie Flynn, "Finding On-line Distractions, Employers Strive to Keep Workers in Line," *The New York Times*, Nov. 6, 1995, p. C6.

11. See Clifford Stoll, *Silicon Snake Oil: Second Thoughts on the Information Highway*, 1st ed. (New York: Doubleday, 1995); Sven Birkerts, *The Gutenberg Elegies: The Fate of Reading in an Electronic Age* (Boston: Faber and Faber, 1994); "What are We Doing On-line?," *Harpers Magazine*, August 1995, pp. 35-46.

12. Hal Varian, "The Information Economy," *Scientific American* 273, no. 3 (September 1995): 200.

13. Infoseek

```
http://www2.infoseek.com
```

is a trademark of Infoseek Corporation.
Lycos

```
http://www.lycos.com
```

was developed and is copyrighted by Carnegie Mellon University.
WebCrawler

```
http://www.webcrawler.com
```

was developed at the University of Washington and is now owned by America Online, Inc., but remains a freely available Internet search tool.

14. Johannes Vermeer exhibition, National Gallery of Art, Washington, D.C., Nov. 12, 1995-Feb. 11, 1996; Royal Cabinet of Paintings Mauritshaus, Den Haag, Netherlands, March 1-June 2, 1996.

15. "Clickable Vermeer." World Wide Web site developed by Roy Williams Clickery. URL is

```
http://www.ccsf.caltech.edu/~roy/
    vermeer/index.html
```

16. Carla Schutte, Global Schoolhouse Telementor. Personal communication, November 1994. The Global Schoolhouse Program

`http:/www.gsh.org`

connects schools across the U.S. and overseas to demonstrate the use of the Internet in the K-12 environment. Classes work cooperatively over the Internet on projects and common curricula.

17. Information conveyed by Betsy Broun, director, National Museum of American Art, while speaking of her institution's on-line site at a roundtable entitled "Art Museum in a New Medium," sponsored by the Getty Information Institute and held at the Association of Art Museum Directors Annual Meeting, June 14, 1995, Baltimore.

18. The Museum Educational Site Licensing Project (MESL) is a collaborative initiative of the Getty Information Institute and MUSE Educational Media to develop methods and guidelines for the academic use of digitized museum materials at colleges and universities. Representative museums, colleges, and universities will define the terms and conditions for educational use of museum images and information on campus-wide networks. For more information about MESL, see the Getty Information Institute's World Wide Web site at

`http://www.gii.getty.edu/gii/muse.html`

or contact MESL Project Manager, The Getty Information Institute, 401 Wilshire Blvd., Suite 1100, Santa Monica, CA 90401-1455.

19. See "The National Digital Library Program," a special issue of *Library of Congress Information Bulletin* 54, no. 12 (June 12, 1995).

20. For more information on CIMI, see its World Wide Web site at

`http://www.nstn.ca:80/cimi/`

or contact John Perkins, CIMI Project Manager, CIMI Consortium, RR1, 252 Viewmount Drive, Tantallon, Nova Scotia, B0J 3J0 Canada.

21. David Bearman, "Strategies for Cultural Heritage Information Standards in a Networked World," *Archives and Museum Informatics* 8, no. 2 (Summer 1994): 93-106.

22. Jane Sledge, "Points of View," *Multimedia Computing and Museums: Papers from the Third International Conference on Hypermedia and Interactivity in Museums* (Pittsburgh: Archives and Museum Informatics, 1995), pp. 335-346.

23. Helen McCorry and Ian O. Morrison, "Report on The Catechism Project" (National Museums of Scotland, Edinburgh, 1995).

24. *Categories for the Description of Works of Art* is a project of the Art Information Task Force, an initiative sponsored by the Getty Information Institute and the College Art Association to define an intellectual structure (i.e., data structure) for information used to describe works of art and images of these works. It is available on-line at

`http:/www/ahip.getty.edu/gii/dcwda/`

25. Barbara Lang Rottenberg, "Brokering Access to Heritage Information: Chin's Strategy for the 90's," *Hands On Hypermedia and Interactivity in Museums: Papers from the Third International Conference on Hypermedia and Interactivity in Museums/Annual Meeting of the Museum*

Computer Network (Pittsburgh: Archives and Museum Informatics, 1995), pp. 123-130.

26. Patricia Young, Canadian Heritage Information Network, personal communication.

27. Some early efforts are reported in the following documents: "1994 Workshop in the Infrastructure Requirements and Design Considerations for a Federation of Botanical Specimen Databases," University of California–Berkeley, June 9-12, 1994; 1992 "Needs and Specifications for a Biodiversity Information Network," proceedings of an International Workshop held at the Tropical Database, Campinas, Brazil, July 26-31, 1992, 265 pp.; Association of Systematics Collections, "An Information Model for Biological Collections," 1992; Report of the Biological Collections Data Standards Workshop (draft), Aug. 18-24, 1992, 99 pp.

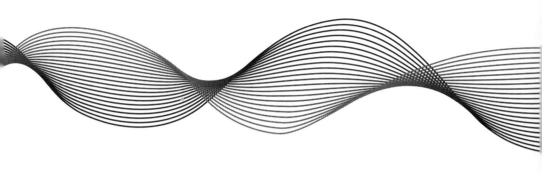

INTEGRATED INFORMATION SYSTEMS

JAMES R. BLACKABY

Senior Systems Developer
Office of Technology Initiatives,United States Holocaust
Memorial Museum, Washington, D.C.

Integrated information systems for museums—the combination of object databases, library data, archival data, audio-visual materials, maps, research files, and educational materials all mixed together like primordial soup—have been an elusive goal of information managers for years. They appear perennially on the wish lists of registrars, curators, educators, and museum administrators. Software vendors make gestures toward this goal, promising a "seamless, integrated package" or "total system integration," as well as the benefits of the Internet and beyond. Grant-funded initiatives for computerization often tout the extent to which they will enable the exchange of information. Years of effort in the area of museum information standards have yielded everything from *Nomenclature* to the *Art & Architecture Thesaurus*, from the *Common Agenda for History Museums* to the recently published *Categories for the Description of Works of Art*. Such efforts have been directed at "providing a single, encompassing structure for descriptive information about works of art . . . [to] enhance the compatibility of diverse systems that wish to share information,"[1] in the words of the most recent of them.

The researcher or visitor who asks anything more complicated than "What is accession number 93.2.1?" or "When was that painting last on exhibit?" assumes that there is an information system supporting the collections and that it can integrate information that might exist for particular objects, might reside in archives, might be filed along with research notes, or might simply exist as general knowledge. Simple questions such as "What is the oldest piece of upholstered furniture that you have from coastal New England?" or "How did the paintings that were being produced by her classmates and teachers at the academy affect her work?" or "Were attack dogs used by the Nazis?" turn out to be very difficult for museum information systems to answer. That difficulty stems partly from a lack of integration in these systems.

If the staff wants it, vendors tout it, foundations fund it, and visitors assume that it is in place, then why doesn't it exist? Is it the hardware? Is it our data? Is it the software? Is it *us*? It will come as no surprise that the answer on all counts is a resounding "YES!" Understanding how each of these factors discourages integration will help move museums toward truly integrated systems. Remarkably, solutions *do* exist; integrated information systems can be made. They are even easy to make, and they are not terribly expensive, all things considered. But they raise a whole host of questions that we may not be ready to answer without first considering the obstacles presented by hardware, data, software, and ourselves. This discussion therefore addresses the problems and opportunities associated with each of these four areas before describing one possible solution and commenting on its strengths and weaknesses.

THE HARDWARE

If computers were the only hardware that we had to be concerned about, there would be no substantial difficul-

ties in trying to make an integrated information system. Data stored on IBM compatibles can be read by Macs, UNIX systems can communicate among themselves, fast connections with wide band width are available, protocols for exchanging information far and near exist, and networks of all kinds are available and increasingly familiar. Fitting all of the parts together may not be easy. Frustration can set in when you try to find the proper driver for the proper operating system, or get the printer to work, or find a cable with the right combination of connections at either end. Often the person who can fit the parts together is not someone who is or ever will be on the museum staff. However, insofar as it is possible to connect computers together, it is possible to integrate systems.

But computers are not the only hardware that museums have to deal with. In the broadest sense of being physical structures that contain or convey information, the file cabinets, the curator's desk, the document boxes, the naturalist's logbook, the educator's cart, and maybe even the curator and the collections manager themselves can be considered hardware. Though a museum may dutifully measure and record the location of each of its blacksmithing tools, for example, actual information about blacksmithing is likely to be in a file folder in the educator's office or in the curator's reference files. An artist's name might be appropriately recorded for each of his or her works, but other information about that artist might be available in an article stored in a file folder, distributed among notes made by a researcher, typed on a wall label now removed to a storage area for old exhibit furniture, or be only indirectly available by reading a selection of letters stored in the archives. The common and scientific name for a unique species of a rhododendron collected from a Japanese island may be recorded in a database, but one might need to read the field notes in order to discover the sto-

ry that makes the specimen important. In these instances, if we wanted to know something besides "How big is this tool?" or "What is her name?" or "What is this object called and where was it found?"—disparate information that could be successfully integrated with computers—we would be disappointed. And in a significant sense, our disappointment would be the result of incompatible hardware.

File cabinets were designed to contain and, incidentally, to sort information; computers were designed to sort information and only recently to contain it in quantity. Quite appropriately, museums have used different information management tools to perform different tasks. Vertical files have articles, notes, research materials, and narratives; computers have counts and measurements and locations. The assumption has always been (and this is appropriate as well) that there would be an interpreter of some kind present to take materials from the various systems—file folder, photo box, notebook, and computer record—and thus offer a fully informative view. If an "integrated system" is intended to take on some of this burden without the intermediary interpreter, then consideration needs to be given to how materials currently stored in non-electronic form can be made accessible. Recounting the results of searching a number of databases in the United Kingdom for a particular query, Edmund Southworth concluded that "it will be some years before on-line systems offer direct access to significant amounts of unmediated collections data. In the meantime those of us who want real information will need real curators to interpret the data for us."[2] This "real information" is maintained in too many different hardware systems to be easily accessible or integrated.

Until museums begin to expand the definition of "hardware" to include repositories of information apart from

computers, a truly "integrated" information system will continue to be elusive simply because much of the most useful *information* has been stored for so long outside the realm of computers.

THE DATA

Integrating data from various parts of a museum necessarily involves considering the form of the data as well as its content. Matters of form—which data elements are to be included in the integrated system and how they will be identified—tend to be dictated by the type of material in the component to be integrated. Libraries and archives that adhere to MARC formats may be more readily integrated than museum objects, which may depend on less rigorous formal models. Object collections are notorious for their quirky fields in spite of general agreements. Matters of content—the data stored within those fields—tend to vary according to the nature of the collection. Art museums may be apt to rely on standard works like the *Art & Architecture Thesaurus*, and natural history collections on standard taxonomies. Integrating these resources depends on developing strategies to resolve these form and content issues. Some of these resolutions have been addressed, some could be addressed, and some of them pose real problems for an integrated information system.

Many of the issues relating to the form of data might be resolved with "mapping" equivalents. Library materials have authors; this is the equivalent of object makers. Library materials are categorized by subject; objects can be similarly categorized.[3] In some instances, equivalents don't exist. Library materials usually lack object names (they are books by default), and objects don't have a number of pages to be recorded. These differences are relatively minor.

Of more concern for integrated systems is the increased complexity inherent in accommodating all of the possible data elements. For example, a relatively simple inventory database of prints at the British Museum was critiqued as follows: "For all its undoubted advantages, the sophistication of the [inventory system used for prints and drawings] entails a complexity which renders it rather user unfriendly. To get the most out of it, the user must be aware of and follow through numerous sequential functions. There are strict rules of syntax which must be adhered to in order to get at the information It would not be possible for a researcher to come into the Students' Room and begin to use the computer unaided. What does happen is that the Students' Room curator will retrieve the appropriate data and display it on the screen."[4] A walk through the exhibition hall at a museum meeting to look at collections software, or a review of data dictionaries and MARC categories, reveals that considerable expertise in the form that data takes and the way it has been entered is required to get answers out of information systems, integrated or not. From the point of view of the trained cataloger, data elements such as "Interpretive History" or "Subject Matter" suggested in the *Categories for the Description of Works of Art* or the "Linking Entry Complexity Note" of a MARC record are important distinctions. From the point of view of the untrained researcher, these distinctions stand in the way of discovery.

For an integrated system, the complexity may become unmanageable. Consider a data element such as the role that people or organizations might play in reference to an object. For library materials, publishers, editors, translators, authors, and illustrators are apt to be recorded in any of several fields. For artifacts, the fields are not even standardized, so the variety of places that a user might have to look to find a particular reference is even greater.

Photographs might have people as subjects, as well as people as photographers, and so on. Anyone using such a complex system must spend more time learning the system than retrieving information.

Not too surprisingly, data content poses an even broader array of problems, but they can be traced to a lack of well-developed tools rather than a lack of direction. There are many procedures and mappings that can be done to "normalize" data from different parts of an integrated system. For example, the formal place name construction that is displayed for MARC records can be linked to the more casual place records typical of other resources that might be included in an integrated system. Thesauri such as the *Art & Architecture Thesaurus* enable related data to be connected. While some of the tools now in use need to be extended, the use of such tools is sound, as far as it goes.[5]

The real problem with data content in integrated systems is the value of the data themselves. Many information management systems are intended to be storehouses for things known rather than tools for developing new ideas. The Catechism project carried out at the National Museums of Scotland addressed the nature and utility of questions put to museum information systems. Among other things, the study concluded that "serendipity is more important than pinhead accuracy in providing answers."[6] Museum and library information systems, especially those in libraries, are designed not so much as tools for creating new, serendipitous knowledge, but as ways to categorize existing data. "Who was the publisher of such and such book?" is a question that leads the questioner to the place where someone has already stored an answer—*the* answer, in fact. That is true of most queries that museum information systems allow, even those that are calculated, such as "How many

pieces of furniture are there in the collection from before 1700?" The particular answer might not have been stored, but the answer will be the direct result of what had been put in ("X items have been recorded") rather than derived from new knowledge.

The lack of potential for serendipity is not unique to integrated systems, of course, but the implication of integrating in the first place is that new combinations of data may actually lead to new insights. If not, the combination simply offers a structure to discover what lots of people have tucked into cubbyholes rather than what just a few people have tucked into cubbyholes. Certainly, one way to encourage serendipity is to begin to accumulate the stories that surround the objects—usually in the form of simple text notations—rather than simply the fielded data.[7] This notion goes beyond the way museums usually think of data, and it involves the incorporation of many more unstructured data elements than is usual in museum information systems.

THE SOFTWARE

If the following represents the information structure that must be realized, then there are several possible solutions to the software problem:

Individual databases	Black box in which integration occurs	User with questions
Objects	Something that	User interface
Library	mediates between	software that lets the
Archives	individual databases	user pose questions.
	and the user.	
	This probably has	
	facilities for processing	
	queries, etc.	

Individual databases could:

- all be written in the same language using the same data formats. (Those who propose using MARC formats—perhaps with extensions—are thinking along these lines. While this is an interesting idea, it is not likely to happen, in part because MARC is good at tucking away remembered facts but not as good at accumulating all kinds of materials for serendipitous discoveries.)

- be written in similar languages that could be queried at the same time using something like SQL (Structured Query Language) or ODBC (Open Database Connectivity) entered from the user side. (This is the most commonly discussed approach, but for the moment it remains very unwieldy and not terribly secure. For example, if the user knows enough about the data structure to ask where things are, why can't he ask what they are worth? To prevent this requires fairly elaborate field locking techniques.)

- be written just as they are now to suit the needs or perceived needs of the individual museum collections (or more usually to reflect what the market offers or what the museum ended up with). This approach assumes that the problem of integration need not be addressed on the level of individual databases.

The user interface could:

- involve considerable knowledge of the data sources and the answers they might serve up so that fields known to exist in the data sources could be selected, and values known to exist in the look-up tables or standards that underlie the individual databases could be accessed. (If this were the case, then query processing would occur on the user side.)

- not depend on knowledge of the data sources at all. (Initially, this may be desirable, as the goal is to provide information rather than teach about how the data resources are organized.)

- offer a blend of data-structure-driven aspects as well as more general queries. (Without a real implementation, this is hard to imagine, but consider a blend of being able to ask for any maker with the name "Smith" rather than all items in the combined data sources—as maker or donor or owner or object name, even that had the name "Smith" associated with them in any way.)

The black box could

- perform certain normalizing functions (such as dealing with upper and lower case so that "Tapered Legs" and "tapered legs" would be found in the same query; or dealing with where words start and end so that "tapered" would not be found in a search for "tape" or all things "red"; or deal with word stems so that "taper" and "tapered" would be found in the same search).

- operate in a Boolean fashion, as we are used to having our individual systems work (this, in fact, is not all that desirable if one is looking for serendipity).

- operate on a probabilistic model, returning items that probably would be interesting (this is great for serendipity, but not so good for narrowing searches or looking for things that were tucked away for later retrieval).

The problems here are that a single software for all aspects of a museum is unlikely, that the single interface to a variety of the data sources is beyond most users or data managers (if it is possible at all), and that black boxes are, well, black boxes.

THE PERSONNEL

Problems of hardware, data, and software may be difficult, but with persistence and willingness, solutions can be found. The real challenge in creating integrated systems is a human one. Holders of museum information, whether curators or registrars or even exhibition specialists or educators, are often reluctant to relinquish control over their data. Where records are thin but curatorial knowledge is not, the records make it seem as if not much is really known by the staff. Where records are complex and filled with information, the budget-minded are reluctant to simply "give away" the work of the staff. Not uncommonly, there are errors in data—everything from simple typos to incorrect information. Without the mediating interpreter, these errors are apt to be presented to the uncritical public as fact, or at least as a measure of the care or carelessness of the staff.

A further obstacle is the reluctance of one department to mix its data with that of another, either because its data are "better" or "not as good" as the other's. Reasons for this can be complex. There may be records created by certain researchers that are considered suspect. Multiple systems for keeping track of information may have been employed. To the untrained eye, there may be no clear demarcation between objects that have been fully "cataloged" and those that have simply been identified and inventoried. Departments may simply be unwilling to acknowledge the methods of others, or they may be threatened by the loss of individual, departmental queries that can be counted and used to verify that staff members are busy answering questions. Information management is not devoid of pride and politics.

Compromise among information managers, a sense of a common goal, vision, and wise leadership may go a long

way toward overcoming these difficulties. But an integrated system is different enough to be threatening. The human obstacles, not the technical, are the most difficult to overcome.

ONE SOLUTION

In 1994, the United States Holocaust Memorial Museum (USHMM) was given the opportunity to participate in a National Science Foundation project that joined educational, industrial, and governmental groups together to test a free-text search engine called Inquery, developed at the University of Massachusetts' Center for Intelligent Information Retrieval (CIIR).[8] The Library of Congress was also a participant, and it seemed like the Inquery engine might be worth testing with the USHMM's information. Though the possibilities offered by the program or the approach to information have barely been tapped, the experiment has been successful, and the result has been an actual working integrated system that was developed with comparatively little effort, is maintained even more easily, and goes far beyond what most people had thought possible in museums. The problems of hardware, data, and software, and even personnel have been addressed in ways that sidestep many of the pitfalls noted above. These areas will be discussed in turn, but a few words about the Inquery search engine will help those not familiar with such tools.

A search engine is not much more than its name implies. A structure collects a question from a user and submits it to the engine. When it gets the question, the engine goes off on its own (following its own rules and logic) to consider the question in light of a warehouse of data, and then it returns with an answer, if it can. By comparison, the curator can be thought of as a search engine: you go to her with a question, she seeks the answer—

either in her memory, the files, the collection, or some warehouse of information—and then she gives you the answer. More formally, a search engine has some way to collect the material that constitutes a query, some way of posing that query to a mass of data, and a mechanism for identifying or displaying the answers. The current generation of search engines are based on some variation of indexing every word in every document included in their warehouse of data and then returning portions of the warehoused data that "probably" will be of interest to you.

Anyone who has used the World Wide Web has probably run across search engines. They typically utilize a little text-entry space for your query, and a list of possible answers are returned to you, each one "linked" to further information. The Library of Congress's catalogues and their index of the *Congressional Record* use the Inquery search engine. Web search utilities such as Yahoo, WebCrawler, and Infoseek use search engines like the Inquery engine. Though these search engines have been appearing with greater regularity as familiar parts of interfaces, their complexity beneath the surface of the little fill-in space and their expense have discouraged museums from creating them for their own systems.

Typically, search engines do things like ignore words of little consequence such as "the" and "but," and reduce words to stem forms, so that "painted," "paints," "painting," etc., are all considered in the search. Some, like the Inquery engine, give words different weighted values. A word that appears frequently within a set of data might be treated as being of less significance than a word that only appears now and then. Others, Inquery included, allow managing fielded data so that the more familiar Boolean searches on such things as "Accession Number = 83.2.14a" can be accommodated as well as all items

that mention "egg tempera." Search engines work by assigning scores to documents, based on the number of criteria that each meets. On this account, all kinds of very complex mathematical functions are available for analyzing data, such as testing for the occurrence of particular words within any window of four (or 40 or 400) words, or the occurrence of such words in particular fields. Additional weight might be given to some occurrences of words or phrases. These complexities may seem beyond the needs of museums. But consider that when searching for all items for which "ball" and "foot" appear within five words of each other, one is apt to find the piece of furniture described as "ball-footed" as well as the one described as having "legs ending with the foot of an eagle holding a ball" (remember, little words are ignored). This kind of fuzziness allows just the serendipity that the Catalyst project suggested was of value in museum information systems.

Learning to use the Inquery search engine has itself involved a fair amount of serendipity. The opportunities it has offered have solved otherwise difficult problems—those of hardware, data, software, and personnel.

THE HARDWARE (II)

While the USHMM may be more technologically sophisticated than many museums, it lacks the technological homogeneity that system designers long for. Most of the computers are IBM compatible, though there is a smattering of Macs. The servers are Unix machines, and there is a Novell network, though some things run on Windows NT. Some people use Windows 95, but most use earlier versions. But because the Inquery engine runs over the Internet and nearly every computer—local and distant, networked or capable of dialing in—can access

the Internet, differences of computer hardware are of little consequence.

Because the data that the engine plows through are simply textual data (insofar as all the material stored in other types of hardware could be made digital—oral history transcripts, books and articles, the newsletter, captions from exhibit labels, as well as more formal materials), it doesn't matter what machines are used to store them. Search engines will quite happily look through disorganized blobs of free text or neatly organized databases; they don't care. This does not entirely solve the hardware problem, but it goes far towards addressing it. The problem becomes one of rendering the data in digital form and connecting machines—whatever their type—to the Internet.

THE DATA (II)

One of the first implementations of the Inquery system at the USHMM was to combine the catalog records of the archives—developed with strict adherence to MARC standards and formats—with the free-text, collection-level descriptions of uncataloged materials, finding aids, and prose inventories of holdings. The merits of being able to search for all items having to do with "gypsies," whether they had been formally cataloged or not, were quickly apparent. Because searching can be done either on unformatted text or fielded text or both, the MARC records with their fielded data could still be searched alone (a search for all things with "Subject = Gypsy" would only select from cataloged materials, because the field "Subject" never appeared in the finding aids).

Even more useful from the researcher's point of view is the fact that all collections-related information that has

been stored following the methods of collections management could be searched at once: library records that follow strict MARC formats, photo archive records that follow a combination of MARC standards and objects standards, maps that have only a title paragraph caption, transcripts of lectures and oral histories, and even synopses of films. Instead of wandering from department to department asking for information about gypsies, a researcher could pose a single question and get a response from many collections at once.

It became apparent that the tool used to *gather* data— the MARC cataloging tool, the collections management database, the word processed transcript—did not have to be the same as the tool used to *sift through* the data. Of course, one needs to have searching capabilities in collections management programs to perform the very precise functions that such tools enable (pinpointing location, listing by artist name, etc.). But the more general business of asking questions is better served with a search engine that can (though it need not) break down the barriers that separate types of data, thus allowing natural language queries. Careful distinctions so important to collections management systems—"hand-crafted in" Greenfield, Mass., as opposed to "manufactured in" Greenfield, Mass.—get in the way of the serendipitous discovery of "all things from Greenfield, Mass."

The probabilistic search offers results, often unlooked for, that a person can quickly divide into significant and insignificant possibilities. Sharpening probabilistic queries with more traditional fielded queries produces even more interesting results. Indeed, the success of searching with the engine is such that problems of terminology control, geographic terminology, and name variants become the biggest impediments to getting answers, rather than the inability to resolve differences of structure and form.

But because the search engine is as happy to search on very long and complex queries as it is to search on simple ones, entering a whole string of variant forms for a city name, for instance, will bring back a good response even if different departments have followed different naming or orthographic conventions.

Note that the search engine does not and cannot solve all problems. Some queries, such as "things made between 1750 and 1833 in Rhode Island," are better handled by formally fielded databases. But as a complement to fielded databases and as a way of integrating disparate forms of data, the search engine is truly amazing.

THE SOFTWARE (II)

In the model of software discussed above, search engines clearly fall into the "black box" category. There are, on that account, two main issues having to do with software: converting data from disparate systems into a form that can be accessed by the search engine; and providing a workable user interface for input and output. Both issues require customized approaches.

The Inquery database uses SGML (Standard Generalized Markup Language) tagging to identify the beginnings and endings of documents, the occurrence of fields, and other administrative matters.[9] In addition, it supports the use of HTML (Hyper Text Markup Language) tagging to create documents used on the Internet. HTML is used for indentation, italicization, and various type sizes.[10] From a software point of view, the not-too-difficult task is to add appropriate tags to existing data sources. For documents like transcripts, this can be as simple as marking the beginnings and endings of the document and giving it a title. For more complicated data such as the relational data structure of a collections sys-

tem, it means outputting the fields and field names that are to be a part of the searched database and tagging them appropriately.

Among the advantages of this approach is that sensitive data can be omitted completely from the public databases. In addition, where library systems may have several ways of expressing "author," and object databases may have several ways of expressing "maker" or "artist," all can be combined under one general SGML field tag such as "Creator" for searching across many databases. This avoids compromising the careful distinctions of the collections manager with the needs of the less sophisticated researcher who simply wants to know how a thing came into being. In addition, data can be prepared and presented without the user having to know much about data structure (the fields are displayed, but need not be components of searches), or about codes and abbreviations that might have been used in the original database but which can be expanded in the Inquery text file.

A disadvantage of this approach is that the data available for the Inquery search engine are transferred occasionally from other sources. For very active databases, it may not be absolutely up to date. From the collections manager's point of view, a reflection of live data may be inadequate. For the researcher, however, or the general public, a searchable snapshot of the data that is even a month old may be perfectly adequate. The collections manager, however, has the active data in the collections application. If one reflects on the broad array of data stored in a museum, there is little change from one year to the next.

Creating routines that will harvest the appropriate data from the active data sources is only part of the software issue, and it is the part that is well within the reach of

most programmers (or at least something that can be contracted out as a finite project). The more complicated side of the software issue has to do with managing the search engine on its server, creating scripts that will gather and (where necessary) parse the queries, and deal with some of the subtler capabilities of the search engine. This aspect of managing search engines such as Inquery is at this time far from user-friendly. The programming of scripts and some of the development of internal management systems needs to be done in programming languages such as "C++." While the routines may not be terribly complicated, their design is left to the user. At the USHMM, the real utilization of the power of the Inquery engine came only after the arrival of a skilled Unix programmer on staff.

THE PERSONNEL (II)

People continue to be the challenge in realizing the possibilities of the Inquery engine at the USHMM. The challenges lie in the areas of the personnel issues of managing the databases, in making the data available, and in learning to be comfortable with the tool itself.

The programming required to make the Inquery engine work elegantly is not terribly complicated on the surface. The engine can generate self-reflecting queries on the fly, create hot links automatically to defining articles, and expand queries to include related words based on the engine's own analysis of the entire database. But the development of such elegance is dependent on a clear understanding of the underlying program conventions of these kinds of expert systems. In addition, while the idea of converting all data from whatever form they might normally take into HTML-tagged ASCII text files is straightforward, the reality is somewhat different. In spite of "standardization," in our experience at the

USHMM no two ASCII output files of MARC records were anything alike. Those who have experienced the frustration of trying to convert word processing files from one format to another with only limited success will appreciate that even the simple task of conversion, while trivial, was not as easy as one would have hoped. Additional headaches were caused by the fact that the USHMM has materials in languages that use not only the regular diacritics such as umlauts and circumflex accents, but crossed Ls or single dots and hooks above and below letters, all of which are represented differently in DOS than in Windows. Solving these problems required people who understand computers, operating systems, the kinds of data that museums and libraries keep, software packages, the kinds of questions that the public might need answered, HTML and SGML tagging, and more.

Because museum information, unlike the information in most other information-gathering enterprises, is so diverse, we cannot yet borrow easily from others. In time, many of the difficulties of this new technology will become trivial, because we can learn from one another. For the moment, however, the USHMM has had to depend on its personnel to realize the potential of these integrated systems. This is a difficulty peculiar to the situation of being first.

Less easily solved have been the problems of making data available. Again, some of the challenges here are peculiar to the situation of the USHMM. Where more traditional museums have spent years of curatorial, educational, and research effort building up original supporting research material—histories of place names, biographical details, descriptions of materials and techniques, and so on—the USHMM began with an exhibit and a backbone of research information that depended on many secondary sources. The result is that many

of the basic building blocks for any integrated system are made of materials for which the USHMM does not hold copyright and so cannot distribute over the Internet.[11] Again, in part because of the mission of the museum and in part because it is dealing with more contemporary materials than most museums, copyright for much of the visual material is held by others. For many museums, the most basic collections pieces are owned by the institution, and the choice to distribute or withhold visual representations of those items rests with the museum. For the USHMM, the necessary reliance on visual materials—photographs, films, and published materials—whose rights are held by others makes presenting them more problematic. These factors, coupled with the reticence to share noted in the general remarks on creating integrated systems, conspire to prevent the distribution of the integrated data in any but test circumstances.[12]

Finally, while the response of the general public to using the Inquery system on integrated data has been quite positive—they do find it easy to use and the results are generally satisfying and often delightfully surprising—there are human problems connected with having access to a tool like this. The most difficult has been that search engines show data from a very different perspective—all mixed together. The probabilistic search gives results that are unfamiliar—not just "right" answers, but likely ones. For those familiar with the data and the tools used to gather them, getting unexpected *(but not incorrect)* results is disconcerting. For most data managers, a query posed to an information system is intended to recover a piece of data that they had stored or they knew had been stored but could not find. They seldom have reason to pose "real" questions to their data. For most researchers and other consumers of data, the questions are real: "What do you have about gypsies in Poland?"

The answers, therefore, are perceived *(correctly)* to be real answers rather than a listing of something that had been put away somewhere.

CONCLUSION

The work that has been done at the USHMM suggests that integrated systems are achievable, and they are as interesting as one would hope. The obstacles of hardware and software can at least be put into manageable terms so that they can be solved. By choosing a single presentation of data and a delivery system separate from any of the programs used to record or manage the data, many of the data problems can be resolved. The human problems remain: rights to information, confidence in data integrity, understanding the kinds of answers provided by different systems, and understanding the questions that the public asks. But the approach is new, and it is appropriate that it should raise such issues.

The biggest problem posed by giving access to an integrated system is that it works as well as it does. And when things work well and questions are answered, this leads to new questions and a desire for more information. Researchers querying the archives catalog want to see the text of the materials referred to on-line, for instance. It may be hard for information managers to keep up with this desire for content. An interesting problem with the search engine is that its relentless search may give too much. A visitor wondering "Where is Treblinka?" is asking a fairly straightforward question that does not need to be answered with every reference to Treblinka in the system. The searching can be too thorough, returning more data than is desired or desirable. Similarly, because the system is based on natural language and frequently the language of cataloging is not

"natural," accommodation needs to be made for providing synonyms. The system is capable of knowing that the user who asks about "boys and girls in Poland" may mean the same as "youths in Poland," but it needs to be given the links to realize that capability. Similarly, while the system can accommodate multiple spellings for places or people's names, it needs to be provided with cues to use lookup tables as well as the data in those tables themselves. Fortunately, one of the powers of the system is to be self-referential, so that the database can be searched for the occurrence of words or phrases; these can be connected as needed. But these refinements only make themselves known after the data has been integrated.

Successful new ways of doing things are often seen as being the best ways of doing things. The Inquery engine may provide the best tool right now for integrating data. But it is a step on the way to somewhere else. It may be long lasting or it may simply be an interesting new perspective on managing museum information. One thing is clear, though. The approach really does work, and it does provide the kinds of access that vendors have been promising (but seldom delivering), that funders have been hoping for, that users have been expecting, and that administrators have believed curators and registrars could produce if they would just apply themselves. It even provides a kind of access to their collections that curators, registrars, and librarians sometimes need. For the foreseeable future, technologies like the one offered by the Inquery engine will provide the most effective and realizable access to integrated data.

REFERENCES

1. The Getty Art History Information Program and College Art Association, *Categories for the Description of Works of Art* (Getty Art History Information Program: Santa Monica, Calif., 1996). A special issue of *Visual Resources* (Vol. XI, nos. 3-4, 1996) prints the *Categories* along with supporting essays and other materials.

2. Edmund Southworth, "Hunting the Unicorn: An Experiment in Tele-research," *Information: The Hidden Resource, Museums and the Internet, Proceedings of the Seventh International Conference of the MDA* (The Museum Documentation Association: Cambridge, U.K., 1995), p. 68.

3. Note, however, that this is not simply a matter of equivalencies. Books and visual materials are usually given subject categories based on analysis of content (e.g., books about trains or pictures of locomotives); objects are usually given subject categories based on their use or history (e.g., curtains from a Pullman car).

4. Sheila O'Connell and James Hamill, "The Base of the Iceberg: Accessing the Treasures in Store at The British Museum," *Information: The Hidden Resource, Museums and the Internet, Proceedings of the Seventh International Conference of the MDA* (The Museum Documentation Association: Cambridge, U.K., 1995), p. 102.

5. Specifically, the hierarchies for named objects need to be expanded beyond those things relating to art. The clusters of identities by which individuals are identified need to be extended to include corporate bodies and social groups. Time needs to be added as a dimension to geographic systems. Other tools would be useful: a format for describing events that had time as its main axis,

an expansion of the work done to describe human activity reflected in the United Kingdom's *Social History and Industrial Classification*, and further efforts to provide multilingual versions of some of these tools, such as the bilingual *Classification System for Historical Collections*, a French-English version of *Nomenclature* developed by Parks Canada.

6. Helen McCorry and Ian Morrison, *Report on the Catechism Project* (Edinburgh: National Museums of Scotland), p. 3.

7. For an interesting instance of this, pointing to the ability of stories to completely overwhelm objects, see Lawrence Weschler's *Mr. Wilson's Cabinet of Wonder* (New York: Pantheon Books, 1995). Weschler recounts the objects and their associated stories exhibited at the Museum of Jurassic Technology in Culver City, Calif.

8. See the CIIR Web site at

`http://www.ciir.umass.edu`

for more information about Inquery and the activities of the center.

9. SGML (Standard Generalized Markup Language) tagging is a method of marking text by enclosing identifying features in angle brackets, as in " < TITLE > For Whom the Bell Tolls < /TITLE > ." When a document is viewed, the material surrounded by angle brackets is not displayed, but it is used in managing the text to identify the beginnings and endings of individual documents in a larger text file, to mark special features of text such as titles and fields, and to indicate text formatting. In an Inquery database, each "record," such as a book or object catalog record, is surrounded by tags indicating its beginning and ending. In that fashion, thousands of individual records are contained within a

single large file, but are separated by tags. Typically, SGML documents incorporate some kind of directions about how the tags are to be interpreted. On that account, SGML is very flexible.

10. HTML (Hyper Text Markup Language) tagging is a special set of SGML tags that is used on the World Wide Web primarily to indicate formatting: the expression < b > this is in bold type < /b > would appear in bold when read with a program that can interpret HTML files. HTML tags follow agreed-upon conventions so that anyone with an HTML compatible browser will see things that are surrounded by < I > and < /I > as being italic. HTML is less flexible than SGML because it depends on conventionally determined tagging rather than the very local tagging that SGML supports.

11. Here is a simple example of this. Most museums have some kind of artist/maker file with either a brief biography written by a staff member or materials that could be readily drawn together into a brief sketch that the museum could use in an information system, even if the figure were familiar, such as Thomas Eakins or George Washington. For the USHMM, the source for such basic biographical information is a single published encyclopedia. Again, most museums as a matter of course are continually adding to the core data—accumulating more notes in the biographical files as facts are discovered, for instance. But because the USHMM has an encyclopedia as the source for much of its core data, there is little practical need to enlarge upon that core, especially given the enormity of managing less central (but certainly not unimportant) research issues. As a result, the materials available for answering the most common questions (again using the example of biography) about Adolf Hitler or Raoul Wallenberg are not available for distribution. That leaves the integrated information system wonder-

fully well equipped for responding to inquiries about less central information—searching for the names of individual victims, for instance—but ill prepared to respond to the basic core concerns that may come first to the minds of the general public.

12. For test purposes, the collections of the archives, library, photo archives, film department, music department, objects collection, and transcripts of oral histories have been combined with the resource materials of a chronology, two published encyclopedias, several museum publications, and the museum newsletter very successfully into a single integrated system. At the time of this writing, only the library and archives data have been made available outside of the very limited confines of testing.

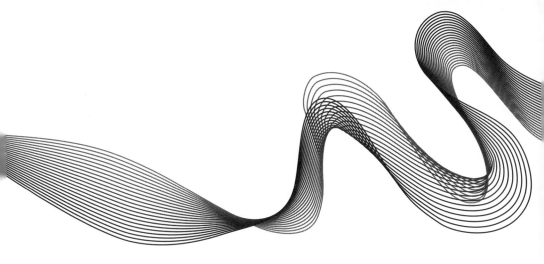

NEW ECONOMIC MODELS FOR ADMINISTERING CULTURAL INTELLECTUAL PROPERTY

DAVID BEARMAN

President
Archives and Museum Informatics, Pittsburgh

In the coming century, museums have the potential to draw large numbers of new visitors electronically. This could enable them to better realize their social role and might represent the difference between surviving as valuable educational institutions and being replaced by commercial infotainment. To realize the potential of electronic access to cultural heritage, museums and other cultural institutions need to better understand how to organize the exploitation of cultural intellectual property in digital form. This means they need to advertise the availability of their intellectual property to potential users and enhance the quality of their information holdings that are most desired by different market segments. It also means museums need to develop mechanisms to license their intellectual property and receive fair return for its use. And it means museums will need to exploit conduits, consisting of new technical and societal mechanisms, through which cultural properties can be distributed.

As a first step, museums, archives, libraries, and other cultural institutions holding unique intellectual proper-

ty need to create a means for educational institutions to use this information. This must be accomplished within the context of the copyright law and with benefits to both the collecting institutions—content providers—and the educators—content users. In 1994, the Getty Art History Information Program (AHIP) and MUSE Inc., invited a select group of museums and universities to cooperate in the Museum Educational Site Licensing Project (MESL). MESL was designed to test how site licenses might be used by museums to allow universities to access the museums' intellectual property—typically, images of a museum's art or other objects from its collections.

The MESL Project, which began in 1995, provides a test-bed for analyzing the economics of a future museum Rights and Reproductions Organization (RRO). Such a nonprofit organization would be administered by rights holders to distribute museum content for educational uses. In order to carry their collective activity forward after July 1997, when MESL is scheduled to end, the participants need to undertake research on the costs and benefits of such an organization. This chapter discusses issues that affect the economics of such new mechanisms and their ability to achieve the aims of cultural heritage institutions.

Ultimately, cultural institutions will need to extend the mechanisms they have created to handle non-commercial licensing to include commercial, mass-market demands for cultural intellectual properties in digital form. To date, museums, libraries, and other cultural institutions generally have been wary of aggressive suitors who are seeking to relieve them of their intellectual property in return for the promised financial rewards of a new global digital market. But the courtship has left some museum directors imagining that the digital pub-

lication and distribution environment of the next century will be a source of untold new wealth for their institutions. While it is too early to completely dismiss this optimistic presumption, it is not too soon for cultural institutions to identify the mechanisms they would need to realize some financial returns in a digital marketplace. Even with such a mechanism in place, I believe there is reason to doubt that museums, archives, archaeological sites, or libraries will find themselves on digital easy-street. But without such a mechanism I am quite certain they will not have a major role in the "re-presentation" of our heritage through digital communications, with adverse consequences both to these institutions and to the quality of the past we carry forward into our future.[1]

PART 1: THE CURRENT SITUATION

EMERGING DIGITAL SERVICES AND PRODUCTS

Museums, archives, libraries, and historical sites use limited and specialized means to convey their intellectual contributions to potential customers. They publish, but their publications rarely come from established publishing houses with broadly based distribution networks. They make films, videos, and interactive multimedia, but these products are rarely produced or distributed by entities with substantial market presence. They organize exhibitions, which occasionally travel but are held in specialized venues that attract only limited audiences. They license the use of images and reproduction rights for individual publications and commercial products, but the mechanisms through which these rights are negotiated and conveyed are so cumbersome as to prohibit the wholesale availability of museum digital content through popular distribution mechanisms such as CD-ROMs or public on-line services. And museums' educational arms

create numerous interpretive products and special exhibits that are rarely seen by anyone other than the teachers for whom they were initially prepared. In brief, cultural institutions have virtually no access to the mass market and their intellectual property rarely reaches mass audiences even third-hand.

Cultural institutions face two major challenges in making their information available to new digital consumers. First, they need to imagine and help invent information services that would use their content to reach educational and mass markets. Second, they need to forge the means through which potential consumers could effectively access that information. These two requirements must be satisfied in tandem. Reaching consumers with new services involves creating needs where none previously existed, or creating awareness of cultural intellectual property among people who don't even know about the institutions that house it. In either case, it means providing large numbers of potential customers with a means to interact with the museum. A third party, whether for profit or nonprofit, needs to have a large enough pool of information that is interesting to a broad enough audience to justify investing in the creation of a new information service.

Most museum directors today are aware of some of the new opportunities created by digital media. For example, cultural calendars could be delivered with airline tickets; travelers might want to know what cultural events are taking place in the cities they will visit. Providing such information could be of value to travel agencies or airlines to distinguish their travel arrangement services from those of competitors. But there would be little interest in providing such information unless a substantial number of cultural institutions across a country or across the world agreed to provide a regularly updated "feed"

for the information. At the minimum, a successful system would require some institutions from every major city within one country.

Another example is remote museum visitation from home. Pre-viewing, reviewing, or simply viewing exhibits at museums around the world might be a very desirable option for a cable company to provide to its subscribers as linear video on demand or as a full, interactive option. But there would need to be a library of considerable size from a variety of institutions and on a variety of topics to make the service economical. At the least, a certain similarity in the way exhibitions are presented and a library growing by 50 or so exhibitions per year (ensuring a minimum change of at least one new exhibit a week) would be necessary to create and sustain consumer interest.

Sharing of educational materials beyond the community in which they were developed is yet another example. School systems would love to have digital educational materials that classroom teachers could use to teach a range of subjects. But individual cultural institutions rarely have the holdings to produce a series of curricular materials on a wide range of topics. The market for resources developed from the holdings of a single museum is likely to be limited to the geographical region of that institution, making production of such a series uneconomical for the publisher.

Travel agencies, cable providers, and schools are only a few of the possible distributors for cultural content. It is relatively easy to imagine many equally valuable new distribution channels, but in each case, the need for collaboration among a relatively large number of institutions makes itself apparent. The underlying issue is always that mass markets, where cultural institutions

hope to find new profitability, require significant amounts of content from a single source of supply. In addition, such markets demand relatively low delivery overheads and assurance that substantial new and updated content will become available over time (and that information will come at least long enough to determine if profitability can be achieved).[2]

As a consequence, mechanisms to reach mass markets cannot be constructed by a single museum acting in isolation, no matter how important it may be. By their nature, museums, archives, and other cultural institutions preserve and interpret only a small, unique sub-set of the world's cultural heritage, and there is limited interest in presenting the specific sub-set held by any given cultural institution, however great its collection might be.

DYSFUNCTIONS OF THE EXISTING SYSTEM FOR LICENSING CULTURAL INTELLECTUAL PROPERTY RIGHTS

The current system for providing commercial and educational markets with access to cultural intellectual property is cumbersome. A potential customer must contact each museum, archive, or library independently, identify items of potential interest, negotiate for rights to reproduce these under specific circumstances, and then arrange to acquire a copy in a usable format. Unfortunately, the current system for assignment of rights to museum digital images is notoriously inefficient. At a recent conference in New York on intellectual property, developers of CD-ROM publications were advised not to bother trying to acquire rights from museums because the process was so costly.[3]

So what is wrong with the current system? Rights and reproductions management in museums, archives, and libraries is currently handled independently, without ref-

erence to the practices of other institutions or any orga-
nized means of cooperation. Each institution sets its own
fees, parameters for use, and methods of payment. While
the income from such licenses is appreciable, the vol-
ume of requests is such that staffing is often left to part-
time clerical help rather than to a trained full-time pro-
fessional. Cultural institutions typically have not devel-
oped sophisticated policies with respect to rights and
reproductions licensing, and few have any policy yet on
the licensing of digital intellectual property. Virtually no
cultural institution in the United States, for example, is
able to offer prospective "shoppers" a catalog, digital or
otherwise, of the image properties available for licens-
ing. There is no way to search across institutions, or
even within a single institution, from a remote location.
Because they do not see licensing as a mission of the
institution, many museums, archives, and libraries can-
not assure buyers that they have clear rights to the intel-
lectual property they offer. They may have clear rights
to the photography, for example, but not to the objects
themselves.

Educational users generally have received favorable
pricing—often so favorable that the transaction costs
to the museum granting the rights are not even fully cov-
ered. But historically, they either have copied images of
museum works from books (and imagined that their
doing so was allowed by fair-use exemptions) or taken
advantage of on-site photography policies of museums
and archives that allow researchers to take their own
images and then use these without restriction or pay-
ment of fees. In addition to the obvious disadvantage
of not earning licensing income, the system further
penalizes the museum or archive because educators do
not obtain the definitive documentation and interpre-
tation that the cultural institution would prefer to see
accompanying its images. Educators are also unaware

of how much additional information, including curricular material, bibliographic references, and links to other collection objects, could have been obtained through the museum.

For commercial users, the current system has been equally problematic. Historically, publishers have obtained rights to reproduce the images of individual items for which their authors have already done the picture research. The publisher is likely to have limited the number of images required, thus reducing the time and expense of negotiations; or even obtained less expensive images elsewhere; or relied on the museum's curators to arrange rights clearances, thereby indirectly charging the institution the major expense of the rights clearance process. Because digital publications typically will use many more images than traditional print publications, the impact of increased costs for rights acquisition on digital publications is much greater.

If cultural institutions could provide a viable means of licensing their intellectual properties, users would have at least four potentially powerful rationales for purchasing images from museums.

1) Although much image information is interchangeable, some things are definitely unique and can only be acquired from the source.

2) Museums and archives document provenance and write authoritative interpretations of the objects in their collections; this authority is of great value.

3) Cultural institutions have reason and resources to generate images of much greater quality than are typically available from commercial sources. In digital images especially, they have reason to include color bars and size (scale) data.

4) Museum data could be acquired with cleared rights.

Cultural institutions, however, often engage in activity that undermines these advantages. This can happen in the following ways.

1) Cultural institutions often compete with themselves by making it easy to obtain from other sources images of unique items in their collections. Past practices of distributing slides, allowing unrestricted photography of objects loaned on exhibit, or permitting on-site photography undermine the sole-source value of much of the content they are licensing. Commercial sources might obtain the same images from several sources.

2) Museum provenance and interpretive data are frequently withheld from image users, either explicitly or because such data are not being included in their orders. The value and authority of this information is often under-appreciated by the cultural institutions themselves.

3) Cultural institutions sometimes provide images that are of poor quality and do not include color and size bars. The original images from which the museum is working might have been taken for another purpose and do not show the work in its best aspect. Sometimes the negatives are old.

4) Museums in particular often provide images with uncertain rights and caveats about using them because they did not explicitly obtain the necessary rights when they acquired the original artifacts.

Because of the way in which the rights clearance and licensing systems have been operating, many cultural institutions have not obtained significant income from rights and reproductions activity. In some cases, the function has actually cost museums money. In addition, museums have paid for this inefficient rights clearance as part of exhibition catalog development and curatorial research. They have lost virtually any educational rights sales and

encouraged poorer quality images and data to be used for educational purposes.

Cultural institutions might look to the commercial sector to better understand the requirements for a new rights and reproductions licensing regime. In the commercial world, they would find three kinds of collective licensing structures: agencies that collect rights, brokers who represent rights holders, and cooperatives of rights holders who administer their rights collectively.

In each case, access is provided to a large body of intellectual property. In the case of domains covered by cooperatives such as ASCAP (American Society of Composers and Performers) or BMI (Broadcast Music, Inc.), access to all intellectual property rights of a certain type is provided through one source. Agencies and brokers, of course, provide a searchable catalog of the properties they administer. This is oriented toward users, and provides as many points of access as possible. Most important for potential licensees, each mechanism provides a unified fee structure or means of aggregating the rights fees and paying for a number of licenses in a single transaction.

For the image-rights consumer, an ideal system would support all phases of the transaction. Costs at each step would be minimized and all costs incurred could be paid in the end as part of the whole cost of securing the license. These costs include:

1) *Picture research.* The potential licensee should be able to search a database according to reasonable picture research parameters and preview images. When images are retrieved, the user will want to review the terms and

conditions for licensing them, calculate expenses based on the type of license desired, and order any that he wants.

2) *Cataloging.* The images should be delivered with complete documentation in a format that makes it easy for the user to build a catalog of images locally and to study the background information and interpretation.

3) *Storage.* A variety of digital formats should be available for each record, including highly compressed and non-compressed files, to facilitate storage.

Other advantages to the consumer should include clear per-item costs; a simplified payment method either by subscriptions, credit cards, or running accounts; and avoiding legal risk.

Museums, archives, and libraries are public interest organizations. Part of their missions is the role of preserving cultural content and presenting it to the public. This gives them an interest in being more than a simple source of image rights. Nevertheless, if they are to be a source of rights for digital images for educational and commercial users, museums will need to supply these images through channels that the markets can use. The requirements specific to cultural intellectual property management systems are, therefore, a hybrid of cultural institution values and market values including: image quality (scale/color), authoritative data, remote availability, ease of integration, searchability, local data manipulation, downloading, and printing.

The impetus for establishing such a new mechanism may derive from a negative: without such a mechanism, cultural intellectual property will be little used by the mass market and will not earn income for the institutions that care for them. However, designers of a new mechanism should seek to maximize the positive admin-

istrative benefits of participating in a unified licensing scheme. For example, obviating the need to refile negatives, thereby reducing requirements for master image restoration and replacement; relieving on-site use of the reference facility; and providing an income stream without per-transaction billing expenses.

The advantages to the cultural institutions of providing images digitally through collective means could also include:

1) Improved ability to monitor and report on all aspects of rights administration, and to track the use of the images.

2) Enhanced ability to target clients for related business, such as the sale of museum goods or particular kinds of outreach activity.

3) Access to a stream of income that could pay for first-copy costs and documentation overhead.

4) Reduction of time expended on conventional rights and reproductions activity, and, potentially, a reduction of staff working on this activity.

5) Greatly simplified bookkeeping.

PART II: ANALYSIS OF THE ECONOMICS OF A NEW SYSTEM, AS REFLECTED IN MESL

In the spring of 1994, at a meeting of museum professionals in New York City, the idea of a cooperative to manage museum licensing of digital rights to educational institutions was advanced. By the fall, a prototype with a three-year life was funded by the Getty Art History Information Program. Cultural content-holding institutions (museums, archives, and libraries) and universities were invited to submit applications to participate in what was called the Museum Educational Site Licensing Project (MESL).

MESL's organizing meeting was held in early 1995. By the fall, the seven universities involved had all received and made available to faculty and students the initial distribution of museum and library data.[4] Entering its second year of operation, the MESL prototype of a museum-to-higher-education site licensing project is a model in which many, though not all, aspects of the economics and technical requirements of a new system of distributing cultural intellectual property can be tested.

Before examining the issues and discussing MESL's potential as a system, we should acknowledge the respects in which MESL does not serve well as a model of the future. MESL institutions are not typical of museums or universities in the United States as a whole. They were consciously selected for the degree to which they were prepared to participate in the experiment. They are larger, better endowed, and more technologically sophisticated institutions. In addition, the participating museums are cultural history and art museums, and include no science centers or natural history museums. The educational institutions are all major universities and include no four-year or two-year colleges, to say nothing of school districts or private K-12 schools.

Despite these facts, a study of the costs and benefits of participating in a site licensing system can provide useful indicators of what the costs and benefits would be across a broader range of institutions. Using the data MESL provides, we hope to make a case for the concept of site licensing museum information for educational purposes, and possibly to demonstrate its benefits for commercial licensing schemes as well.

Baseline costs that need to be measured and collected for content providers (in the MESL case, museums and

the Library of Congress, but potentially archives, libraries, historic and archaeological sites, research institutes, parks, university-owned collections) include:

1) Degree of documentation of the collections, as measured by the percentage of objects having various categories of documentation; of photography; and of digital images.

2) Suitability of documentary products for digital licensing, as measured by the percentage of objects having in-depth documentation and/or interpretation; photography with color bars and scale indicators; high-resolution digital images; and clear rights.

3) Content investment, as measured by the estimated cost per object of documentation; photography (average number of images per object); and digital images (average number of digital images per photograph).

4) Infrastructure investments, as measured by the annualized cost of collections management systems (including personnel), and the annualized cost of network access (including personnel).

5) Digitization, estimated from expenditures of the latest three fiscal years.

6) Rights and reproductions management costs, as measured by the number of requests for rights and permissions from educational institutions, the average processing time for such requests, and the income (if any) from such requests. In addition, the time and money spent in acquiring rights from other museums, libraries, and cultural institutions for museum publications and exhibits.

7) Order fulfillment costs, including the costs of photography and documentation for items requested for reproduction. These costs might be presumed to be the same for analog and digital supply, but this ought to be examined, especially when including the marginal costs to the provider of infrastructure investments required solely for the delivery of digital images.

These cost measures for content providers should be off-set by the benefits of participating in educational site licensing. Measuring these benefits requires gauging attitudes within the cultural institutions and programs, particularly the value attributed to increased accessibility for local and remote visitors and researchers, and the potential this creates for attracting new categories of users, or providing existing users with new ways to exploit visual resource collections. Among the activity that should be measured is:

1) Increase in public use, as measured by the growth in electronic visits per annum (and possibly by increases in on-site visiting that follows from electronic contact).

2) Increase in staff use, as measured by the number of museum staff accessing the data and number of uses, and reduced costs to museum staff of internal access to their own image and data resources

3) Content availability, as measured by the number of objects with images available to electronic visitors, available via fixed media electronic publications and available over in-house network to staff.

4) Content preparation, as measured by the number of objects in MESL distribution published electronically by the museum and the number of objects for which electronic rights were granted to non-MESL uses in latest year.

5) Content improvement, as measured by number of feedbacks on MESL objects from educational institutions.

6) Income, as measured in reduced agency fees for photographic agency management and payments received for use of digital images and data in educational institutions and elsewhere, if the service becomes commercial.

The other side of the equation is equally important and can also be studied within the context of MESL. Baseline costs and benefits for content-using organizations,

when compared to costs and benefits of a new system, will ultimately determine the value of the site license to the educational institutions. This will determine the amount they would be willing to pay for participating in a broader site licensing scheme. Benefits that should be measured include:

1) Market "penetration," as measured by the percentage of courses using images, digital imagery from all sources, and MESL images; the percentage of students using images, digital imagery from all sources, and MESL images; and the percentage of faculty using images, digital imagery from all sources, and MESL images.

2) Use, as measured by the number of accesses to museum object data and the traffic in networked images downloaded from MESL.

3) Information resource enhancement, as measured by the number of items in the "library" catalog, including the number of digital representations of cultural objects (artifacts, specimens, slides) available on campus and the percentage increase in such documentation as a consequence of MESL.

3) Opportunity for distance education, as measured by the use of digital resources from the homes of faculty and students and the actual number of students enrolled in distance education programs using these materials.

4) Impact on cultural collections, as measured by the percentage of collection objects on campus made available digitally within the campus, and subsequently through site licensing to others.

Of course, these benefits have ancillary costs associated with them that need to be measured, including:

1) Increased end-user system requirements, as measured in the costs of classroom projection, student work station, laboratory, and library viewing or printing facilities.

2) Increased network requirements, as measured by costs of increasing bandwidth, storage, and speed on campus and the costs of supporting access beyond the campus to and from MESL.

3) Increased application support requirements, as measured in costs of creating or maintaining methods for access to digital libraries of object documentation.

In addition, the content-using institutions have established costs that might be increased or decreased by virtue of participation in a site licensing scheme. Some of these costs include:

1) Rights acquisition costs, as measured by current levels of requests for rights and permissions for educational uses of images, the present average cost of processing requests for permission, and their current average fee payment for such use.

2) Content acquisition costs other than rights, such as time and effort expended by the university to acquire visual information, the cost for potential users to acquire slides they need, including the cost of research by users to locate visual information.

3) Software licensing costs, such as site licenses for software tools with which to search, manipulate, or present MESL content and site licenses for similar or related databases used to create the augmented information resource.

4) Estimated marginal cost of adding new objects to MESL distribution.

5) Income produced through access to MESL data, services based on it, or software licensing to others using the content-provider's facilities.

There are aspects of a fully digital licensing system that could produce significant cost savings to educational institutions depending on how (or when) they switch over from a hybrid environment that needs to support both

present and future methods of serving image data. Areas of potential cost savings here include:

- Cost of maintaining slide collections, such as the space, equipment, and staff costs of current visual information management services.

- Costs of educational use, such as classroom equipment or data conversion costs incurred in providing copies of images for laboratory/reference use.

- Cost of infrastructure investments in delivery/presentation. Cost of liabilities, such as risk management, legal protection, or intellectual property violation insurance provided by the educational institution.

There are, of course, known costs of supporting the new environment as well, although again these might differ significantly from institution to institution based on different implementation strategies and architectures. Among those generally identified are:

- Cost of mounting or downloading site licensed data and the costs of serving that data on campus networks, including the estimated marginal cost of adding new MESL objects.

- Costs of teaching with digital resources, mostly involving the costs of training and supporting faculty using the resources in their preparation and presentation of instruction. Separately, one should measure the estimated marginal cost of an additional course offered by an instructor with prior experience teaching using these resources.

- Costs of capturing and transforming MESL data for campus distribution.

PART III: ISSUES IN THE DESIGN OF A FUTURE SYSTEM FOR CULTURAL INTELLECTUAL PROPERTY MANAGEMENT

The MESL project has revealed a number of systemic problems on the way to an integrated, end-to-end, user-responsive licensing service, whether limited to educational institutions or open to mass or niche commercial markets.

The most critical of these problems has been well known to museum and archives specialists for years and is only exacerbated by the digital environment: there is a tremendous lack of uniformity of existing source data, both text and image. The absence of standards in the documentation of collections, when compounded by the general chaos in imaging standards, creates a situation in which it is extremely difficult to compile a usable local resource of documentation from diverse sources.

The second problem has to do with the current lack of "critical mass." In the absence of an adequate amount of data from which to teach any given topic, educators need to have a "pull" mechanism by which they can make specific requests to content providers in order to acquire data not yet digitized. The complexity of maintaining such a mechanism for a large number of content consumers and providers is daunting, so MESL has adopted a "collegial" person-to-person model.

A third problem arises from the fact that MESL planners made a conscious decision to produce redundancy in order to promote a variety of competing solutions to the need for a "directory" server. Currently, each educational institution maintains a full collection of all licensed data on its campus and provides mechanisms to deliver data to campus systems. This will allow MESL

to examine costs and functionality of a variety of implementations and select the best for a future system.

Finally, the current implementation provides little place for value-added collections or interpretive packages, built on documentation of the individual artifacts in the database. After the first year of the MESL project, it became evident that such value-added products would be very desirable to some museum educators and directors, and may be critical for attracting elementary and secondary educators. But the cost analysis for introducing these has not yet been conducted.

The lack of uniformity of current sources means that either providers or users will need to assume certain costs. If providers are to bear the costs of uniformity, each providing institution will need to assume the costs of data recapture or reformulation, or the costs of constructing software to output its existing information in a uniform fashion. If users are to bear the costs of uniformity, individually or collectively they will need to develop software that exploits a variety of text and image formats. Experiments being considered within MESL will explore how well the Document Type Definitions (DTDs) developed by the Consortium for Interchange of Museum Information (CIMI) can serve for MESL data interchange. There is a general recognition that greater conformance with data standards adopted by CIMI, by the Museum Documentation Association (MDA)of the U.K., and by the Committee on Documentation of the International Council of Museums (CIDOC) would be desirable. But the reality, especially for a system that desires to add hundreds, perhaps thousands, of new content providers over the next decade, is a continued lack of uniformity or unification of data within agreed-upon standards. This will be a barrier to participation on the part of many potential contributors. To date, there has

been little analysis of the costs of achieving the degree
of uniformity we have achieved, because the only data
distribution to date was based on a newly agreed-upon
set of rules. Meaningful cost analysis will come with
experience in repeatedly providing data under fixed rules,
however much those rules require data reformulation
or recapture.

One troublesome element of the initial phase of MESL
is how to ensure that the contents of the site-licensed
library are useful or adequate for the educational pur-
poses of the users. When the library is relatively small,
as it is in the MESL prototype, potential users may be
prevented from using the resource because it lacks images
and data they require. In theory, this ceases to be a prob-
lem when the site licensing agreement achieves partic-
ipation from most providers. But even then most of their
content will not be digitized for many years. What con-
stitutes a "critical mass" is unknown, and we have yet
to devise a mechanism for ensuring that the future crit-
ical mass will be best suited for education purposes.
MESL ended up accepting individual user requests to
individual content providing institutions, but it is dif-
ficult to imagine this model working with hundreds of
participating institutions.

An expensive aspect of the MESL experiment was the
decision to encourage each content-using institution to
establish its own complete system for access to the con-
tent library on its campus. The intent was to gain expe-
rience both in the costs and complexities of this under-
taking, but it was recognized early that most content
users would not be able, or want, to maintain a com-
plete library with all the search software, especially once
the licensed body of material grew to include hundreds
of thousands of objects. The experience of MESL, which
collected all data from each contributor in one location

and redistributed it to each subscriber, was that such a redundant copy method of distribution is very expensive. Costs would have included media and mailing charges, mounting time and machine reading time on the receiving end, even if the process had been smooth.

Before a full-fledged system for site licensing can be implemented, costs of providing a directory server and on-demand downloading must be assessed. The relative costs of site licensing under such a scheme must be keep competitive with the costs of acquiring the digital resource from a commercial supplier, such as the Academic Press Image Directory, and paying a per-item fee.[5] Potentially, the value added by in-depth textual information might make the site licensing option more desirable, too. Alternatively, museums and archives will have to resist making their content available to educational institutions except through site licensing, in order to create the demand for site licenses.

Even with central directory services, the expansion of the site licensing approach to smaller colleges and to secondary and elementary schools will mean that many potential users would prefer access to pre-edited collections of resources, curricular packages, or interpretive guides, rather than to individual images without any added value. It seems unlikely that such value-added resources can be created simply from pre-existing textual resources, such as museum education packets, exhibition catalogs, catalogues raisonnées, etc. But certainly some types of integrative, multi-item, interpretive packages do exist already. Cost analyses will need to be conducted to determine if providing such information requires additional investment by the network, or if it could be included as a site licensing feature, giving the licenses themselves more value. Such packages could offset the costs of training faculty members to make their

own teaching packages. In addition, museum educators are always seeking larger audiences for their somewhat limited-use publications.

It would be difficult to determine which benefits of an end-to-end delivery and rights clearance system are most desirable to users without interviewing different participants in the overall licensing system. For example, administrators at museums, libraries, and archives—supplier institutions—have shown less interest in the potential to tap new sources of rights licensing income. They are more interested in extending educational activities beyond the groups reached by the education department, and in using resources brought in by licensing to make better visual and textual documentation of the collection. Administrators of educational institutions—the consumers—seem most excited by the opportunity to distinguish their institutions through acquiring greater digital resources, and by positioning their institutions to take advantage of distance learning.

Visual resources library staff seem to view the digital image as just another format of slides, which will co-exist with current image collections. They see the benefits of drawing from a larger universe of images, but I fear they may undervalue the textual information that comes with the images (both object documentation and contextual and interpretive data) and underestimate the long-term threat that widespread availability of digital images with secured rights poses to existing slide collections. Because of the legal risks, I anticipate that existing slide collections will largely be abandoned as sources for digital delivery.

Expanded use is a slippery but important benefit. At most universities today, faculty typically don't use images because image research is too expensive and complicat-

ed. To the majority of faculty, the benefits of the scheme would be to integrate visual resources into teaching. When they try, however, faculty will realize that many other infrastructure, training, and pedagogical issues are involved in successfully exploiting images delivered over the campus network. Students, whether graduate, undergraduate, or elementary and secondary, have little experience using images as research or source material. They rarely exploit images as part of their formal papers. To them, the benefits of these new resources may reside in the raw material they provide for multimedia formats, which is going to be a preferred mode of presentation.

Learning about benefits through open-ended interviews will be essential to the design of adequate and cost-effective services. It will help us understand the uses of a licensed image library, which include both where the image was used (in a lecture, a publication, an exam, or a dormitory) and the purposes (to illustrate a point, review classroom presentations, create a new image, test a technical assumption). Ideally, interviews would help define the estimated dollar value of using the image library, which, when combined with types of uses, could provide a measure of the overall value of the site license.

PART IV: MODELS FOR FUTURE CULTURAL INTELLECTUAL PROPERTY MANAGEMENT SYSTEMS

There are several models of what a future licensing environment for cultural intellectual property might look like. One model, being advanced by Corbis, Kodak Picture Exchange, and similar commercial interests, is the agency resale model. Another, being advanced by Picture Network International (the Seymour System) and Academic Press's planned Image Directory, might be thought of as the brokering model. A third, suggested in

outline by the MESL project and by DACS (Designers and Artists Copyright Society) in the U.K., is the cooperative of rights owners. The current system, in which the rights holders license rights on a product-by-product basis, could be regarded as a fourth model, but I have already said enough about its limitations and will not discuss it here.

In effect, these models produce very different results for rights holders and end-users, although they look very similar at the point of technical implementation. Each requires:

- the compilation of an inventory, or provision of distributed access to that inventory through a central directory
- cataloging of the available cultural properties, along with the documentation that surrounds and interprets them
- a means of searching the database and previewing the images and documentation
- a mechanism, consisting of dialog and contract negotiation or blanket subscription for rights clearance and licensing for the range of allowable uses
- methods for downloading the retrieved images and documentation once rights have been licensed for local use
- facilities for monitoring uncleared uses of licensable properties and for reporting on use when fee schedules are based on numbers of accesses

Let me discuss issues raised by each of the four models in turn, beginning with the agency resale model. In this model, rights holders contract with an agency to relicense their rights. The rights holders' fees may be paid as a fixed advance, as a royalty based on use, or as a percentage of income. But the agency makes the bulk of the profits in return for building the central library and pro-

viding the value-added access services and absorbing the re-licensing costs.

In the brokering model, the rights holders set their individual prices and collect income based on use, less the percentage for administrative fees charged by the broker. They determine what types of uses are allowable and do not grant re-licensing rights. Digital brokerage can work in either a centralized or distributed mode, with more or less of the costs of the license negotiation and fulfillment borne by the broker or the rights holder.

In the cooperative model, the rights holders own the licensing and distribution mechanism that is recognized in the laws of most countries as a special kind of entity (a Rights and Reproduction Organization), exempt from many anti-trust regulations, price fixing, and monopoly restrictions. The RRO absorbs its administrative costs as an overhead and distributes profits among rights holders according to an agreed-upon formula. This model's power derives from being the sole source of rights for a given kind of intellectual property.

In the product licensing model, which is today's approach, each rights holder negotiates with each producer separately. While the rights holder retains all the income and control, there is less of a market for rights than anticipated, because the burden of shopping for the correct images falls to the buyers. When compared to any of the three collective models, this approach raises many of the same issues: What are the economies of scale, and is there a point at which there are dis-economies of scale?

The agency and the cooperative incur relatively heavy expenses signing up rights holders and consumers. As a consequence, they will favor suppliers and users of

large quantities of data over those with small collections or single uses. Of course, the agency may incur the added costs of paying for rights up front, but this is not necessarily part of the model. The brokerage operates on an item-by-item level and incurs relatively high expenses tracking transactions. These expenses may also be incurred by agencies that pay royalties.

The agency approach may produce dis-economies of scale at a certain level of participation because of the present limitations of computing and networking technologies and because it is, by definition, a central system. The brokering model implies a central directory with distributed holding of the licensable content. The cooperative can employ both central and distributed approaches in response to technology constraints. The advantages to the centralized provision of rights and data are that both terms and data delivery can be standardized. The distributed model, however, will generally be implemented without such control, and indeed because central control is considered unacceptable.

The three models are also quite different in their ability to deal with competition. The agency model, having typically paid up front for rights, needs to sell them, and if necessary will do so by reducing the fees and trying to increase market demand. Its basic strategy is to create a mass market, if necessary by price-based competition. The brokering model is able to accept any amount of competition, as long as the rights holders do not offer the items they place in brokerage at more favorable rates elsewhere. The competition is between items in the brokered inventory.

The cooperative is sensitive to any availability of individual items from other sources. The classical RRO doesn't have any such competition. The MESL model,

if extended to include more institutions but still dependent on site licensing, would be vulnerable to item-licensing competitors (including the museums themselves acting outside the collective), because potential site licensees might decide to acquire items on an as-needed basis from other sources rather than subscribing to a full library at a fixed annual fee.

One of the uncertainties dealt with in any economic projection has to do with the size of the market for cultural intellectual property and the degree to which cultural institutions will participate in any of the proposed models. While it is virtually impossible to predict the market share that would be controlled by any of these potential systems, a model could incorporate an estimate of size of the licensable pool of data based on the percentage of institutions participating. At some point, the snowball effect of critical mass will cause a large percentage of organizations to join a working scheme.

In previous articles I've argued that cultural intellectual property will only succeed in earning money for museums, archives, and libraries if they deliver a quality of content beyond that which the commercial market is providing for general consumer infotainment.[6] One of the unanswered questions of the economic study is what such added quality would cost cultural content providers. The specific answer will have to wait until further analysis of which qualities would best differentiate the product from commercial offerings and add to its value, as perceived by consumers.

Each of the new models departs from the existing system by providing a central directory from which the contents of a large number of cultural heritage institutions are available, rather than requiring potential licensees to contact each institution separately. Each model involves

slightly different levels of fixed costs, however, for the maintenance of the central directory, because each implements the system in a different way. Under the agency approach, the central directory co-exists with all the digital contents. In the brokerage model, the directory is free-standing, and the contents are resident in each content-providing institution. In the cooperative as implemented under MESL, many copies of the full directory and digital contents are implemented (although a future MESL model is unlikely to perpetuate this redundancy for hundreds of institutions).

PART V: UNKNOWNS

One of the reasons the topic of electronic museum services is of critical interest is the widespread expectation of significant new money-making opportunities in the exploitation of digital information resources. It is anticipated that over the next decade consumers will increase the amount of money they spend on the acquisition of images and information from all sources. In part, it is suggested that this increase will be a consequence of shifting consumer expenditures away from material goods and toward products and services that merge information and entertainment. Whether such a shift in consumption patterns will actually occur, of course, is a huge unknown.

Nor is it possible to know whether the specific model adopted by a new licensing system would attract any of this hypothetical new money. There remains a lot of uncertainty surrounding just how licensed images and information might be distributed to the end consumers. The models most often discussed—fixed-media (such as CD-ROMs) publication, Internet services, and narrowcasting—involve different distribution systems and have different economic consequences. In the fixed media

business, the publishers acquire rights for products or titles and disseminate these in traditional "editions" to end-consumers. The number of end-user consumers will be restricted up front by the size of the edition. Publishers will be interested in acquiring large numbers of rights through a single system. In the Internet services model, end-users will largely be acquiring rights on an as-needed basis with the number of users exactly equal to the number of downloads. In the narrowcasting model, both push (publishers) and pull (on-line search) modes could exist, but the number of users will not be known except through audience-estimating methods. In any of these models, the per-image license fee needs to be very small. Only the purchase-as-needed model provides an opportunity to realize as much as $1 per image.

Another open question in the economic equation is whether the cultural sector will compete with itself. I believe that the holdings of cultural institutions, compiled as they were for scholars, are highly redundant from the consumer's point of view. Elsewhere I've described this by saying that individual holdings are fungible. If so, two unintended and undesirable consequences are likely. First, the prices that cultural institutions charge for licensing individual items in their collections will be driven down because the "same" items (from the perspective of the average non-expert) are available from another source for less. Second, cultural institutions will not be able to afford to digitize most of their collections because once they "skim" their holdings for the most salable properties, there will not be any profit in adding more. The concept of site licensing of whole collections was in part developed in order to defeat this economic barrier. It also has a major advantage for both the cultural content providers and users in that it encourages increased use of the resource. Increases in use reduce the unit costs (because annual

fees are fixed without respect to use levels), while in other models increased use translates into greater expense.

In addition, the entire premise behind capturing digital data for re-use by the market is impeded by a tremendous unknown: To what extent are digital intellectual properties re-usable? The premise behind digitally capturing images, sounds, video, and even text relating to cultural properties is that more than one user will be able to take the digital file and use it, or one user could use it in a variety of products. The problem with this concept is that we really know almost nothing about the costs of reconfiguring data for eventual publication or dissemination, whether in the traditional analog environment or the newer digital one. There are many reasons to doubt that any one method of capturing an audio-visual record of an artifact will be entirely appropriate to a range of different products. Should we provide a video file with rotation and close-up views? Or would multiple still images with a calculation of the movement between each be preferable? Should we shoot very high-resolution images, or are any of these larger files even worth saving? Among the things we don't really know are whether economies of scale could be achieved by any other means than capture—for example, in delivery or in post-production, through making choices about formats. We do know that different products will place a different value on the image(s), the tombstone data, the extensive curatorial files, or associated educational and interpretive materials. Of course, the cultural institution wants to encourage, or even insist on, use of its tombstone data and background documentation. This argues against pricing them separately, but perhaps pricing should be structured in such a way as to penalize those who don't use the cultural institution's interpretation.

Finally, the pricing of cultural intellectual property will be sensitive to whether it is being licensed for a long or short period, the types of uses to which it will be put, and its commercial value to the licensee. Public policy is also likely to enter the picture, because the provision of cultural information is considered a social benefit, and most countries are anxious to promote their heritage and identity. In addition, pricing will depend on ability to pay, which to some extent will depend on whether the new system replaces the old or simply lives side-by-side. For example, if digital image acquisition from agencies, brokerages, or cooperatives replaces the analog slide collections of universities, money will be released to participate in the digital market. But if the digital library lives side-by-side with current slide libraries, or even is managed by the slide librarian, then there will be fewer funds.

CONCLUSIONS

The development of rational systems for exploiting intellectual property is a major challenge for cultural institutions. There are experiments underway that help identify the critical intellectual, social, and economic issues, and that may help design a better cultural properties licensing mechanism. This chapter identifies many of the measures that will need to be taken in order to create a new economic system. At the same time, it identifies numerous unknowns and many areas in which chance and timing will probably play a large part. But it is crucial that cultural institutions begin to study the economics of these new technologies and the opportunities they present. Without such studies, museums and archives will be unable to price the licenses they sell or develop services using digital intellectual properties that reach the intended markets.

Concrete figures are needed soon in order to guide management of our cultural institutions between the shoals of two potential disasters. One is to lose control forever of digital intellectual property in return for the proverbial pittance. The other is hoarding it in a way that prevents many potential users from gaining access to it.

The first scenario is a real threat, judging by the flirtations between some museums and for-profit vendors over the past few years. It could result in the exploitation of cultural institutions and a violation of the trust invested in their management.

The second would ensure that cultural institutions of the next century play little role in informing the public of the dimensions of cultural heritage. It could inspire the infotainment industry to manufacture more ersatz heritage material.

A single study will not suffice; others will be needed. As cultural institutions move cooperatively towards the definition of new structures for administering intellectual properties, they will need to keep testing assumptions and strategies against the changing realities of the market. But the time to begin analyzing the new economic situation is now. The task must be undertaken seriously.

REFERENCES

1. Elsewhere I've discussed some of the new products and services that museums might develop, the problems they confront in selecting appropriate standards, and the general question of why the world would want intellectual property developed by cultural institutions over that which is likely to be available from commercial interests. See: David Bearman, "Information Strategies and Structures for Electronic Museums," in *Information: The Hidden Resource, Museums and the Internet* (Proceedings of the Seventh International Conference of the MDA, 1995), ed. Anne Fahy and Dr. Wendy Sudbury (Cambridge, U.K., Museum Documentation Association, 1995), pp. 5-22.

2. For a variety of reasons, publication of series and provision of consistent information through regularly updated information services will be more cost effective than single titles or providing access to a relatively stable database. These reasons include the potential that repeated content delivery has for recouping some "first copy" costs, the benefits of normalizing production methods, and integrating content creation into other everyday functions of the museum, as well as the benefits of resales based on building customer loyalty.

3. cf. Lyn Elliot Sherwood, "Moving from Experiment to Reality: Choices for Cultural Heritage Institutions and their Governments," fn. 11.

4. Jennifer Trant, "The Getty AHIP Imaging Initiative: A Status Report," *Archives and Museum Informatics* 9, no. 3 (1995).

5. This planned database has not yet established a fee structure or proven that museums and archives will be willing to use a reference database publisher as an image broker. It was expected to get underway in 1996, but had not yet happened in early 1997.

6. David Bearman, "Museum Strategies for Success on the Internet," *Museum Collections and the Information Superhighway* (London: Science Museum, 1995), pp.15-27. Also published in *Spectra* 22, no. 4, pp.18-24.

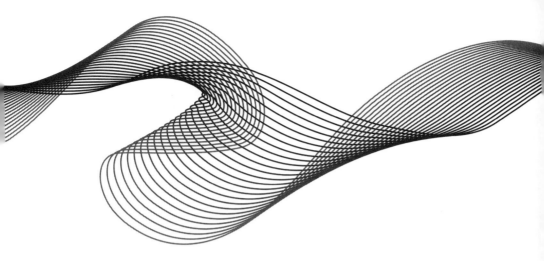

CONCLUSION:
TOWARD THE META-MUSEUM

GEORGE F. MACDONALD
Executive Director
STEPHEN ALSFORD
Special Projects Officer
Canadian Museum of Civilization, Hull, Quebec

(An earlier version of this paper was presented by one of the authors at the conference "Digital Knowledge: Canada's Future," Toronto, Feb. 6, 1996)

I t is possible to trace, in the professional literature and conferences of the museum community, a slow but steady growth in awareness both of digital technologies and of the fact that museums cannot remain aloof from technological trends if they wish to attract 21st-century audiences. Tomorrow's museum visitors will be people for whom computers and multimedia have already played a prominent part in their lives through schooling, recreation, and work experience. With public funding sources diminishing in Canada (and many other countries), museums are becoming more reliant than ever on the support and interest of their visiting publics. The opportunities that digital technologies present for the dissemination of knowledge on a scale never before possible, and the pressures to conform to audience expectations, will be key factors in transforming museums. That transformation won't mean that we

lose what museums are and have to offer as physical sites conveying knowledge of heritage through the medium of material objects. It means that we will construct another dimension to the museum world—a digital dimension.

For the most part, museums' involvement with new technologies has been cautious. They have tended to be followers, not leaders. Perhaps this is because they naturally think more in terms of the past than of the future. In the 1980s we saw a few museums experiment with videodisc, initially for collections management purposes and later for public access and/or retail. Digital imaging technologies are with us now, but only a relatively few museums have adopted it for similar purposes. In most of these cases, small-scale, one-off pilot projects were involved, rarely followed up by anything with broader or longer term goals.

The number of institutions doing anything on a wider scale is even more select. Since the Canadian Museum of Civilization (CMC) is among that select few, we will briefly review its particular situation. The initiative to design and construct a new building for the museum, and to rethink every aspect of how we were pursuing our mandate to disseminate knowledge, coincided with the rise of the personal computer and appearance of digital telecommunications. Consequently, the new vision for our institution had the concept of electronic outreach as one of its key ambitions. This has since been embodied in our first Strategic Plan (1993), which requires CMC "[t]o share and communicate its knowledge to a degree unprecedented in museums." The new building incorporates a sophisticated network including digital switching and fiber-optic cabling. This combination of vision and intelligent-building infrastructure helped us create strategic alliances with Digital

Equipment of Canada and Kodak Canada, which brought to the institution the specialized high-tech expertise it was lacking.

The alliance with Kodak began with a project to create a digital image archive based on our photographic archive and new photography of the artifact collections. Once complete, the project will leave us with about 300,000 images, a third of which will be new photography of artifacts. We have experimented with making accessible to staff a subset of the images through our in-house network, and are now embarking on a project to make several thousand accessible via our World Wide Web site, as an interim step toward an on-line image-server, which will make a much larger selection accessible. The Photo CD archive has also enabled us to test both the multimedia production process and the market for multimedia products by publishing CD-ROMs and Portfolio CDs. We have 12 products (released or in process) in our catalog at present. In addition, we have made arrangements for distribution of some of the digital images through Corel's Professional Photos CD-ROM series and through Corbis Corporation. Again, our hope is to use these arrangements to get a sense of where market interests lie.

The alliance with Digital Equipment of Canada (DEC) gave us access to their network management skills and to some of their more powerful hardware; led us into a World Wide Web project; and in September 1996 resulted in the opening, inside the museum, of one of six of New Media Centres that DEC is establishing around the world. This center serves not only the museum but multimedia developers generally, and even the general public, by providing a showcase for new technologies, the ability to test-drive those technologies, and multimedia R&D facilities.[1]

Even a large museum like CMC is not well enough resourced (compared to for-profit organizations) to pursue the vision of the digital museum at the pace we would wish. Most Canadian museums are struggling when it comes to finding money to invest in computers, or the skills and labor necessary for digitization, prototyping, and product development. Each museum will have to find the level at which it can participate in the Information Superhighway.

For a while the Information Superhighway was the darling of the media. Right now, however, the *soup du jour* is the Web, anticipated precursor of the Superhighway. Over the last three years museums have begun to jump on this bandwagon. For many it has been a way of getting familiar with the technology at relatively low cost and risk. At CMC we appreciated the value of gaining experience in the new medium as quickly as possible, and had a site up in late '94. At that point there were a couple dozen museums with Web sites. By February 1995, about 70 museums had Web sites; this had grown to around 130 by May. By the beginning of 1996 the number was over 200, and during that year it increased exponentially (this does not include those museums represented only by minor entries in an on-line tourism guide). Although American museums remain by far the best represented, the Canadian count has increased significantly—again, 1996 was the key year—and is now around the 130 mark. All of Canada's national museums and most of its provincial museums now have an on-line presence.

The swift rise in popularity of the World Wide Web has led many to predict that a mass audience will be on-line by the end of this decade, although recent statistics show that the growth in the Web's population is slowing. A further major jump awaits the spread of plug-and-play

TV/PC combos with fast Internet access via cable. Those museums that have had time to acclimatize to the environment have captured an audience share and are prepared to continue investing in the technological developments that are driving the Web. They should find themselves well positioned when the mass audience arrives.

At present, information about the particular subset of Web users who are visiting museums' home pages is scarce, but general demographics indicate that their profile is similar to that of the traditional museum-visiting audience in terms of income and education. For the Virtual Museum section of its Web site, launched in the summer of 1996, CMC required access via registration and log-in in order to obtain demographic information about its users. Analysis of information supplied by the first 2,643 registrants (of which 1,773 data sets were considered reliable enough for analysis) does indeed suggest a broad similarity of profile with Web users as a whole:[2]

■ 2/3 were males, median age in mid-30s, the majority with a university-level education;

■ the most common occupations were professional, student/educator, and engineer/technician;

■ anglophones predominated, with the largest group from the U.S. and the second largest from Canada.

As the audience grows and the demographics are better understood, museums will be able to develop more narrowly focused niche services targeted at particular groups. Whereas today Web users are disinclined to pay for access to individual sites that are of only casual interest to them,[3] it will become possible to deliver targeted services for special audiences on a subscription or pay-per-use basis. This approach is almost inevitable if muse-

ums are to continue to justify investment in on-line services. In essence, those services will move closer to the narrowcasting paradigm of Pay-TV specialty channels.

What will the digital museum be like? It presents some wonderful opportunities:

■ overcoming the confines of space that enable museums to display only a limited number of exhibits and a small sample of their collections at any one time;

■ overcoming the geographical or logistical obstacles that hinder people from visiting the physical sites of museums;

■ forging more direct links with educational curricula by making museums a resource that students can visit from their classrooms; and

■ presenting subject-matter and integrating diverse media in new and interactive ways to enhance the learning process.

It is surely likely that the digital museum will adopt metaphors that make it look much like the real-world museum. Museum exhibits and the hypermedia environment of the Web already have characteristics in common. Each uses diverse media forms to communicate messages: texts, still images, audiovisual. Each is structured to facilitate exploration of knowledge domains. Each tends to have layered information, with main themes branching into sub-themes. And, yet, each offers visitors the chance to wander almost randomly, on associative principles that reflect highly personalized interests. The Virtual Museum section of CMC's Web site employs metaphors associated with real-world museums: Web-surfers arrive in a lobby where they can go to the information desk and find out "What's On" currently, or take the elevator to various floors of the Virtual Museum, each containing galleries or other facilities.

Technological trends on the horizon—virtual reality and 3-D imagery—will encourage the molding of digital museums into close simulations of their real-world counterparts. Such developments may help trigger a mass museum movement on-line—but not before the Internet infrastructure is upgraded, virtual reality moves beyond state-of-the-art workstations to affordable off-the-shelf technology, and intelligent agent software is available to allow easy navigation around extensive multimedia databases. It is easy to envisage a virtual museum in which the armchair visitor can travel through simulated galleries; observe, circle around, and manipulate objects; and have immediate access to catalog data or audiovisual materials showing the objects in context of use. Quicktime VR already provides a simple means for 360-degree navigable environments to be presented via the World Wide Web; it is possible to work one's way through museum galleries and to select artifacts from display cases and rotate them.

Furthermore, it is not difficult to imagine a further extension of this metaphor, in which the intelligent agent software has a front-end interface that takes human form: guide, interpreter, or curator. A recent initiative at the Jorvik Viking Centre in York, England, involves laser scanning 1,000-year-old human skulls, followed by 3-D computer modeling. The resulting reconstructed Viking faces have been used to create some 30 lifelike mannequins for exhibits. CMC worked on a pilot project with Canada's National Research Council, which has developed a digital 3-D laser scanner system, to demonstrate museum applications—enhancing an exhibit of tiny paleolithic figurines with large 3-D images of the carvings that visitors could rotate. This collaboration is now moving to a larger project that will supply us with an archive of three-dimensional artifact images.

Projects such as these not only demonstrate the museum-specific applications of digital technologies; they also suggest the possibility that the digital museum's virtual guide might be a historical scholar or curator. For instance, a visit to the virtual version of CMC's Pacific Coast Native villagescape might be guided by Marius Barbeau, whose own important writings on totem poles would be the source of the information programmed into the tour guide. Or, wandering through virtual CMC's Canada Hall, a visitor might encounter simulations of particular historical figures and be able to converse with them and gain some insight into their perspectives and values.

This detailed reconstruction of a human persona has not yet been attempted, to our knowledge, but it is surely the direction that development of intelligent agent software will take. It will be a humanizing or, if you prefer, anthropomorphizing, approach. After all, humanity's vision of the ultimate robot is one that so well mimics the human form and personality as to be difficult to distinguish from the "real thing." And one of the major thrusts in museology in the 1970s and '80s was to have interpreters impersonate historical figures in reconstructed historical settings in open-air or indoor museums.

The attempt to reconstitute communities in open-air museums will find its sequel in the digital world in efforts to reconstitute past cultures—bringing together in virtual space the formerly fragmented and geographically dispersed evidence of those cultures in digital form. Colonialist and migratory trends over the last two centuries have resulted in the fragmentation and even annihilation of many of the world's cultures, a process from which museums have been among the beneficiaries. The digital museum offers the opportunity

to redress that situation somewhat, if museums are prepared to take on the role of cultural dynamos. Through a resynthesis of the fragments it should be possible to provide a better appreciation of the vitality of past cultures than can be given by books or static exhibits. This is one reason why indigenous groups have become so interested in the Internet—it might help them regain access to cultural information that has been dispersed into other hands.

As one example of pointers in this direction, we might consider Project Buhen, a collaboration among virtual reality developers, the computer industry, and the educators and curators of the Museum of Fine Arts, Boston. This consortium's goal was "to provide students with the opportunity to have vicarious first-person experiences with distant, forgotten, or lost ways of life." Its demonstration project was the computerized reconstruction of various settings from ancient Egypt (notably the Fortress of Buhen) using photographic and archaeological data. The fortress can be toured in virtual space with a computer-generated Egyptian scribe as the guide. Its developers envisage that, as VR technologies mature, "virtual travelers may be able to access interactive visual or text databases and even visit other virtual sites all from within the experience of the original location."[4] This could, of course, include not just historical sites but museums around the world.

For the present, however, there are many barriers museums must surmount if they are to operate successfully in a digital world. There is not space here to address challenges such as the need to convert or upgrade in-house skills, to resolve issues surrounding standards and copyright, and the importance of assuring progress through revenue returns from new initiatives involving expensive technologies.

However, we should say something about the competitive challenge to the museum community in a digital world. The digital environment presents a relatively level playing field in which museums no longer have the same, almost monopolistic roles of stewards and interpreters of heritage. The World Wide Web, with its hundreds of thousands of home pages issuing from all sorts of institutions, interest groups, communities, schools, and private individuals, is a democratized environment in which anyone with a relatively small amount of disposable income can create digital "exhibits" reflecting her own perspectives on culture and heritage. In fact, it is not easy to distinguish on the Web a bona fide museum's site from a purely digital museum created by an individual or a school class—as demonstrated by the public confusion between the WebLouvre (now renamed the WebMuseum) and the real Louvre. Assuming this democratic character is not bureaucratized or commercialized out of existence, we can expect that virtual exhibits or virtual museums will be created by others than just bona fide museums. In fact, that is already well underway: dozens of examples of virtual exhibits or virtual museums may be found in the metadata Web sites listing museum resources on the Internet. Most of these are initiatives by non-museums. On the other hand, CMC itself has created two virtual museums—the latest, recently launched, being the Virtual Museum of New France, an international collaborative effort.

Although they face this new competition, bona fide museums need not go the way of the dodo. They still possess incredible resources in the material evidence of the past and the expertise necessary to make that evidence understandable to the public. Their future role, however, may be based more on coordination than intellectual author-

ity or monopoly. The true vision of a virtual museum extends beyond the digitization of the resources of any individual museum, into a collaboration recombining the resources of multiple institutions, as well as those of private citizens. How many important objects of heritage are in the hands of private collectors, for example?

No museum has in its keeping the sum total of human knowledge. Each holds pieces of a gigantic jigsaw puzzle. CMC's Web site had about 7,000 screens of information as of February 1997, and we have only scratched the surface of what we hope to present, based just on our own information resources. Other parts of the heritage puzzle are held by libraries, archives, historic sites, scholarly societies, families, and so on. Heritage resides everywhere. The digital environment presents the prospect of bringing that all back together, in virtual space, to create a new entity: the "mega-museum" or "meta-museum."

Over the past decade or so, human history museums have come to recognize that it is not enough to present display cases full of artifacts, each in isolation from its historical setting or use; that recontextualizing these objects gives them greater meaning. Digitization offers the best prospect we have for recontextualizing on a grand scale. The task of reconstructing our past digitally is truly vast. It will not happen overnight, nor within the span of a single generation. But once museums accept that the future will be one in which people are much more inclined to acquire knowledge and experiences through computer mediation, we can expect to see many more institutions diverting money and effort into the digitization of their information resources. And gradually we will see the emergence of the digital meta-museum.

REFERENCES

1. The center's mission is "to offer innovative, interactive new media technologies and services in the areas of multimedia, Internet services and electronic commerce. It is designed to facilitate the creation, archiving, and distribution of content for the Information Highway; to forge new partnerships for the development and distribution of interactive new media applications and services; to work with universities and the academic sector for market research; and to create a new media showcase and a window on the Information Highway for businesses and the general public." For further information see documentation on CMC's Web site at

```
http://www.cmcc.muse.digital.ca/cmc/
        cmceng/pr18eng.html
```

2. However, this initial analysis covered those who registered during the summer, thus likely underrepresenting the student population, who are believed to be an important part of the clientele of CMC's Web site.

3. Repeated surveys, notably those by the GVU Center at the Georgia Institute of Technology

```
http://www.cc.gatech.edu/gvu/user_
        surveys/
```

have shown opposition to user fees additional to those for general Internet access, but this attitude may change as more quality information is available on-line and its value becomes more generally perceived.

4. Information on the Buhen VR can be found on the World Wide Web at

```
http://www.learningsites.com/buhen.htm
```